art
of
drawing

Translated from the Spanish by María Constanza Guzmán and Olga Martin

Library of Congress Cataloging-in-Publication Data Available

9 10 8

Published in 2003 by Sterling Publishing Co., Inc.
387 Park Avenue South, New York, NY 10016
Originally published in Spain in 2002 under the title
Fundamentos del Dibujo Artístico by
Parramon Paidotribo, S.L., Badalona, Spain
Copyright © ParramonPaidotribo - World Rights
Production: Sagrafic, S.L.
English Translation © 2003 Sterling Publishing Co., Inc.
Distributed in Canada by Sterling Publishing
C/o Canadian Manda Group, 165 Dufferin Street
Toronto, Ontario, Canada M6K 3H6
Distributed in United Kingdom by GMC Distribution Services
Castle Place, 166 High Street, Lewes, East Sussex, England BN7 1XU
Distributed in Australia by Capricorn Link (Australia) Pty Ltd.
P.O. Box 704, Windsor, NSW 2756, Australia

Printed in China
All rights reserved

Sterling ISBN-13: 978-14027-0932-6

Art of drawing

■ ■ ■

The Complete Course

STERLING
New York / London
www.sterlingpublishing.com

Con-tents

training the artist's eye

Drawing allows us to represent a three-dimensional image on a one-dimensional surface by using basic elements of form such as composition, proportion, and volume effect. Drawing is the fundamental basis for all types of artistic works. Sculpture, painting, architecture, and even film and photography use drawing as the initial medium to conceptualize, understand, and develop the various components that will work together in the final project. Drawing is many times an original work in itself, giving us the ability to reproduce our surroundings and environments.

As is the case for any art form, drawing can be learned; it is not a special talent that only a few possess. Like writing, which begins with letters that form words, which in turn form phrases, drawing begins with a succession of points that form lines, which create shapes, shades, and stains. The secret of any drawing does not lie in one's ability to apply a certain technique, but rather in one's ability to learn how to observe and analyze a theme, create the drawing's outline, arrange its composition, and calculate its proportions. Therefore, training the artist's eye is the first step in any artistic work. The trained eye precedes the drawing and helps create what may be called a drawing of the drawing that is based on a set of both abstract and schematic approaches to better understand a model, establish a relationship between the seemingly disorderly gesture and the clarity of the structure.

Since we are aware that the lack of this basic knowledge is the greatest obstacle a beginning artist may encounter, this book is intended to provide all the necessary information needed to begin drawing. We explain clearly and methodically each of the processes and techniques that professional artists often apply instinctively. In addition to these, you will find information about other important aspects, such as training the hand, controlling the stroke, composition, and volume effects offered by various mediums, tools, and materials. It is essential to understand and master these basic lessons in order to draw confidently.

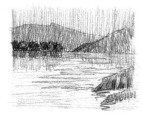

Composition and structure are the basis of any drawing.

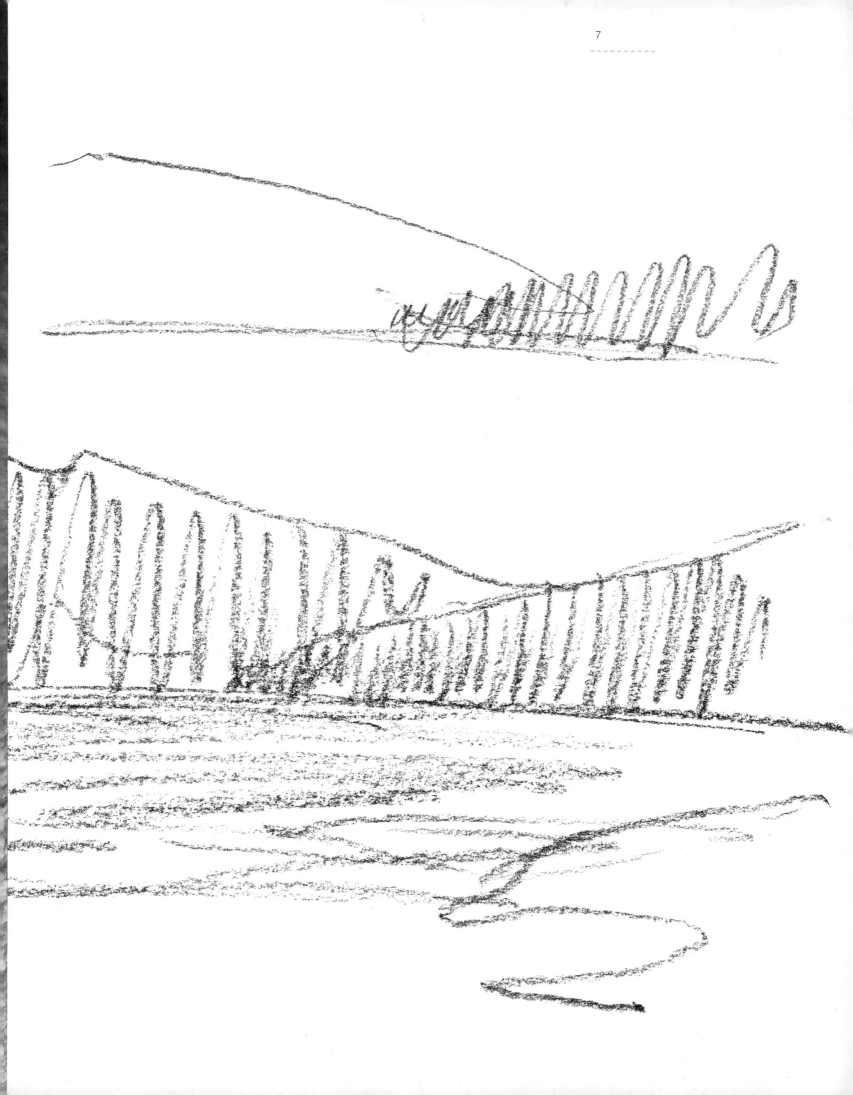

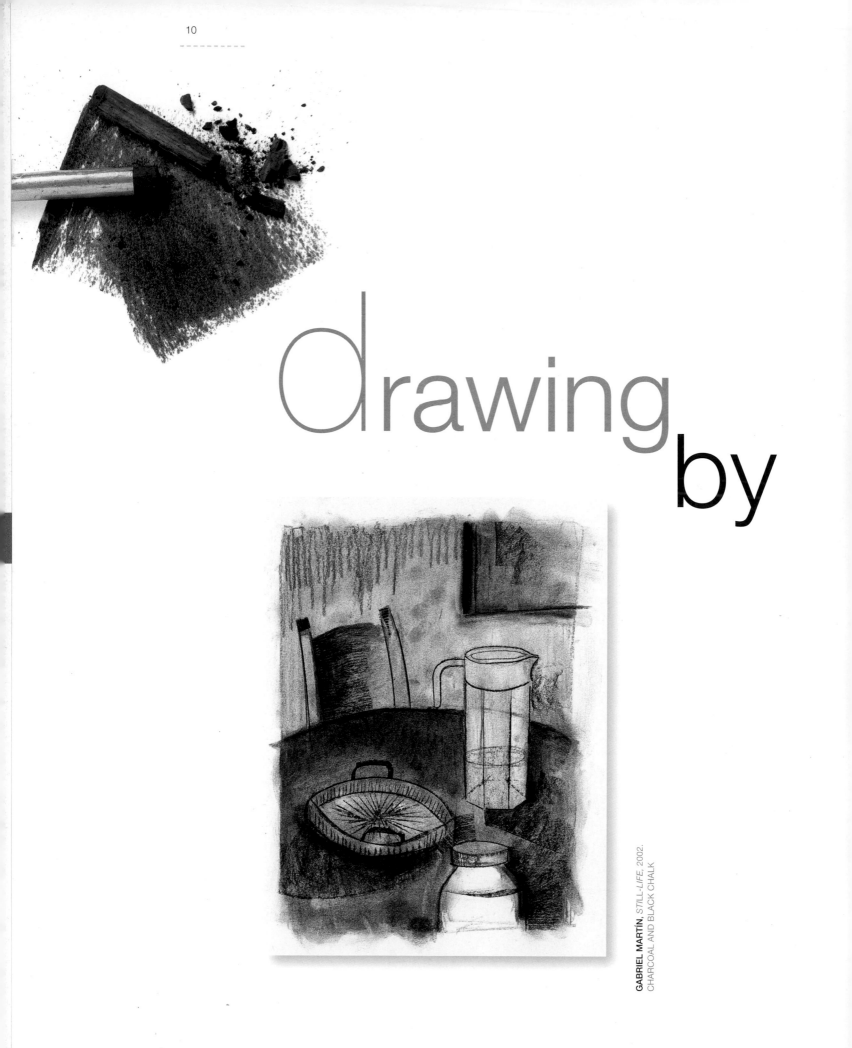

drawing

by

friction.

Believe it or not,

but just a bit of friction

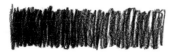

will start you on your drawing course. When a paper's surface is scratched with any pigment medium particles are left behind. These particles leave an intense, yet delicate stroke. A simple touch with your finger and the stroke will vanish as charcoal dust. Due to its delicate properties, charcoal is the ideal medium to begin drawing with, since mistakes can be easily corrected.

Although an artist has a considerable amount of freedom regarding how he or she chooses to apply various techniques, the inherent characteristics of mediums and materials and how they are used cannot be ignored and must be learned. Anyone interested in drawing and in obtaining the most benefit from a given material should know and follow its "rules." Each tool and material gives specific and unique results that no other medium can duplicate.

graphite: line,
control, and properties

Graphite is one of the most popular drawing mediums among both art students and professionals. Compared to other media, it is durable and very easy to handle. Graphite is the most immediate, versatile, and sensitive drawing medium that is suitable for quick sketches as well as for detailed work. Graphite is fragile, oily, and soft to the touch, and comes in several forms: sticks, pencils, and powder. It can be used on almost any kind of surface. Due to its oily texture, its marks are permanent and do not require a final fixative, although in some cases it might be advisable to do so. When used for shading, graphite has a smooth, velvety appearance, which can appear sharper and more intense when the point is pressed directly against the paper. The artist has great line control with graphite, since it can be erased and redrawn as many times as necessary.

A

B

C

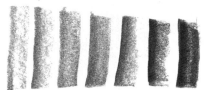

It is a good idea to experiment with graphite sticks and pencils that have different degrees of hardness.

The shape of a graphite stick's point and how it is positioned on the paper are essential in controlling a stroke's quality. Different effects can be obtained with (A) a sharp point, (B) a dull point, or (C) the side of the point.

The graphite sticks below have various degrees of hardness. The hardest sticks produce a soft stroke and are commonly used in preliminary sketches. The softest sticks provide a thicker, more intense stroke and are used for sketches with movement and tonal properties.

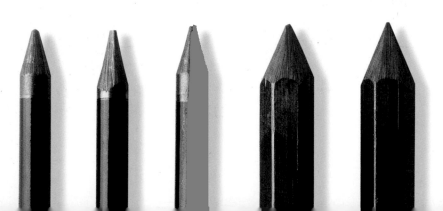

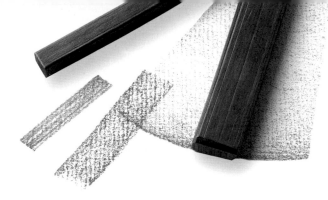

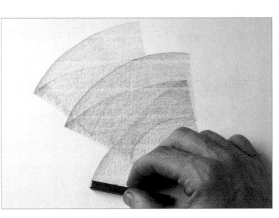

When held on their flat side, graphite sticks are used for drawing wide strokes and for shading large areas.

Graphite sticks come in different sizes and various degrees of hardness. Above are rectangular graphite sticks.

FLAT GRAPHITE STICKS

Some types of graphite sticks, such as flat sticks, are used for large-scale works in which large areas need to be shaded. They also create intense strokes. Flat graphite sticks do not have a point and are many times drawn on their flat side. Since graphite sticks are not covered in wood or plastic, their point configuration is not limited, which means you can draw a large variety of strokes.

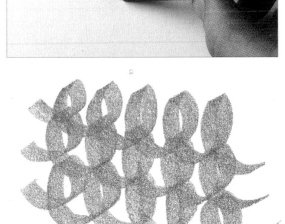

When held upright, the graphite stick's point creates a thin and intense stroke.

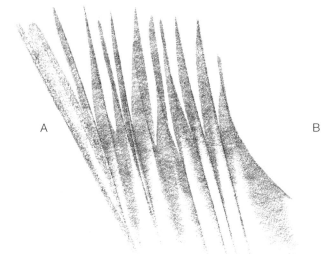

A

B

Here you can see a sample of the strokes and effects that can be obtained from flat graphite sticks: (A) linear stokes with the flat side, (B) ringlets with the point held upright, (C) wide strokes with the flat side, and (D) wide strokes with the point.

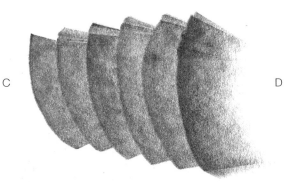

C

D

Mechanical pencils are very convenient to use since they can be carried around easily. Like pencils, refills come in a wide range of soft and hard leads.

DEGREES OF HARDNESS

The various possibilities of a stroke's intensity depend on the graphite stick or pencil's hardness. This variation in hardness allows us to use light and dark lines to create light or dark shading. A number and letter, engraved onto the pencil's side, indicates its hardness. Pencils with the letter H have hard leads and make thin, light lines that are commonly used in technical drawing. Pencils with the letter B have soft leads and make strong, dark lines. The number that accompanies the letter also indicates the pencil's hardness or softness; the higher the number, the harder or softer the leads is. A good selection to begin with is: 5B, 3B, B, and HB. Artists usually use the softer leads because they create intense lines, which makes shading much easier. It is also a good idea to have some mechanical pencils, so that you have different options to choose from.

It is a good idea to have a selection of pencils with various degrees of hardness in order to obtain different strokes with different values.

Elaborate linear figure work can be achieved with graphite pencils. Draw firm strokes with a well-sharpened point. Since tone (shading, hatching, cross-hatching) is not built up in these types of drawings, use very soft pencils.

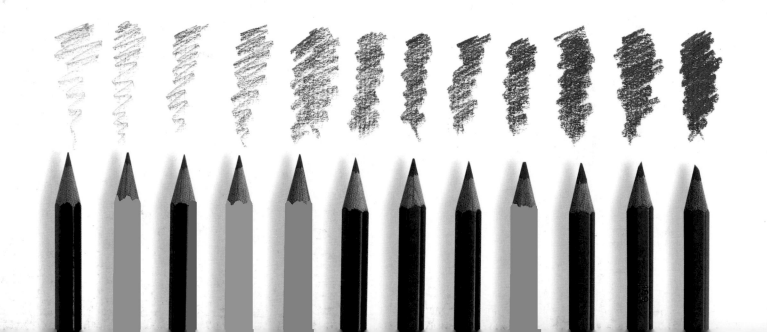

LINE QUALITY

If you need to draw wide strokes, we recommend using flat graphite sticks. Combining graphite stick and pencil produces fascinating results. The graphite pencil gives you a lot of control of the line and its tone, while the graphite stick's width enables you to cover large areas quickly. Hard leads are used for the detailed areas and for the initial shading, while softer leads are used to accentuate the darker areas. Many artists combine pencils with different degrees of hardness to create complex drawings with lines and strokes.

Soft pencils allow you to create continuous gradations. Blend the gradations with your fingers or with a blending stump in order to create an atmospheric effect. Look at the different shadings in the drawing below. The combination of different strokes give variety and depth to the work.

A. shading
B. finger blending
C. superimposed shadings with various intensities
D. intense, parallel sketching
E. parallel stroke hatching with an eraser
F. tonal gradation
G. tone contrast to emphasize different planes
H. doodling for vegetation textures
I. eraser marks made on blended shading

Just rubbing your finger over a graphite stain will blend the strokes and create an atmospheric effect.

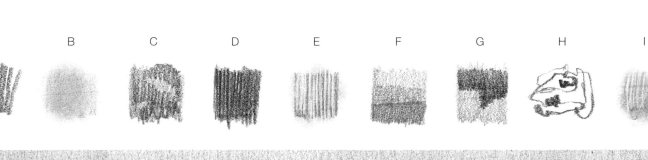

| A | B | C | D | E | F | G | H | I |

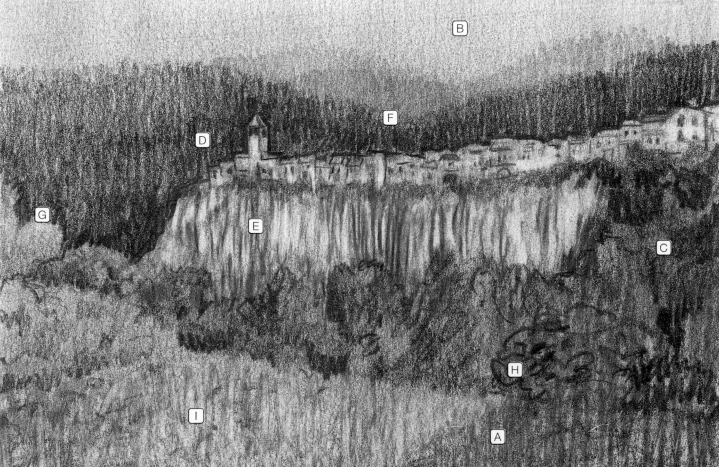

Charcoal is one of the oldest and simplest means of drawing. Because it is carbonized willow branches, charcoal makes a strong and intense black stroke. The basic difference between graphite and charcoal is that charcoal is dry and graphite is oily. Because charcoal is dry, it does not stick to the paper very well, which means you have a considerable amount of control over it and can correct mistakes easily. Just running your finger over charcoal will erase it; be careful though, because doing so will also create gray tones. Blowing on charcoal will lessen the stroke or the shading's contrast.

A

Charcoal:
the oldest medium

TONE

One of the best qualities of charcoal is that it is the easiest medium for shading, which creates tone. Tone is the degree of lightness or darkness of a color—with charcoal the tonal range runs from black to white. With a little practice, there is nothing that is more pleasing or fun than making quick smudges, reapplying them, erasing, etc. with charcoal. Because of its versatility, charcoal is an ideal medium for beginners, since it allows for corrections and for the treatment of a variety of themes without requiring too much attention to detail.

It is very easy to combine strokes, tones, blends, and gradations with charcoal.

B

C

Above are some examples of charcoal strokes: (A) with the stick's point, (B) with the point held upright, and (C) with the stick held on its side.

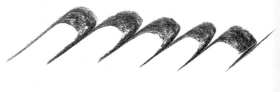

Above are strokes made by rotating the charcoal stick while drawing.

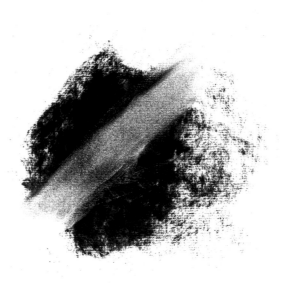

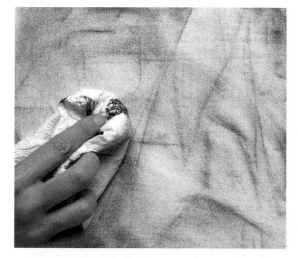

You can break charcoal sticks in order to obtain the size you need. The ideal length for drawing is about 2 to 2½ inches. This size will allow you to create almost any desired effect.

Above are natural charcoal sticks, which are very fragile and brittle. Natural sticks are more expensive than compressed charcoal sticks.

Charcoal will come off the paper with the lightest touch.

Since charcoal does not stick to the paper very well, it can be erased easily. However, even when the particles are removed, parts of the strokes remain visible.

Charcoal allows you to sketch or outline quickly, using the stick's point or its side interchangeably.

A dull point makes extremely intense strokes.

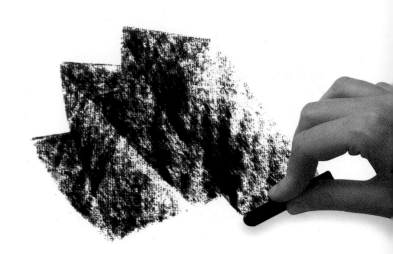

Dragging the charcoal stick on its side produces wide strokes.

USING CHARCOAL

Charcoal can be used in many different ways. The way the stick is held determines a stroke's effect. For example, holding the point horizontally or on an angle will create different lines. Also, by turning the point or varying the pressure you place on the charcoal stick will produce either soft, delicate strokes or bold and intense strokes. Soft charcoal is more granulated and therefore adheres better to the paper than hard charcoal, which is better for detail and line work since it does not erase as easily.

A beveled point creates wider, more regular strokes.

Charcoal drawings no longer have to be temporary works. Spray fixatives allow charcoal to remain on the paper and retain its classic and noble reputation.

Drawing on the charcoal stick's flat side makes linear lines thinner, firmer, and more defined.

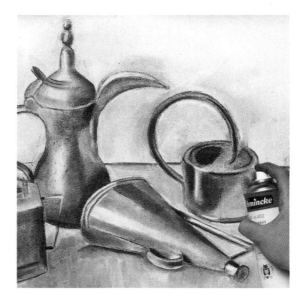

STROKES AND EFFECTS

If you hold the charcoal stick like a pencil, the strokes will be neater and more controlled by your hand movements. If you drag the stick on its side over the paper, the stroke will be thin and solid. With the charcoal stick held transversely (on its side in an upright position), you are able to create shadings that are as wide as the charcoal stick. Drawn with one continuous hand movement, transverse strokes become lateral (lengthwise) strokes.

A
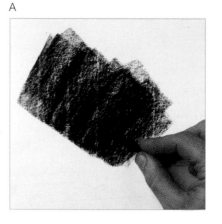

B
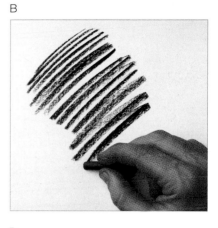

C

D
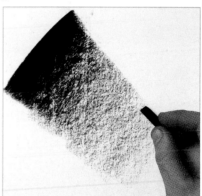

To the right are the basic effects that can be achieved by mastering the use of charcoal: (A) even shading, (B) different strokes and intensities, (C) blending, and (D) gradation. By learning these four skills, you will be able to draw any shape and master any tonal effect.

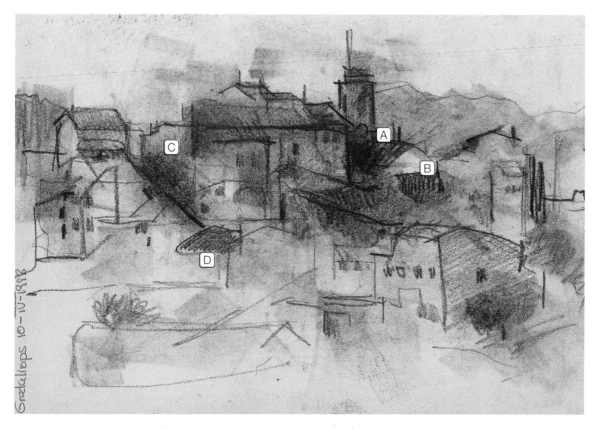

Charcoal allows for an initial schematic approach to a theme without relying on a lot of detail.

tone techniques
with charcoal

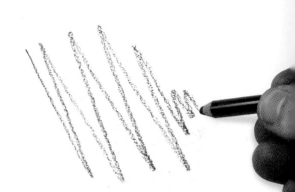

An artist must be much more courageous when using charcoal than when working with a pencil. Charcoal calls for drawing complete, whole forms instead of bringing out detail in a work, which is why this medium is more effective for large-scale drawings. Appropriately combining different strokes will allow you to draw seemingly complex shapes.

Compressed charcoal pencils are ideal for linear lines and strokes.

DRAWING WITH STROKES

Compressed charcoal pencils are the best medium for drawing strokes. These pencils are very useful for small-scale works in which lines prevail over stains. Intense charcoal strokes add greater expressiveness and intensity to a drawing than those produced by graphite. Shadings begin with small strokes, their intensity depending on the dark areas. Pressing the charcoal pencil harder against the paper will create darker shaded areas.

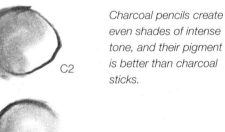

Charcoal pencils create even shades of intense tone, and their pigment is better than charcoal sticks.

A

B

C1

C2

C3

C4

Charcoal pencil strokes can be blended, but they are less malleable than charcoal stick strokes.

Above are some basic blending effects with a charcoal stick. You can see how volatile this drawing medium is. Simply rubbing your finger or a blending stump over a smudge or stroke will quickly blend it (A and B).
To test the pliability of charcoal sticks, draw a line or a circle (C1). Drag the pigment inside the circle with your fingertip to obtain a very basic shading effect (C2). This can become a tonal treatment by blending the charcoal pigment on the paper's surface with your hands or with a blending stump (C3 and C4).

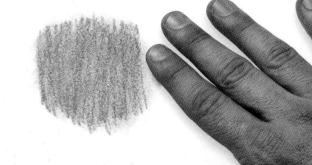

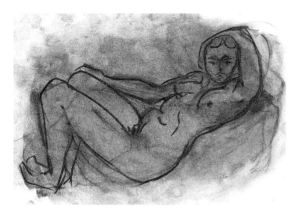

After applying different charcoal stick strokes, the body is outlined with a defined line, thus preventing any possibility of another "ghost" line.

If you need to draw neatly defined shapes, cut the desired shape out of a piece of paper and use it as a stencil.

GHOST LINES

Charcoal drawings are built up by superimposing many juxtaposed lines on top of one another, which are later erased and corrected as the work progresses. This accumulation of erased lines, or "ghost lines," produces an interesting tonal effect on the background. Many times these lines add more emotion and variety to the drawing. A good outline of an object is one that is intense and firm.

Linear charcoal strokes produce strong, expressive effects. It is important to keep in mind the kind of strokes that you will apply in each area in order to create definition and contrast.

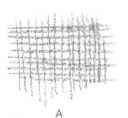

A

B

C

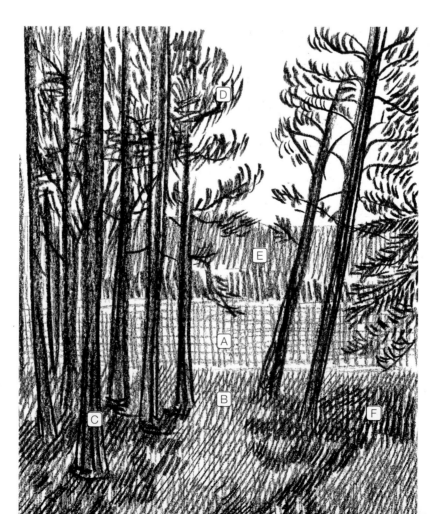

D

E

F

SFUMATO

Charcoal enables us to create a drawing simply by blending strokes, which gives the drawing an atmospheric effect. This technique is called sfumato. Lightly blend the charcoal strokes when using the sfumato technique so that you retain the paper's texture. The only problem with this technique is that due to the absence of defined lines and strokes, which give pictorial effects, the drawing could appear artificial.

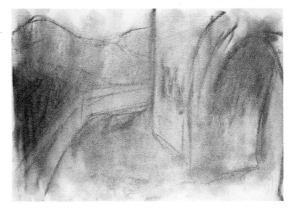

In these two sequences you can see how an atmospheric effect can be created just by running your hand or a piece of cloth over the charcoal strokes. The malleability of this medium enables you to modify the surface several times.

Sfumato is used to create pictorial and atmospheric effects.

Some artists use charcoal powder to create smooth gradations and shadings in large-scale works. Powdered charcoal is applied by rubbing the powder onto the paper with cotton rag.

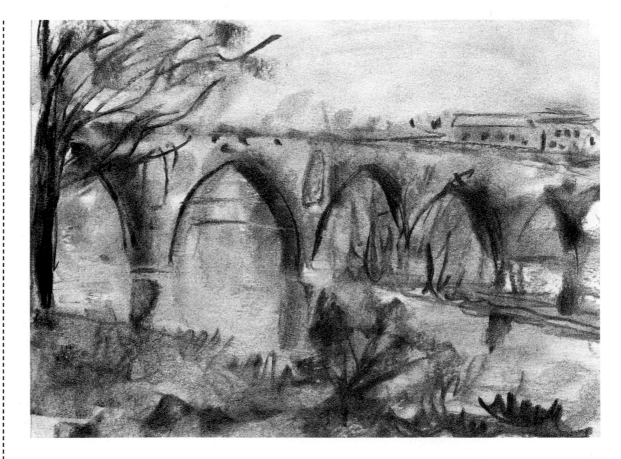

USING A PAPER'S TEXTURE TO YOUR ADVANTAGE

One of the most interesting characteristics in charcoal drawing is how well it adjusts to a paper's texture. If you draw on a highly textured sheet, the strokes will have a granulated appearance, an even semitone effect that will make the drawing more interesting. The rougher the paper, the more intense the strokes will be, given that the sheet will hold the charcoal particles. The pressure you apply on the stick will determine the darkness or lightness of the drawing.

In the darkest areas, (here the arch), intense shading covers the paper's tooth.

Compressed charcoal sticks and natural charcoal stick offer similar effects, but compressed sticks give more intense and contrasted strokes.

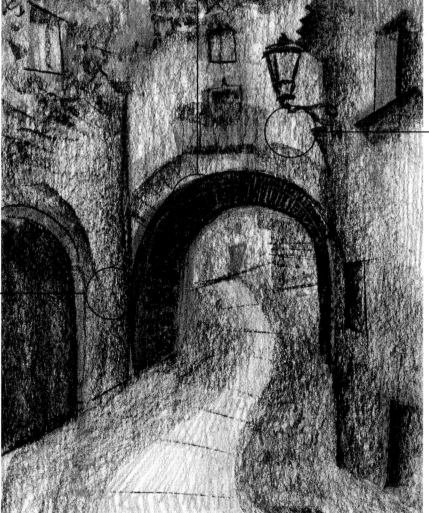

Even shading is used for the walls of the house.

The sides of the walls and corners are shaded with tonal gradations.

Interesting tonal effects can be achieved by simply using compressed charcoal sticks.

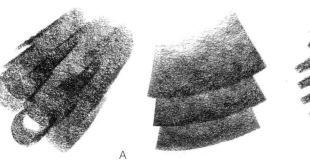

A

B

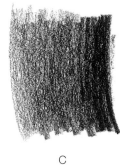
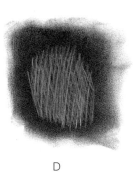

C

D

As you can see, chalk strokes cover the paper more densely than charcoal. To the right is (A) shading, (B) intense strokes, (C) gradations, and (D) white chalk outlines on dark shading.

EFFECTS WITH ARTISTS' CHALK

Since artists' chalk is more delicate than charcoal, the strokes it produces are slightly less intense and much subtler. Like charcoal, you can use the whole chalk stick to draw, leaving strokes that can be easily modified and blended. Before beginning to draw, break the chalk stick to the desired size. Then, begin to make strokes, holding the stick lengthwise. Use the point to draw the outline of the model. Finally, run your finger over the contours to blend the strokes.

Shades and strokes are combined to create forms. It is best to begin practicing with simple subjects or models.

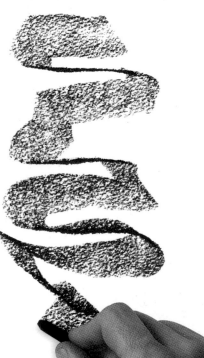

When drawing with chalks, it is important to maintain a continuous stroke and to vary the position of the stick on the paper.

1. When drawing with chalk, begin by outlining the tonal areas. Here, shading was completed with the flat side of the stick in an abstract manner.

For the best results, apply chalk on colored paper.

2. Little by little, the initial shape is completed until the dorsal profile of the female figure can be distinguished.

3. The best technique to use when drawing with chalk is to apply continuous shades with the stick held lengthwise, then to combine them with intense linear strokes.

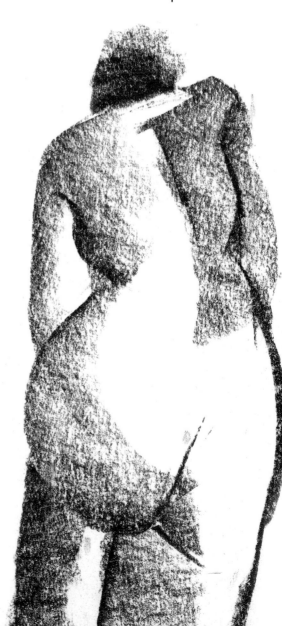

Sanguine:
a classic medium

Among artists' chalks and chalk pencils, sanguine, due to its unique characteristics, is the most commonly used color. Somewhere between brown and terracotta red, sanguine is made of iron oxide and endures as a favorite and classic medium among artists. The popularity of sanguine is due to its warmth and sensitivity to the paper's texture. In combination with other mediums, sanguine is at its best.

Some examples of sanguine chalk and pencil strokes applied with different amounts of pressure and different hand positions.

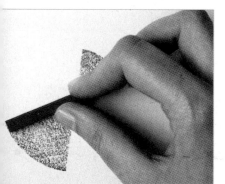

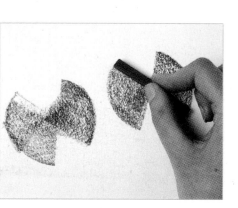

A sanguine stroke and line is primarily plain and flat. Therefore, it is necessary for you to get familiar with shading. If you place the sanguine stick's flat side on the paper and turn your wrist, you will see the interesting shading and gradation effects that can be achieved. Remember, the effects also depend on the amount of pressure you apply.

Sanguine offers a huge variety of drawing treatments: (A) naturalist, with soft shading, (B) structural, with the stick held lengthwise, (C) hatching, and (D) expressionist, with lively, hurried strokes.

A

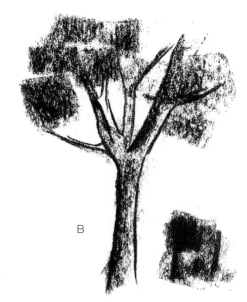

B

Sanguine, like charcoal and chalks, comes in sticks, which are used for medium- to large-scaled drawings.

BETTER WITH STICKS

Like artists' chalks, sanguine combines the best of pencil and charcoal in that it produces line and also texture in a single stroke. It is better to work with sanguine sticks than with sanguine pencils, since the sticks offer a broader, more dramatic stroke than pencils. Like charcoal sticks, you can draw lines with the end or cover large areas with the flat side of the sanguine stick.

1

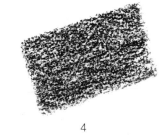

2

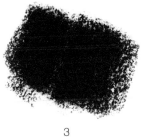

3

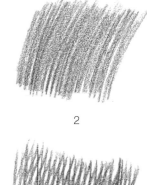

4

5

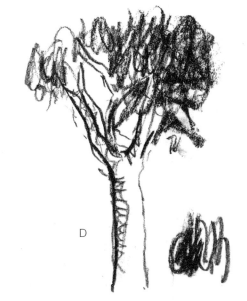

6

Familiarize yourself with sanguine sticks by creating different effects on various textures and papers. Above are examples of (1) a sanguine stick shading, (2) a sanguine pencil shading, (3) sanguine stick shading, (4) sanguine stick shading on rough paper, (5) sanguine pencil hatching, and (6) sanguine pencil cross-hatching.

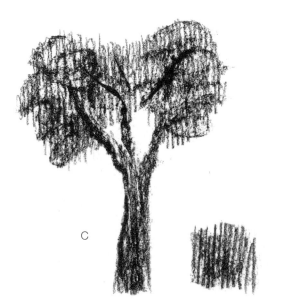

C

D

DRAWING LINES AND STOKES WITH SANGUINE

In order to achieve the best stroke or line from a sanguine stick, draw a continuous line without lifting the point from the paper. Extend the line and vary the amount of pressure to create more color intensity and darker tones. Then do the same with a sanguine stick pencil. Given its sensitivity to texture, sanguine should not be used on very rough papers because the strokes will be fragmented. Also, try to avoid shading toned areas.

When drawing with artists' chalks or sanguine, do not work on textured papers; these papers tend to break up strokes and shading.

Learn to draw in a single stroke, barely lifting the sanguine stick from the paper. Modify the line's width and quality by turning the stick or varying the amount of pressure you apply.

Sanguine gives a unique, warm feeling to a drawing. Combining both sanguine stick and pencil will give beautiful effects.

Sanguine is also available as lead for mechanical pencils, ideal for small-scale works or for those in which line and texture dominate.

Sanguine and charcoal are almost identical in use; however, the results and finishes are very different.

Sanguine pencil is easy to control and offers a rich variety of tonal gradations, as can be seen in this landscape sketch. A fairly good landscape drawing can be achieved by alternating between three or four values (tones) of sanguine. The contrast among the different planes increases the effect of depth.

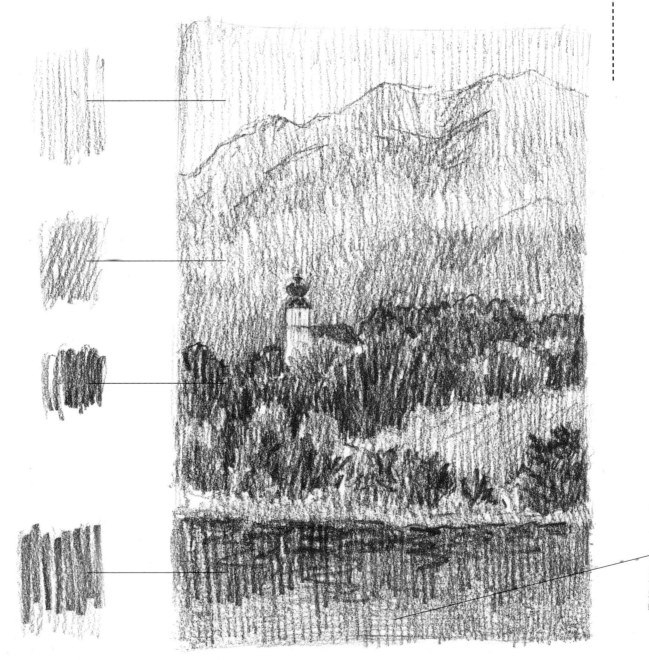

the blending stump:
many possibilities

A blending stump is made from a soft paper felt that is double-ended and pointed. It is used for rubbing and blending. Blending stumps come in different degrees of thickness. Use the point for darker tones and the blunt end for lighter tones.

BLENDING STROKES

Blending stumps are very useful tools for the artist because, as the name suggests, they allow us to transform the drawing through the use of soft gradations and blended shadings. Blending allows you not only to integrate strokes but also to eliminate the white areas within them. When the tones are gradated, a perfect representation of the object's volume can be achieved. The blending stump can be held in any manner; however, using it excessively will reduce a stroke's vibrancy.

A blending stump allows you to blend a line, giving the drawing an atmospheric effect.

Blending closes the paper tooth completely, turning an irregular shading into an even one.

Blending the strokes with a blending stump gives volume to a figure and softens the transition between light and dark.

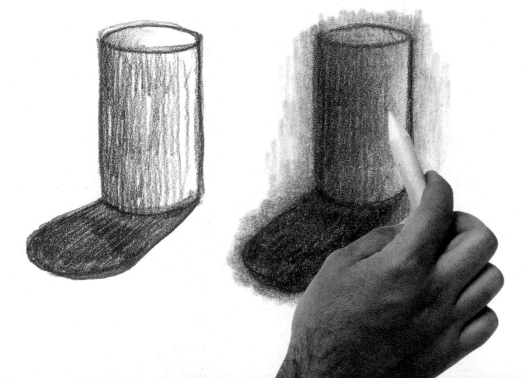

When, after blending in a dark area, you move toward a lighter area, clean the stump on a separate piece of clean paper, so that you do not dirty the drawing or the shade.

Rubbing the stump on a stroke or hatching will smooth tone transitions.

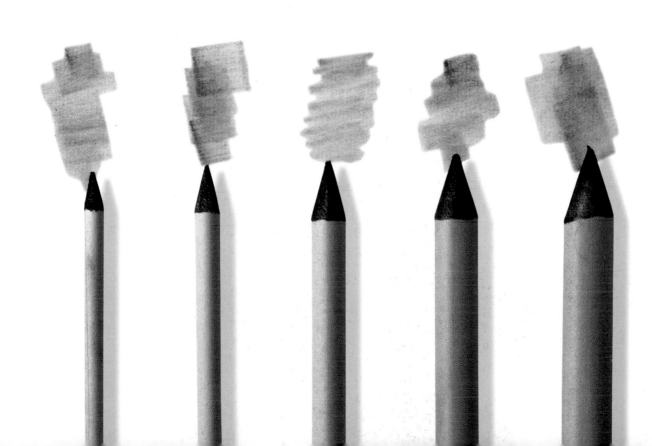

It is a good idea to have several blending stumps of various widths. This will allow you to work with different colors and with large or small areas at the same time.

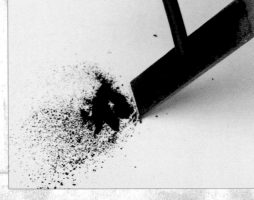 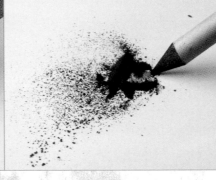 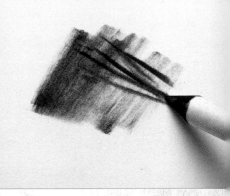

To draw with a blending stump, start by rubbing the charcoal stick with rough sandpaper to make charcoal powder.

Then saturate the stump's end with the charcoal powder.

Draw strokes on the paper. The more charcoal on the stump, the more intense the strokes will be.

DRAWING WITH A BLENDING STUMP

Blending stumps can also be used as drawing tools. To do so, rub the stump's point in charcoal powder until it becomes saturated. Then, draw with the blending stump. For darker tones place more pigment onto the point, less pigment for lighter tones. The final result is a smooth drawing without defined lines.

There are two basic blending techniques with the stump: (1) use the point for smooth, intense strokes or profiles and (2) use the wide, blunt end for wide areas. Your hand movements should follow the direction of the model's texture. If working on an undefined background or plane, use circular movements.

Your hand can also be very useful to blend, shade and stain. The upper part of the palm is ideal for applying wide stains with even tones, whereas the fingertips are normally used to blend and shade local areas.

Blending stumps give an evanescent, atmospheric effect to any drawing. Since it is an effect technique, the drawings do not require a high degree of definition.

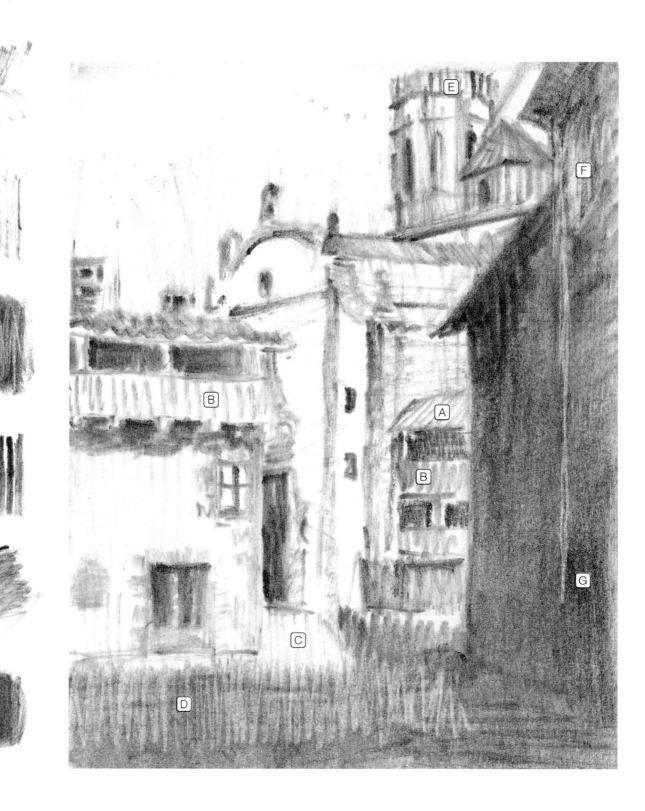

With soft strokes and without a great deal of tonal contrast, a blending stump will produce a drawing with many pictorial effects.

A. Light hatching on the roofs

B. Spaces between strokes on the balcony

C. Soft shading in the illuminated street areas

D. Erasures for more graphic effects

E. Intense hatching on the church bell tower

F. Cross-hatching on the building's façade

G. Intense tones in blended dark areas

A

B

C

D

E

F

G

FINE AND THICK LEADS

There are two types of colored pencil leads available: 3.5 mm, which are used for special works that require a lot of detail, and 4 mm, which are thicker and ideal for wide and intense lines and strokes.

Soft and wide leads are recommended when you are combining techniques. They produce wide lines, which contrast nicely on a colored background.

There are several kinds of colored pencils, whose differences reside in their lead compositions. Although percentages vary, a waxy pencil's pigment is agglutinated with kaolin (a type of clay) and wax. Oil pencils are the most common and are available in hard and soft leads—the softest allow you to color the most easily.

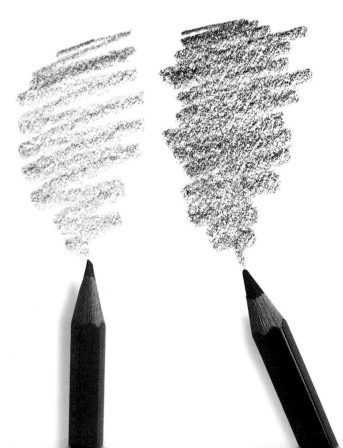

WATER-SOLUBLE COLORED PENCILS

Also called watercolor pencils, water-soluble colored pencil leads are made with coloring pigments that are agglutinated with waxes and varnishes. They have a soluble ingredient which enables them to dissolve when water is added. Watercolor pencils were created for graphic designers and illustrators, and only recently have they been incorporated into the Fine Arts. Even though watercolor pencils combine two techniques into one, they are, nonetheless, considered a mixed-media technique.

Drawing with watercolor pencils is just like drawing with conventional pencils. Because of their waxy composition, conventional pencils do not dissolve when they come in contact with water; they resist it. Watercolor pencils, on the other hand, explode with color when water is added. Hatching will vanish after a wash is applied, but hard strokes will still be visible. Additional colors and details can be added after the wash dries. If you add them while the paper is still damp, they will blend into the paper.

Watercolor pencils have the same characteristics as colored pencils. However, with a wet brushstroke the pigment dissolves, creating a stain that brings washes and strokes together.

In this drawing, colored pencils and watercolor pencils were combined. Watercolor pencil strokes need not be mechanical and symmetric. Note the fine, thick lines and how the shapes of the trunk and branches are rounded, producing a great graphic and chromatic richness.

MIXING COLORS WITH OIL PASTELS

While soft pastels are known for their velvety texture, oil pastels give bold, intense strokes. Images created with oil pastels are flexible enough to be worked on; however, start with light strokes and lines in the first working phases because erasing is not easy. Unlike paints and inks, both oil and soft pastels do not cover the paper very well, unless heavily applied. Hatching and crosshatching are also suitable for the whole range of pastels. For broad effects made with side strokes, you can overlay colors more directly by simply placing one stroke over another. Oil pastels cannot be blended by rubbing, but the color can be "melted" with turpentine or white spirits. Another advantage of using oil pastels is that they do not need to be fixed, so you can build up layers of color without worrying that the top layer will fall off. One popular technique with oil pastel

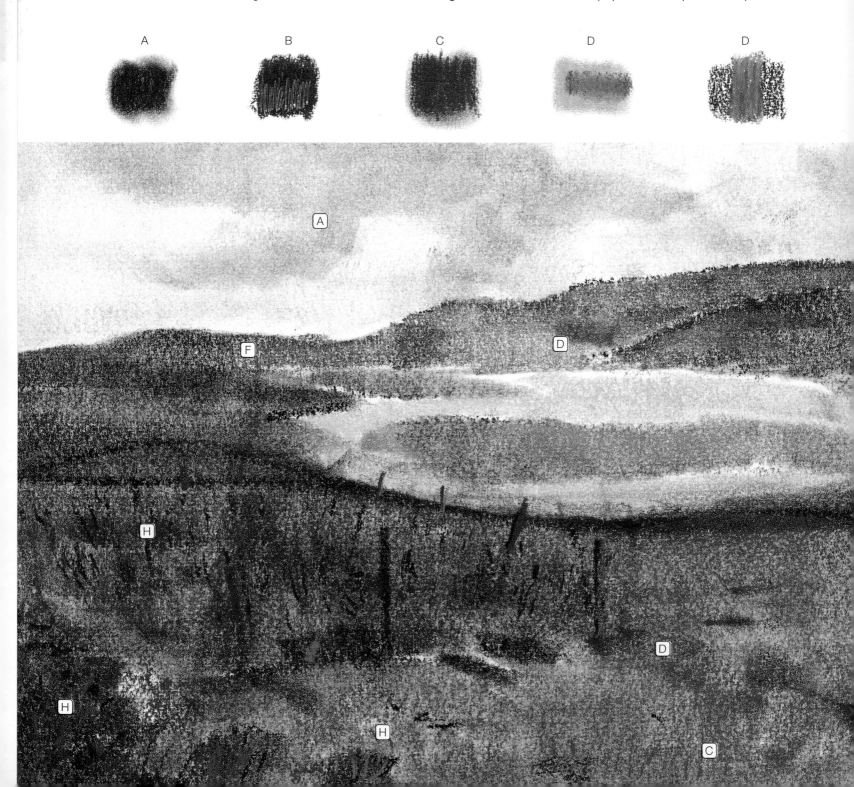

is sgraffito, in which one layer of color is scratched away to reveal another below. This can be done with soft pastels, but the first layer of color will have to be fixed—it is a little more difficult and the effect is not as good as with oil pastel.

One half of this drawing was made with dry pastels (left) and the other half was made with oil pastels (right). Here you can see how these two media respond to (A) blending effects, (B) sgraffito (cutting away parts of a surface layer to expose a different colored background), (C) blending, (D) scumbling, (E) impasto (thick application of color), (F) gradations, (G) water or turpentine dilution, and (H) superimposition of intense strokes. These effects are next to the drawing, shown separately and with different colors.

Simple themes can be interpreted with bright colors. If you want an element to contrast with the background, work on a dark-toned background, using dull, blended colors.

E

F

F

F

G

G

H

H

H

different drawing papers:
different characteristics

In addition to a theme, technique, and medium, paper is also a major protagonist in a drawing. The drawing's final result will vary considerably depending on its color and whether it is smooth, rough, thick, or thin.

CHOOSING PAPER ACCORDING TO THE MEDIUM

Each medium requires a particular type of paper. Smooth-grained papers, with an extremely fine tooth, are hot pressed and come in a wide range of grays that maximize the quality of blends when working with graphite pencils. Fine papers are also suitable for detail drawing with colored pencils. Medium-grained papers are appropriate for charcoal and chalk work because they retain the charcoal and chalk particles. Laid paper is traditionally used for charcoal work. Its texture enables the artist to draw fluidly and blend shadings.

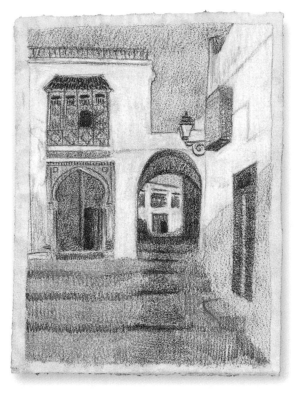

A rough paper breaks the trace of the stroke, giving a granulated appearance to shading.

There are different paper types for every drawing technique and medium.

Smooth-grained paper with a fine tooth is more appropriate for graphite or colored pencil drawings and for making sketches.

A paper's tooth and texture determine the final result of a drawing.

COLORED PAPER

There are many brands of high-quality colored papers available. In order to create a vibrant effect, you should choose a paper color that contrasts with the dominant color of the drawing you are about to start. To achieve a harmonious effect, choose the closest color to the dominant color of the drawing. Colored papers are available commercially in a wide range of textures; therefore, you should remember the effect that not only the color but also the surface will have on the materials. In addition, colored papers allow for white chalk outlines.

PAPER WEIGHT AND TOOTH

The heavier the paper, the thicker and more resistant it will be. It is easy to perforate very fine paper with the point of the pencil when drawing; therefore, low weight papers should be used with special care. Fine tooth papers show a pencil's varying gradations, allowing for the creation of shadings and for clear, high quality lines. Rough paper, instead, breaks lines and strokes, giving a discontinuous and fragmented look. This type of paper also allows for rugged shadings, which give the drawing a much more atmospheric effect. Pigment particles remain fixed to rough paper, in the grooves of the granulated surface, like small color specks. This effect allows for the reflection of the light of the paper, which gives the colors more translucence.

Medium-grained and rough watercolor paper provide more energetic shadings to the drawing.

The medium texture offered by Basik *paper is ideal for almost all of the dry techniques.*

Laid paper is traditionally used for charcoal work.

liquid techniques:

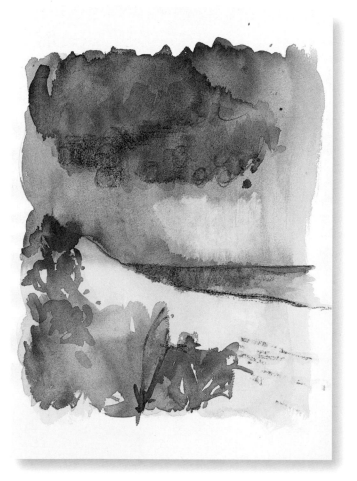

brushes and inks.

Drawing with brushes is the first step towards

drawing with liquid techniques. In principle, working with washes and strokes is very simple: you just add water to a color with a brush. Whether you are an experienced artist or not, you will see that the effects offered by the brush and quill pen drawing techniques are closely related to those of drawing. This creative medium allows you to combine line with areas of color and tone. It can be used in monochrome or in multicolored drawings. Experiment with different pens. Try an old quill pen, a modern fountain pen, ballpoints, or technical pens. Once you are familiar with all the possibilities this medium offers, you can begin your study of color and its techniques.

Practice making tonal gradations in order to see the rich shadings that washes can offer.

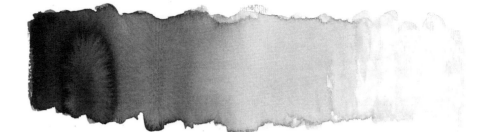

EXTENDING THE WASH

Wash allows for wide and rich tonal gradations. In order to create these gradations you should stain the paper with a very saturated and intense color, wash the brush with water, and then dissolve the color over the paper. As it slides, the color expands through the dampened area, since the water on the paper transports the color. As you extend the color, the tone turns lighter. The more times you repeat this operation, the lighter the tones of the gradation will become.

A VERY SIMPLE METHOD

The best way to learn how to extend a wash is through practice. Start with a very simple example: a pear. After making the pencil drawing, the first step will be to outline the fruit with the tip of the brush, with a constant and continuous brushstroke. Then, apply a very light wash in the inner area of the pear, leaving a small white space. This space will be the reflection. Before the wash is dry, add a second wash, with a much more intense tone. When painting over the damp surface, the tones will mix rapidly. Squeeze the brush and help distribute the tones with very light brushstrokes.

When working with washes, it is always a good idea to have a piece of cloth handy to remove any excess water; this will keep the stroke from spreading all over the paper and losing precision.

1. This simple example shows the easy execution of a wash drawing. First, draw the outline of a pear.

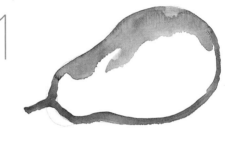

2. Then, with very diluted washes, begin to stain the inner section, extending the color of the initial outline.

3. Finally, add new colors to better define the light and shadow effect on the fruit.

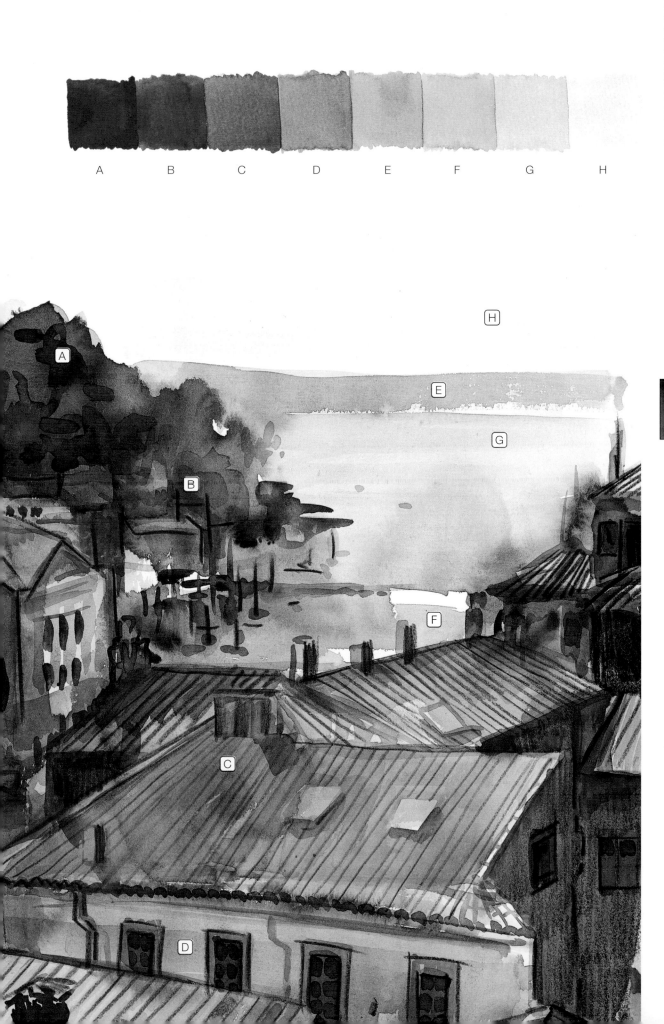

A B C D E F G H

In order to achieve effective backgrounds with broad gradations, the paper should first be dampened with clean water. Before the sheet dries, put the color on the brush and make the stroke. The humidity of the paper will cause the colors to expand and distribute, forming gradations.

Wash drawing enables the artist to develop a rich variety of tones. Tonal juxtaposition, contrast, and gradations are fundamental to appropriately represent the various planes within a landscape, which in this case is a succession of roofs with a small pier in the upper part of the drawing. Notice how the tones complement each other in the drawing.

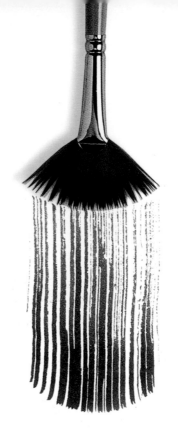

brush
effects

In wash, it is very important to be able to manipulate the brush correctly, being that it is the most common drawing tool for liquid techniques. Although wash is classified as a drawing technique, the brushstroke is the main medium used to create stains, values, and strokes. Due to the rapid absorption of the brush, no other medium can compete with it. The brush expresses movement, light, and atmosphere; however, the artist needs to rely on his or her repertoire of techniques and ability since wash cannot be corrected and the addition of too many lines will create confusion, all of which will damage the end result.

Brushstroke allows for rapid strokes with either a firm or wavy line (A, B, C). Washes and various kinds of tonal effects can be applied, which range from gradations to dry brush applications (D, E, F, G).

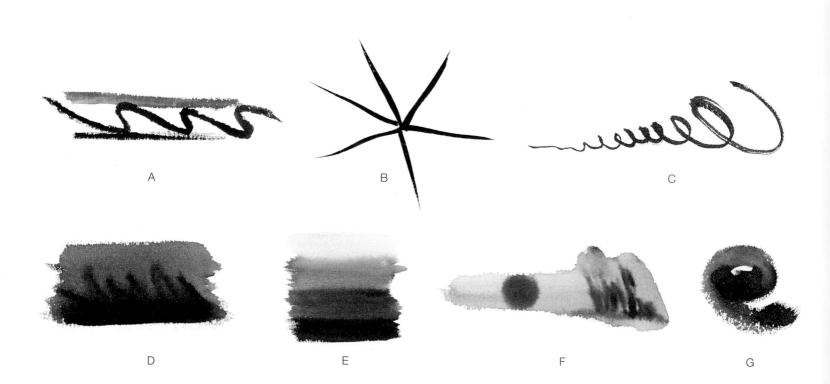

A B C

D E F G

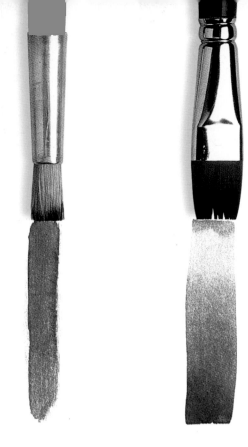

It is necessary to have a variety of brushes in order to achieve diverse brushstroke effects.

The brush enables you to create the definition of a dark silhouette from a single stain, as well as to outline the contour of the shapes from broken and loose strokes.

FROM LIGHT TO DARK

Brush drawing begins from a completely transparent background in which the value work is always made from light to dark; this means that the tonal additions should always be made to the lighter tones, and not vice versa. Therefore, it is extremely important to establish from the very beginning the work areas of the drawing. This allows you to obtain an exact measure of the gray tones that correspond to each area.

LINE WITH WASH

Among the watercolor techniques, linear wash is closer to drawing than painting because it has the same characteristics of drawing: monochrome; value; and the combination of strokes, lines, and shapes. Through wash you can come to a truly drawing-like understanding of the model, alternating the brush stain and the line. Because of its purely drawing-related character, the wash enables you, besides applying chiaroscuro, to outline the volume of shapes from the direction of the stroke on the darkest areas.

If you practice making strokes with the brush on a damp background, the lines will expand, producing interesting pictorial effects (H, I, J).

Washes on a damp surface produce atmospheric tones, useful when painting rainy or foggy landscapes (K, L, M). The same application of wash over a dry surface will produce more intense strokes, where the paper's tooth will remain visible (N).

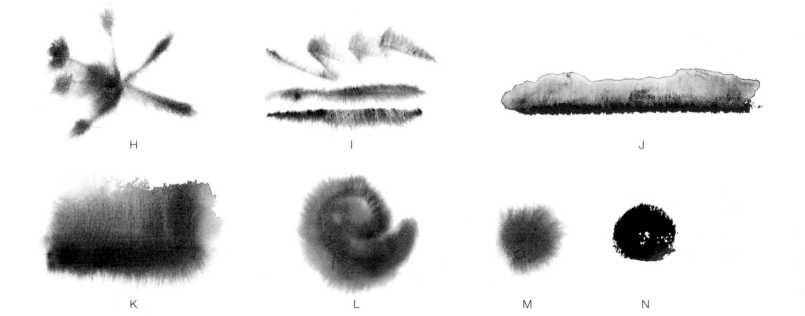

H

I

J

K

L

M

N

Inks:
strokes and effects

The stoke is the basis of drawing. From this simple gesture on the paper, volume will be constructed by modeling the shape, caressing the paper with the medium, or simply by drawing the shapes with a clean and direct stroke. If wash, as explained before, allows for the location of the various planes of the model according to their tonal values, drawing with a brush helps to make the object's outline stand out against the background by creating contrast.

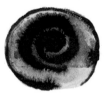

A

B

C

Black India ink is a more intense black than black watercolor, has greater tonal richness, and expands more easily (A, B, C).

When drawing with a brush, shifting from lines to stains depends only on the hand movement and the amount of pressure placed on the hairs (D, E, F, G, H).

A fine and round brush offers an interesting stroke range. Superimposing hatchings of different colors creates bright and colorful effects (I, J).

D

E

F

G

H

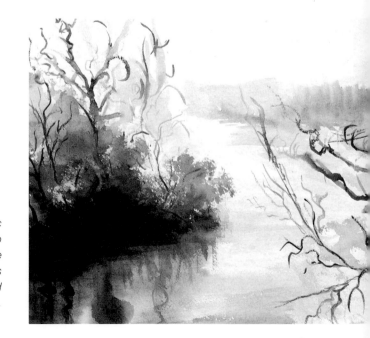

Once you understand the basic principles of wash and learn to handle the brush, you will be able to produce interesting sketches by combining washes and strokes.

I

J

THE BRUSHSTROKE

The brush is a very flexible drawing medium and is easier to handle than the quill pen. You can move brushes very rapidly and fluidly. If you vary the pressure on the tip as you draw, you can achieve lines of varying widths in a single stroke. You can easily shift direction by bending and rounding corners, where pencils and quill pens would fail to do so. A round sable brush in good condition transmits stroke, rhythm, and modeling in one stroke.

 In brush drawing you may use one or, at the most, two colors. If more tones are used there will be mixes on the paper, which will produce a mingling of the shape outline. This limitation in the use of color is compensated by the tonal variations deriving from a "higher or lower" dissolution of color in the water.

Different stroke possibilities achieved through shifting pressure and inclination of the hairs against the paper:

(A) A fine brushstroke with the brush's end.

(B) A wide brushstroke by pressing harder on the paper.

(C) A wider brushstroke if you flatten the hairs against the paper.

(D) A slightly damp brush applied in short and rapid strokes will give the texture effect of a broken line.

If your work involves a lot of thick color, the strokes will reveal the paper's grain. The brush will not flow easily and will leave a granulated and discontinuous trace.

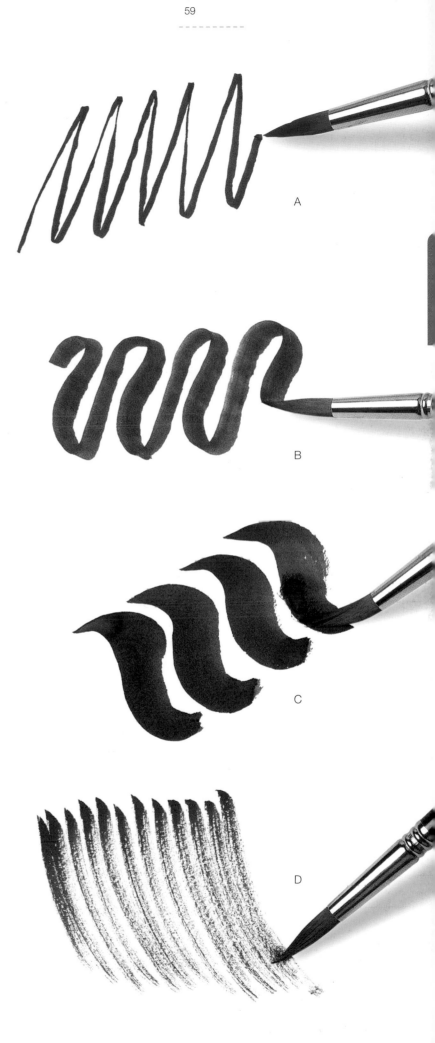

QUILL PEN STROKES

The quill pen makes a fine and clean line, which can be used to outline any object's form in a drawing. But if you want to shade and give texture and volume to an object without using a wash, you will need to use the white of the paper and different strokes. Each type of hatching, depending on the proximity and shape of the lines, will create various shades of gray. You need only a simple theme in order to build up volume and texture.

A

The quill pen and reed pen offer various stroke possibilities according to the position of the hand. Here are some examples:

We begin with cross-hatching on an angle, one of the most characteristic effects of quill-pen drawing (A).

1

The classic zigzag shading can also be drawn with the quill pen, although using this medium will result in a more unstable and irregular line.

2

You may shift the stroke pressure in order to vary the line's width (C).

B

The greatest advantage of this medium is that you can go from fine and sensual lines to firm and intense strokes, like the ones shown in (D).

3

4

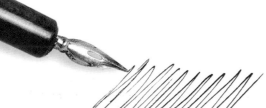

C

5

D

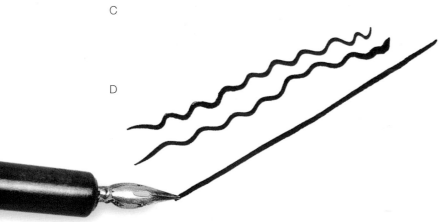

On the right side of this page are various samples of a quill pen and ink drawing: (1) parallel, (2) zigzag hatching, (3) spiral hatching, (4) curved hatching, (5) crosshatching, and (6) spiral shading.

6

When the areas of absolute white are combined with intense strokes, a strong, clear contrast is made between the illuminated areas and the shadow areas.

A saturated color is used to emphasize the essential lines or the shadow areas and a color diluted until it becomes almost transparent is used to create smooth contours.

In order to shift the stroke intensity, dilute the ink with a little bit of water; this will allow you to combine intense strokes with soft gray strokes.

The direction of the lines should always follow the object's volume.

Brush and quill pen ink drawing require a subtle treatment. The white of the paper represents the light on an object.

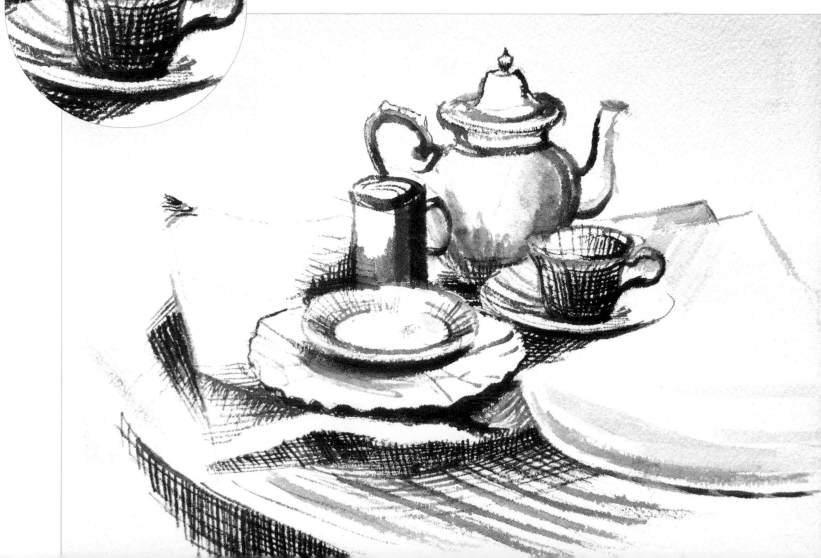

Combined with other media, washes, whether made with watercolor or with ink, allow for countless effects, which may make the drawing more aesthetically interesting. In these next pages you will be introduced to some of the most common effects that drawing professionals use to create texture.

Washes:
effects and techniques

Sgraffito is applied by scratching lines on top of the wash while it is still wet.

APPLYING SGRAFFITO
Sgraffito creates white marks or strokes on dark backgrounds. This operation should be done on a recently painted area, while the watercolor is still wet. There are two ways to "open" these white strokes. One is scratching strongly and firmly, using the edge of a brush handle; the other way is to use the tip of a razor blade or cutter. The strokes made with a razor blade will be deeper, thinner, and more intense.

Salt produces the richest textures. Sprinkle salt on the wet wash and wait a few minutes until you begin to see small marks forming on the surface.

TEXTURE EFFECTS WITH SALT
If you paint a regular, mid-tone wash and, while it is still wet, sprinkle a little bit of cooking salt over it, you will see, as the wash dries, the grains of salt absorb the pigment and produce interesting, light blended stains. Once the paper surface is completely dry, you can easily shake off the salt grains.

In order to apply a smear, load the brush with a small amount of water. It will leave a dry, brittle, and discontinuous trace, which will give an interesting texture effect to your drawing.

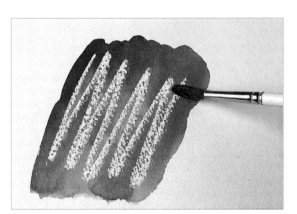

After applying the wash you may see that, while the paper absorbs the color, the wax strokes resist and become clearly visible, producing an interesting effect.

Make white marks with wax or an oil pastel. The wax will resist the wash.

SMEARING OR SCRUBBING

Also known as the dry-brush technique, this technique consists of using a brush saturated with color and a little water, to produce a rough texture when applied to the paper. The dry-brush technique is perfect for making contrasts and for representing the rough texture of certain objects.

WAX RESISTS

If you draw with an oil pastel or with wax, you will be able to preserve a series of thin lines on the paper's surface. Afterwards, you can cover them with washes and the waxes will resist the water.

This drawing uses wax resists to give texture to the foliage and to the tree trunks.

achieving a

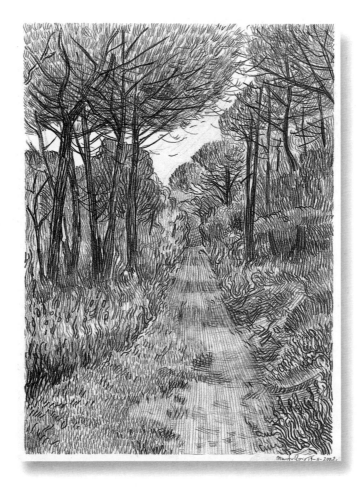

professional stroke.

One of the main

challenges for the beginner

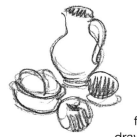

is drawing long and continuous lines with just one stroke. People who do not draw regularly have the habit of drawing in a static manner, placing their hand firmly on the paper, the same way they write.

The hand of a person who draws should not rest on the paper, but instead should move and slide, brushing over and caressing the paper.

The secret to a professional stroke lies in the mobility of the hand and the forearm, trying to make them work together as a whole. To be successful in drawing, it is fundamental to acquire the ability to draw continuous lines without lifting the pencil from the paper, to know how to hold a pencil, to train the movements of the hand, and to master the basic strokes. Learning all of these skills will allow you to obtain the most from texture effects and will give expressiveness to your drawings.

HATCHING

This form of shading is achieved by drawing parallel lines close to one another to obtain the effect of tone. The broken nature of parallel hatching, when observed from a distance, can produce a more vibrant quality than plain tonal areas. By combining different varieties of short, parallel strokes in random patterns, you will achieve solid tone and color.

DRAWING WIDE LINES

Slanting the pencil to obtain a wider line, draw a series of consecutive parallel, vertical, short lines, trying to maintain the same space between lines.

basic
strokes

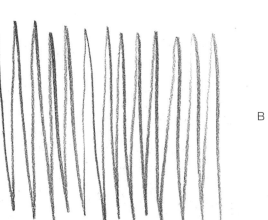

A

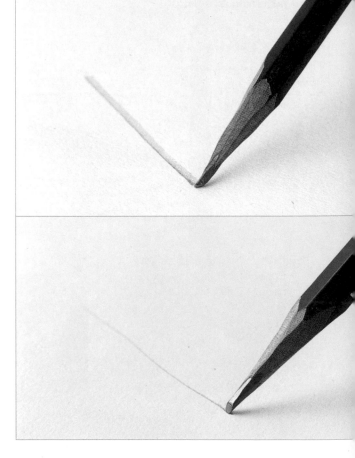

The following figures show different strokes made with: (A) a wedge-shaped point for wide lines and (B) the edge of the same lead for thin lines.

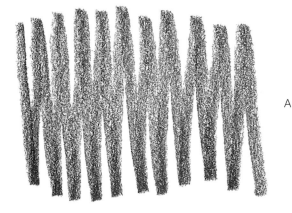

B

CROSS-HATCHING

Cross-hatching consists of a series of parallel lines crossing each other at an angle. These lines can be straight and systematic, or freer and imprecise. The closer the lines are, the darker the shading, which will allow for different shade tonalities in the same drawing. Cross-hatching does not have to be done with straight lines only. By crossing curved or wavy lines, or doodles, you can achieve a wide variety of effects.

DRAWING LOOPS

With a slight slanting of the pencil, draw several loops swiftly, as if cracking a whip. If you do a gradation with loops without lifting the pencil from the paper, you will have spiral strokes.

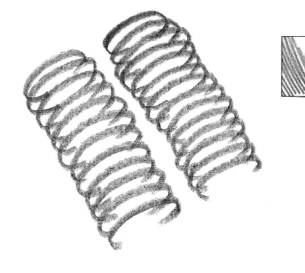

Vary the Pressure
The intensity and quality of the line can be changed and controlled according to the hardness of the pencil, how sharp it is, and the amount of pressure you apply.

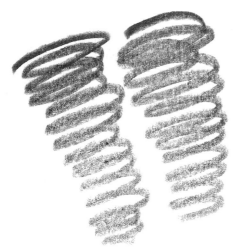

SHADING WITH SPIRALS

Some of the most interesting shadings and gradations are those made with small circles or spirals. Just draw small spirals, resting the point of the pencil slightly slanted on the paper and turning the pencil as if cracking a whip. Filling all the space gradually and controlling the amount of pressure on the pencil will produce a homogeneous shading.

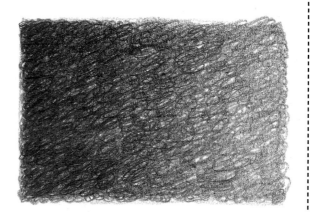

techniques to

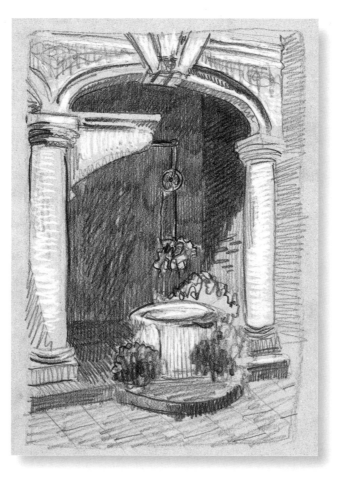

improve pencil control.

Controlling the pencil is important not

only for those who see pencil drawing as an end in itself, but also for painters, engravers, and sculptors. A line's quality is an important element in the finished work. The lines may be wide or fine, straight or wavy, with an endless diversity. Only in technical drawing are straight lines with consistent widths essential. The weight and width of the line, its fluidity and its character, whether continuous or discontinuous, are all devices that can create effective visual illusions in a drawing.

creating Volume
in drawings

The simple linear drawing is the most difficult to draw in that the artist has to achieve the tones and textures of the model without resorting to shading or tonal gradation. In a skillful artist's drawing, the line itself should be capable of describing the form and the volume, as well as the contrasts of lights by merely controlling the direction of the stroke.

THE DIRECTION OF THE STROKE

Not only is the intensity and the width of the stroke important when it comes to drawing, but also the direction you give to the stroke. In other words, the way the lines are drawn form the particular texture of each object. Lines are also useful to express an object's shading. Drawings seek to represent the "roundness" of objects, as they appear in nature. Of course, this refers not only to spherical forms, but also to some curved surfaces. There is a rule among artists: "The direction of the stroke should envelop, follow, and explain as much as possible, the volume of the object."

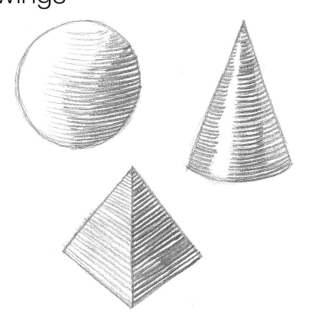

Strokes should represent an object's volume. The intensity and width of the stroke should also describe its tonal variations. Here are some examples of simple geometrical figures built up with lines. On the cube and the prism, the lines should be straight, while on the sphere and the cone they should be curved.

A STROKE FOR EACH SURFACE

When analyzing a model, you should keep in mind the direction of the lines at all times. In other words, on flat surfaces the stroke should be straight, on curved surfaces it should be curved. For example, in a drawing of a wheat field vertical lines would represent grass and some doodles would represent the vegetation's texture. On the other hand, in a drawing of a house, cross-hatching would successfully build up the volume of the floors and walls. On cylindrical figures, the stroke should envelop them. Wavy and sharp lines give the natural appearance of people and animal hair. Also take into account that strokes can be grouped together or spread out to represent light and shadow, as well as the object's texture.

The best way to understand the principle of representing volume is through the direction of the stroke.

A STROKE'S FUNCTION

The function of the stroke will vary according to the artist's needs. It can be used for shading, modeling, or toning, or it can have a purely descriptive ornamental role. The combination of different kinds of strokes in a drawing creates different planes in a drawing. A well-drawn stroke recreates the sensation of volume in a drawing. This helps to understand that in nature elements are not simple spheres or cylinders, but present very irregular forms composed of different segments.

A stroke should never be broken or appear "uncertain." Also, unnecessary, repeated strokes should be avoided.

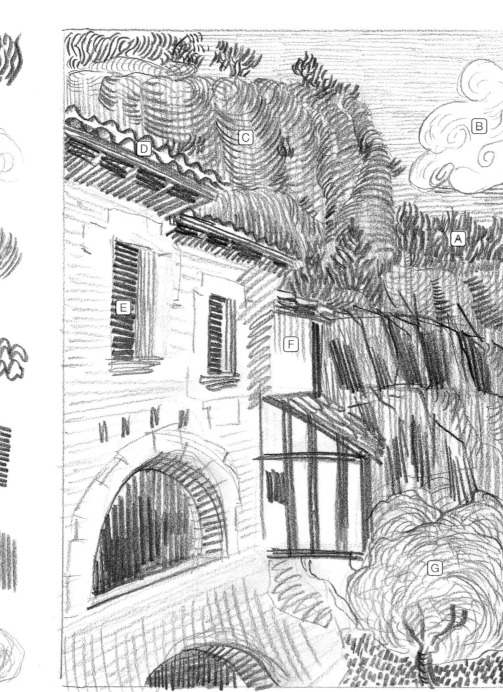

A

B

C

D

E

F

G

When drawing a model, you should be aware of the direction of the strokes in every area:

A. A fluttering stroke for the vegetation

B. Spirals to recreate diaphanous clouds

C. Curved strokes to increase the volume of the rocks

D. Wavy lines on the roofs

E. Intense parallel strokes in the shutters

F. Straight perpendicular strokes on the façade

G. Soft doodles to suggest the tree's foliage

Hatching is a technique that is used for drawing areas of tone with fine, parallel strokes. The closer the strokes, the deeper the tone. Similarly, the amount of pressure exerted on the pencil will determine the intensity of a stroke. Hatching and cross-hatching techniques for building tone. Practice drawing them, since each one provides a different finish to the drawing. Graphite and mechanical pencils are ideal instruments for hatching. There are several ways of making a type of stroke or hatching, according to the effect you are looking for. In just one drawing it is possible to use several different hatchings, alternating shadings and colorings.

Successive strokes create hatching, which gives volume to a drawing.

Hatchings can be made with fine or thick strokes. What is important is that the strokes appear orderly.

hatching:
possibilities and combinations

Hatching can consist of straight, curved, or wavy lines. The important thing is the tonal result.

A

The tonal result of the hatching depends on two basic factors: (A) the intensity and the thickness of the line and (B) the space between them.

B

In a good drawing, it is essential to vary the type of stroke or hatching according to the surface texture you want to reproduce.

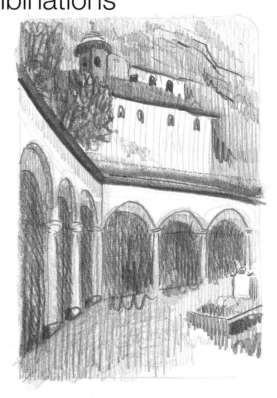

HATCHING

Soft drawing materlals, such as
build up a solid area of tone by
also possible to create tone wit
of hatched lines will suggest so
space between the lines will ma
lighter. The broken nature of ha
tance, can produce a more vibr
tone. Since the white part of the
tone maintains luminosity, whic
the technique. By manipulating
you can obtain a variety of shac

Hatch
straigl
stroke
pressi
hatchi
differir

*When drawing
freehand, the easiest
lines to draw are
those that go up from
left to right or vice
versa. The ones that
go down from right to
left, if they are drawn
too quickly, will have
hook-like ends.*

d on a continuous and
gonal, in a zigzag form.

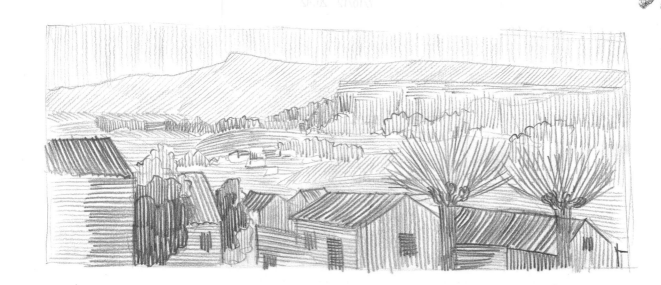

CROSS-HATCHING

Cross-hatching is a series of parallel lines that cross each other at an angle. These lines can be straight and systematic or free and imprecise. The closer the hatching, the darker the shading will be. Cross-hatching does not have to be made exclusively of straight lines. Crossing curved or wavy lines or doodles may also achieve a wide variety of effects. Likewise, you can modify the tone by varying the angles of the lines.

Below on the right-hand side of this page are different samples of cross-hatching. Depending on the degree of inclination of the line and the quantity of superimposed hatching, we have: (1) crossing at an angle, one of the most commonly used; (2) perpendicular crossing; (3) diagonal crossing at right angles; (4) triple crossing at right angles and diagonally; (5) quadruple crossing, which superimposes a diagonal crossing on the perpendicular crossing; and (6) triple crossing at an angle.

A

B

C

D

E

F

G

Take a look at some of the hatches you have been studying in a drawing. The variety of cross-hatchings allows you to obtain different gradations, textures, and surfaces in a work.

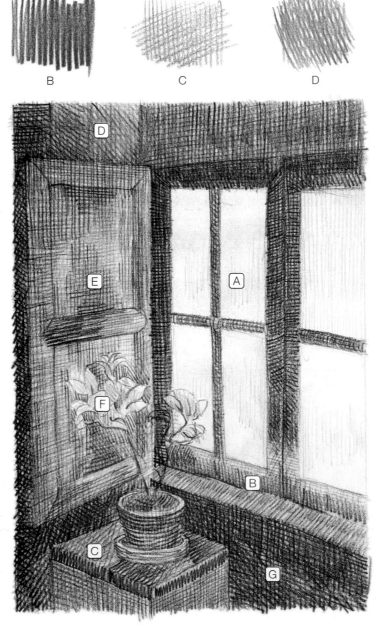

1

2

3

4

5

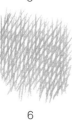

6

TONAL VALUE

Tone depends on the amount of pressure you exert on the pencil. Applying more pressure makes the tone darker; with less pressure the tone is lighter. With or without hatching, each shading presents its own tone. Hatching will be darker if it is denser and more pressure is applied to the pencil. You can obtain a tonal range from exerting different pressures on each tone. You must also take into account that the stroke may be darker over the light depending on the pencil's hardness. Also, if you use a softer medium, the tone of the colors will be more intense.

Varying the amount of pressure on the pencil and the thickness of the line determines the tone of the shading and hatching. In this drawing you can see a sample. The variation in the intensity and in the spacing represent the different planes in the landscape.

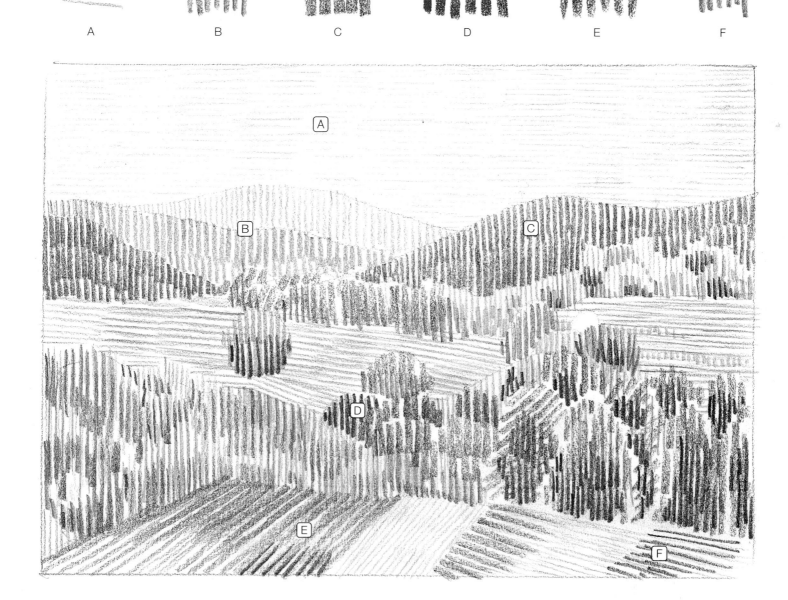

A B C D E F

Pointillism:
a divisionist technique

Pointillism requires lots of patience. Different tonal areas are achieved with intense dots or by decreasing the distances between them.

Pointillism is a technique in which small dots of color are applied to the paper in a way that, when the drawing is viewed from a distance, the lights reflected on each one of the individual spots appear to blend. Thus a unified effect is achieved, which provides an attractive texture with very uncommon effects. In the pointillism technique tonal effects are achieved by combining groups of points together: an agglomeration of different particles of different colors that interact. The quantity of points will automatically be interpreted as tonal areas by the observer. This drawing method became popular at the end of the nineteenth century with the Divisionists, who interpreted nature through juxtaposing tiny dots of color to provide the model or object with an even distribution of light. In monochrome drawings, tonal areas can be achieved by combining dots or small strokes of different sizes and spacing. By altering the size of the dots, the distances between them, and the amount of pressure you apply on the pencil, it is possible to create a complete tonal range.

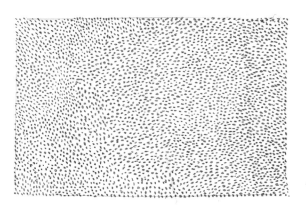

With a very sharpened graphite pencil, clean and uniform pointillist shading can be obtained.

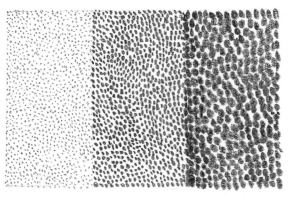

You can create tonal variations by varying the size of the dots, intensifying pencil pressure, and compressing the dots together.

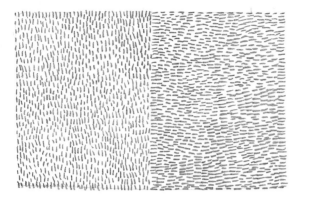

The small dots can be converted into short lines that follow a direction to create texture. Here are two hatchings of linear marks, in vertical and horizontal directions.

Compressed doodles visually give an effect similar to pointillism. It is a resource that can be combined with other pointillist effects.

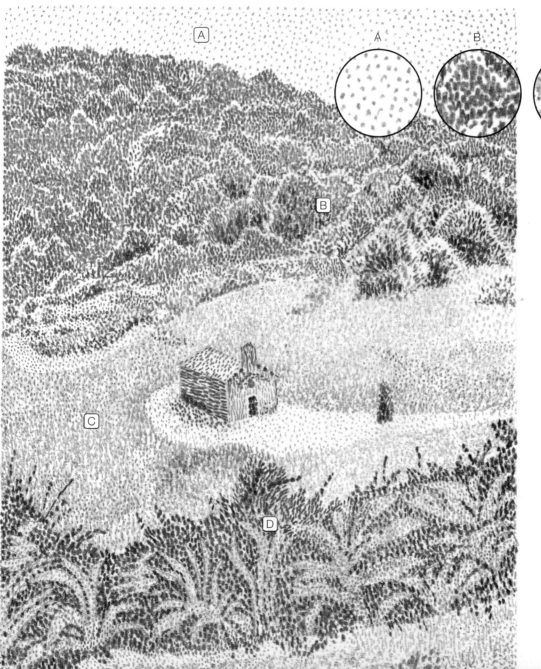

Pointillist shadings should not be applied mechanically; the dense hatching of small dots applied, sometimes in two or three superimposed layers, should never have the aspect of a uniform application.

A. The points should be small and distant from one another to represent the clear area of the sky.

B. For the foliage, the pointillism should be denser and the distance between points should be reduced.

C. Grass should present an intermediate tone. To achieve this use a pencil with a flat and worn out point.

D. The forms of the vegetation on the foreground are achieved by the contrast between two tonal areas with different intensities and dot size.

gestural
and outline drawing

Gestural drawing and outline drawing allow you to represent the model with linear, sinuous, and carefree strokes. Artists resort to this technique when they want to form the rough basis of a more finished work or when they want to give the sketch a more expressive effect.

When drawing a landscape, the elements nearest to you should be represented with more intense, marked strokes, while the strokes should be softer and imprecise in the areas farther away..

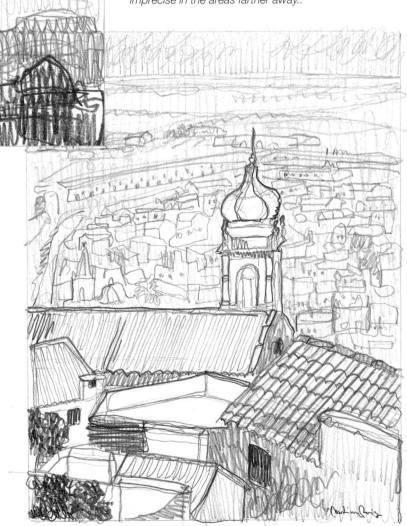

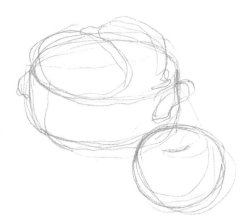

Random hatching allows you to draw several lines on top of one another to describe the profile of a fruit. Then, the artist selects and emphasizes the one that is most defining.

GESTURAL DRAWING

Gestural drawing is made with quick, nervous, rough strokes, which the artist executes intuitively as gestural training. In this type of drawing, spontaneity emerges from the vivacious movements of the artist's forearm, while the theme is translated through rhythmic and dynamic lines.

Gestural drawing is a good method with which to begin drawing. Even if the strokes seem to be made in a nervous and casual manner, a certain degree of control must exist. Artists use gestural drawing as a form of shorthand to include information in their sketchbook. This technique could be applied when working outdoors or with themes that require the artist to draw quickly, such as a landscape where the weather conditions are changing or a pedestrian area with the constant movement of people.

Look at the application of the definition in this urban view. The elements in the foreground appear more streamlined and are more emphasized than those in the background.

OUTLINE DRAWING

Outline drawing describes the model through lines that outline the object's profiles. The lines can be compared to the contour lines in a map, in which the graded lines represent the relief of a landscape.

In a finished work performed with these types of strokes (vigorous, fine, short, or long), the lines are combined to describe a pleasing scene. To attain a three-dimensional effect in the contours of the drawing, it is necessary to vary the quality and value of the strokes. An isolated line may be ambiguous, but if its intensity varies, it may transmit the illusion of space or volume, even when used only as a contour. Widening the line may indicate shadows or proximity to the viewer, and a thin line may indicate light and distance. Success in silhouette drawing has to do much more with knowing how to observe than the act of drawing itself. This technique is an excellent form of training the hand to interpret what the eye sees.

A

B

C

D

A fun variant is blind drawing. It is a drawing technique that consists in not looking at the paper while drawing. The eyes remain focused on the theme while the hand draws the contours on the paper.

In this sequence you will see an apple interpreted through outlines. First draw a circle (A). Then start sketching the inside form and add new lines to the profile (B). With a line, differentiate the illuminated parts from the shadowed ones (C). Finish the form gracefully by drawing the fruit's casted shadow (D).

If you do not lift the pencil from the paper while outline drawing, you will achieve a sketch that will seem to be made from a long wire.

Outline drawing brings to mind a map's contour lines. The lines not only describe the profile of the figure but also the border between the light and dark areas.

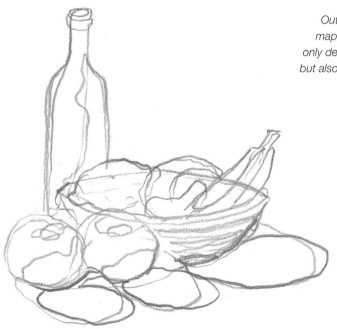

drawing proportionately

Objects that are part of an ensemble require you to study their positioning in order to construct a proportionately balanced drawing. We do this by first setting up "boxes" to define the height and width of the different objects in a composition. You could call this beginning phase the outline sketch; it will be used as a preliminary composition throughout the rest of the drawing phases.

SYMMETRICAL OBJECTS

To learn how to draw a well-proportioned symmetrical object, you will draw a cup as an example. Positioned in front of the cup, first draw a line to define its height. Mark with line segments the upper and lower limits. Draw another line across the first one to define the cup's width. Again, mark with two segments the cup's outer borders. Connect the cup's border segments and height segment with a perfect ellipsis. Extend the outer border lines and draw a square; you will draw the cup's form inside the square. Draw the body of the cup using the vertical line as a reference. Finally, draw the base in the same way you drew the neck. This method is ideal for drawing symmetrical objects (bottles, cups, pitchers, etc.) and is very helpful in drawing still-lifes as well.

In the next drawing, try to use the least number of lines possible to define the positioning of each object.

A square is a good aid when drawing an object. By marking the outer borders, height, and width, you obtain useful reference points from which to draw the object's contours.

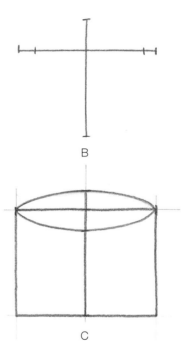

A

B

C

D

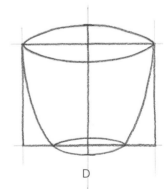

This example demonstrates how to draw an object in proportion: (A) First draw a vertical straight line to define the object's height. (B) Then, cross the vertical line with a horizontal line to define the object's width. (C) Extend the lines to obtain a square. (D) Where the horizontal and vertical lines meet, draw an elliptical circle with the ellipsis at the base. (E) Finally, you only have to erase the initial outline sketch, streamline the contours, and add a handle to finish the drawing.

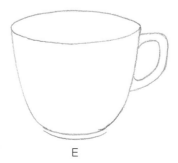

E

DRAWING AS IF THE OBJECT WERE TRANSPARENT

To draw an object, it is necessary to understand its structure. For this purpose, it is often helpful to draw the object as if it were transparent, that is, drawing the parts that would be hidden from the observer. This allows you to study more easily the object's structure as well as its form. It is always easy to first place forms within the context of a square and then develop the drawing later.

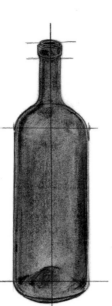

Occasionally, an object's contours should not be closed in, since this could spoil the transition between light and shadow.

Starting from a vertical axis will allow you to obtain proportionally symmetrical objects.

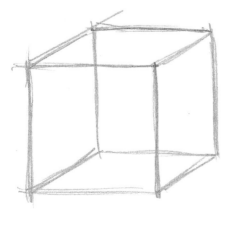

Imagining that the objects are transparent is a good method to study and understand their internal structure.

Starting from a simple geometric form enables you to construct more elaborate ones, in this case a chair.

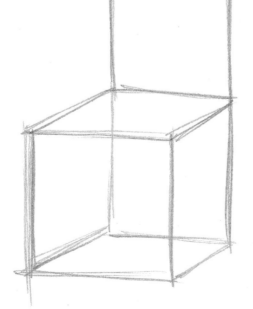

Once the fundamental form of an object has been drawn, you can begin to work and build up its texture by drawing the profiles and emphasizing the the object's contours; do not worry about the tonal zones at this point. You should work with soft lines and strokes that can be easily erased in these next steps.

Strokes
and profiles

REAFFIRMING THE LINES

When the external part of the model is complete-ly finished, reaffirm the lines with a much freer and firmer, but not too rigid, stroke. You will see that it is easier to accent the more definitive lines when you have drawn a previous sketch. Now you can begin to superimpose different strokes on the previous ones to make the forms more concrete. As you continue drawing, the lines will be firmer and more intense and will define the forms with more precision.

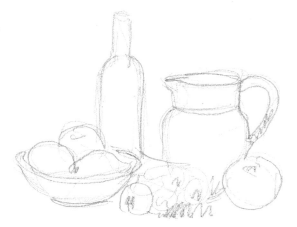

Outline sketches are usually riddled with lines that give too much information, sometimes even contradictory, so it is necessary to clean the profiles.

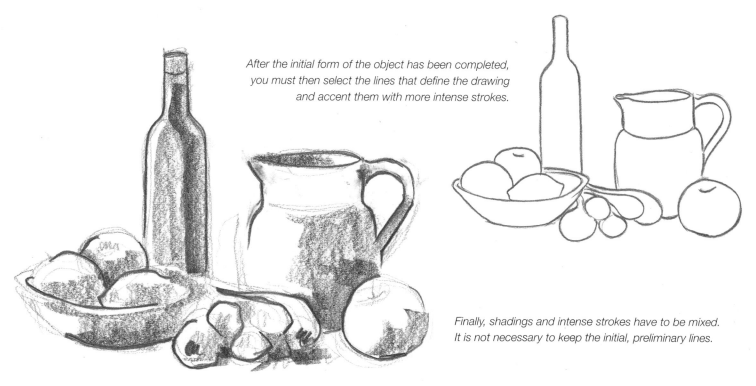

After the initial form of the object has been completed, you must then select the lines that define the drawing and accent them with more intense strokes.

Finally, shadings and intense strokes have to be mixed. It is not necessary to keep the initial, preliminary lines.

After finishing the outline sketch with soft strokes that can be easily erased, you need to accent the drawing with more intense strokes.

PROFILES

After the preliminary outline sketch is finished, it now time to highlight the profiles and build up the tones. Do not make the mistake of drawing the whole object with an intense stroke, only the zones that define the object have to be emphasized. When the outline sketch is considered definitive, you can start superimposing different strokes on the previous outlines to make the forms concrete. Remember, the strokes you are drawing represent the different borders, internal as well as external, of the theme. Using pencil gradations will give more three-dimensional character to the object as well as present some diverse strokes. Thicker lines will make the object stand out from the background, while finer lines should be reserved for hatching and for the object's internal details.

General profiles are lost if there are too many strokes. It is necessary to clearly indicate where there is a crease, a fold, or a shadow.

The outline sketch may be a simple doodle or sketch; later you will select and reaffirm the more important strokes and profiles.

Working with an even, continuous line will not suffice; you need to use different gradations in the lines to establish a hierarchy in the drawing.

a linear landscape:
controlling the stroke

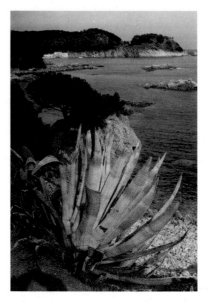

The following exercise will demonstrate how to develop linear hatching and shading in a landscape, in this case a cliff. Combining these tonalities allows for rich transitions between light and shadow. It is gratifying to draw a landscape in which you have to represent an object in the foreground, where the observer can clearly see its texture. You can create three-dimensional effects in a drawing based on hatching made with directional strokes. Frequently, you can include strokes that go across or surround the model to support the representation.

1. The first step consists in dividing the paper into four equal parts; this will make the layout easier. On this grid, start sketching the plant with an H pencil. The strokes should be light in case you have to correct them with an eraser. The cliffs in the background are lightly sketched and laid out.

2. Once you are satisfied that the proportions are correct, reaffirm the lines and draw the contours and basic forms of the plant in the foreground with an HB pencil. Do not worry about the details; you must concentrate on the general structure of the drawing.

1

2

The hatchings of the objects situated on the first plane should be more intense and defined than those in the farther planes.

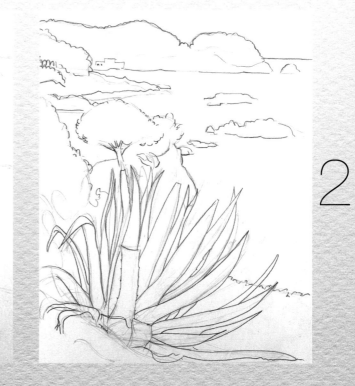

3. Start shading the plant in the foreground with parallel hatching. Then proceed to shade the cliffs and coastline in the background planes with cross-hatching. In the finished work notice the quality that can be obtained by drawing with lines only. These lines are combined in a skillful way to create a three-dimensional illusion,suggest texture, and have a range of tones. Observe below the different types of strokes used in the different zones of the drawing.

Drawing a vertical and a horizontal line before you start working can help you in establishing dimensions and placing the elements on the plane of the picture.

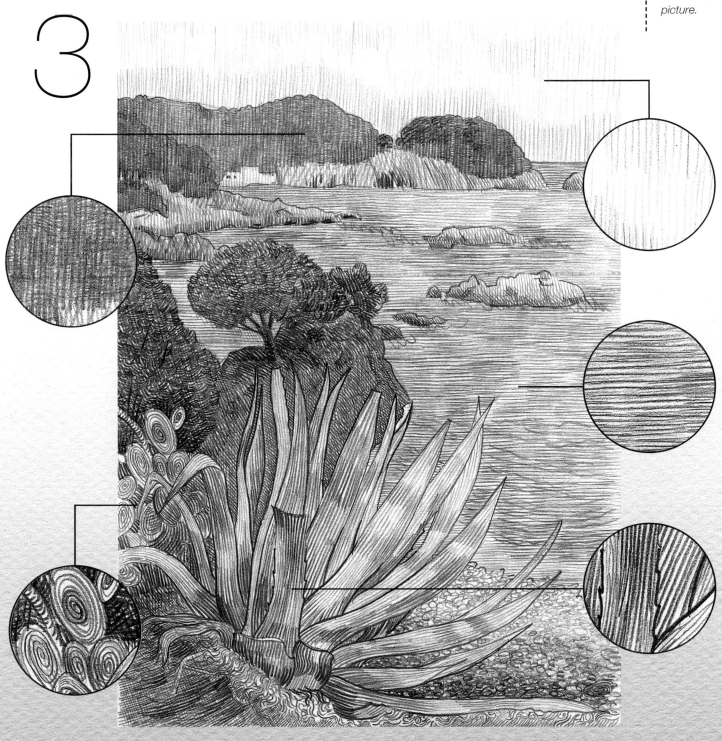

a theme:
selection and

Compo-
sition

factors in

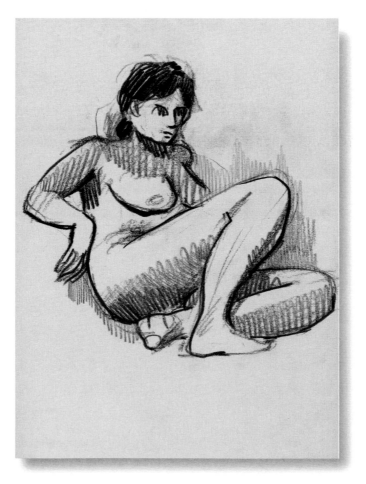

selecting a theme.

Everybody has the

ability to find

in any theme something that is extraordinarily significant. This is the skill that transforms a person into an artist. However, selecting a theme is not enough; it also has to be presented to the observer in an attractive and interesting way. There are several factors that you should take into account if you want to turn a model into a visually stimulating drawing, among them: observing analytically, selecting an interesting point of view, selecting an original framing, and composing the different elements within the drawing. To develop these factors, look for drawing themes in your natural environment (a nearby park, the street where you live, the plants on your balcony, etc.) and study their composition and values. If you sketch persistently, your visual perception will soon heighten and you will discover themes that for others go unnoticed.

Composition
and blocking in shadows

Composition refers to the way in which a
theme is presented and laid out within the differ-
ent planes of the drawing. Before you begin
drawing, you have to break down, sketch, and
evaluate the different elements in the theme and
try to understand how each one balances the
other for a well arranged drawing. Think of how
the object or model will effect the overall draw-
ing. In order to compose, you must first learn
how to make a rough outline. A rough outline is
the first step that an artist takes to define the
form of the model, its limits, and its proportions.

BREAKING FORMS DOWN
INTO A FEW LINES

All forms in nature can be broken down to a few
outlines, whether it is a chair, vase, jug, or tree.
You will see that these structures in turn can be
reduced to spheres, cubes, and cylinders. This is
a good starting point for a sketch; that is, to
make a rough outline of the model or object on
paper. A rough outline is not the same as con-
structing a frame into which the whole subject
will fit. The artist must know how to identify the
most important basic shapes to be included in
the rough outline.

*The best approach in constructing a rough outline is to
start with simple blocks (boxes) in which you draw the
forms. These forms should be simple, flat, and very
basic.*

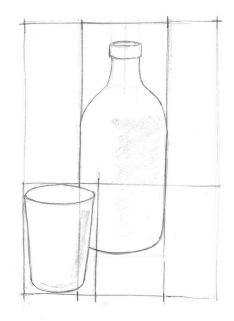

*You should learn how to break down objects into simple
geometrical forms. Here are three examples: (A) a vase
with a flower arrangement can be reduced to an
inverted trapezoid and a circumference, (B) a jug can be
drawn into a triangular form, and (C) squares of different
sizes can be used to frame a group of trees.*

A B C

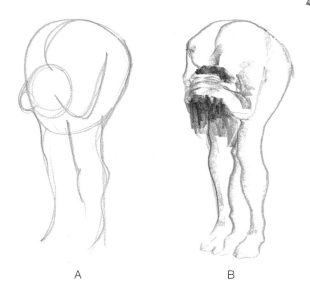

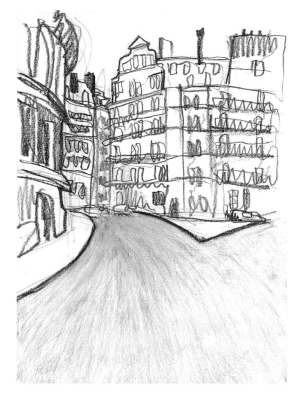

A　　　　　　　　B

Observe in these two drawings the difference between a structured outline and a free one. (A) The structured outline allows you to analyze the form from a previous sketch. (B) The free outline differs from the first one because you try to draw the form directly, without a previous rough outline of the different forms.

The free outline allows you to be less concerned with proportions and gives the drawing a more expressive effect.

DRAWING WITHOUT AN OUTLINE

You can also begin to draw objects and models without the aid of geometrical forms by instead drawing a general form directly and repeating the process until you achieve the adequate form. The strokes must be swift and spontaneous. Try to include composition and proportion at the same time. This kind of quick sketch will help you understand the model's form and will help you later in more developed drawings. The lines that define the contours do not have to be fine and elegant; they can be broken lines. To begin a drawing without an outline, it is best to draw the ensemble freely, without streamlining or shading every form. The lines may be reaffirmed as many times as needed, but remember that you should give form to each object with only a few free strokes.

In a drawing, you should alternate pencils of different hardness to vary the width as well as the intensity of the stroke.

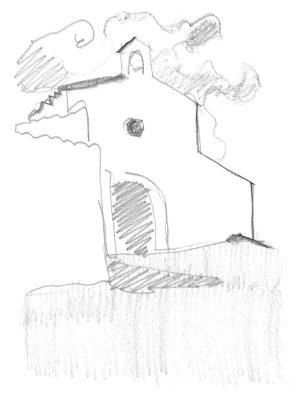

Direct outlining, without geometrical forms, is more appropriate for simple compositions. In this example, it was better to develop a structured outline in order to avoid errors in the form and avoid arranging the elements disproportionately.

The rough outline should simplify the model into geometrical forms. These forms will provide the initial composition of the ensemble. Here are two examples, one with a triangular composition and another with a circular one.

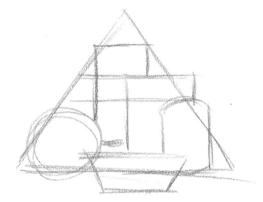

ARRANGING THE BLOCKS

After you have broken the objects or model down to basic geometrical forms, they must now be arranged within the drawing. This means that if you fit the model completely inside its block, the drawing will be limited to that particular object, thus creating a concise representation. When the model is composed of many objects, each block, with a form, is added to the main block. It is easy to complete a drawing if you start with the basic forms. The guiding lines can always be easily erased.

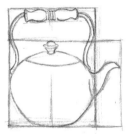

The main model must be able to fit into the main block, in this case a tea kettle. Once the form of the tea kettle has been drawn, new blocks (for the handle and the spout) can be added.

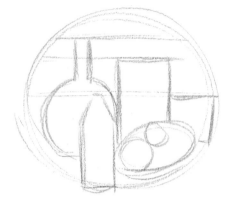

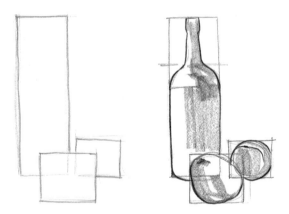

The first step in creating an outline sketch should be to place each element into small, simple blocks. Then according to the dimensions of the blocks, place each one of the forms inside them, paying close attention to their profiles.

If you learn how to break down simple still-lifes, you gradually will be able to draw more complicated models by combining more forms and lines.

BLOCKING IN SHADOWS

In cases where the model is strongly illuminated, a useful technique called blocking-in allows you to establish shadows which will later be built up. Blocking in dark zones becomes part of the initial drawing process, to the point where it is common to start a drawing by alternating between initial lines and preliminary stains. Do not worry about details at this point; you are simply establishing the main areas of tone. The profiles of shadows are a good reference point for blocking in, especially in models that have a strong light and dark contrast. You can also establish the illuminated areas by outlining them with dark lines—again, do not worry about details at point.

Using outline sketches helps you to compose and establish the various elements so that you can use it as a general reference throughout the later drawing stages.

Blocking in shadows during the early stages of a drawing serves as a reference when working in later stages. Below, compare the blocked-in shadows with the final result.

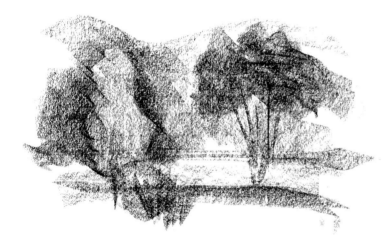

Blocking in shadows is good when you are sketching a landscape. Working with a chalk stick on its side, you can create a sketch like the one above in a few minutes.

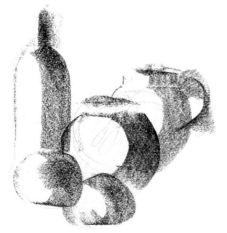

The shadows in a model, when clearly contrasted, can be a good reference for blocking in a theme.

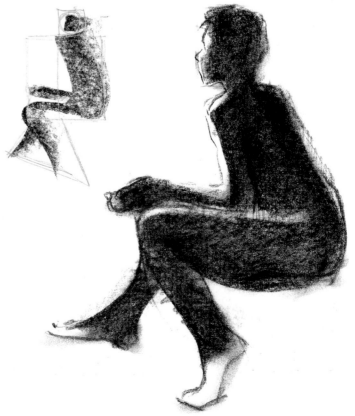

The geometric forms can be applied to any model. Here is an example of a pyramidal prism used to lay out a figure.

COMPLEX OBJECTS

A complex object can be broken down into several geometric forms that can then by laid out in one general geometric form. First start with a simple form and then combine or superimpose new geometric forms according to the object or mode's composition. Use simple and straight lines and do not worry if at first the geometrical forms are not similar to the object. These geometrical forms are simply that, mere geometrical forms. Also, do not use a ruler to draw the lines; draw freehand, even if they are not perfect. Later, you can go over them until you obtain the desired result.

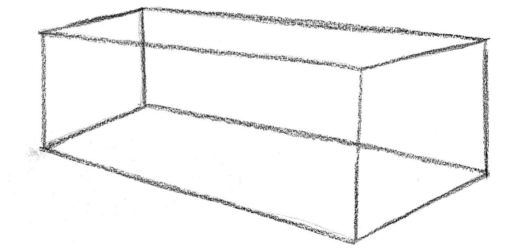

1. A drawing based on three-dimensional geometric forms is used for drawing objects in perspective or for those that present certain foreshortened effects.

You should practice drawing cubes, orthogonal shapes, and prisms by freehand. A simple method is to first draw the flat geometric form and then project its volume in perspective.

1

2

2. Once you have drawn the geometric form, draw the first lines of the model. Remember that a rectangle is always a good reference point to determine the size of the object.

.

When trying to lay out objects within geometric forms, remember to draw the geometrical axis: a perpendicular straight line that divides the figure in two. It will act as a reference to draw the model symmetrically.

3. Gradually, you will define the profile of the object with firm and decisive lines. This first linear layout will act as a guide to develop the drawing's tonal effects.

3

4. The last phase culminates in building up volume in the model. Once the drawing is complete, you can erase the geometric form.

4

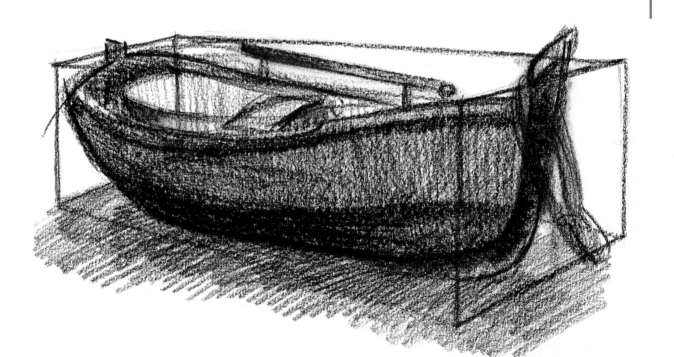

It is very helpful to first divide the drawing with a cross in order to break the area into four clearly distinguished zones.

SEARCHING FOR EQUAL PROPORTIONS

The search for equal proportions among the different objects of a model can be a very helpful exercise in learning to relate the different parts of the structure. This consists basically in comparing and determining (as has been done already in the previous chapter) that the height of the pitcher is approximately equal to half the total height of the bottle and that it is almost twice as wide as the apple found on the second plane.

When you are in front of a model, you should mentally take it apart and study how the proportions among the different parts of the model relate to each other. You may, for example, decide that one zone will be one third the other zone, or that another zone will measure exactly twice as much as the previous one. Many times, especially when approaching architectural themes, you should compartmentalize the façades in equal-sized segments in order to place correctly the windows and the balconies.

You will see in these images the importance that the relation of dimensions has in blocking in. First, draw the box where you are going to develop the theme.

To draw a balcony, divide the box in half, making sure that the upper limit of the rail coincides with this measurement.

Divide the upper straight line into four segments and use the two central portions to project the vertical lines.

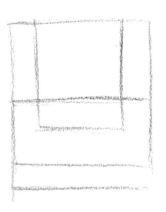

Once the first measurements have been studied, finish the vertical lines to obtain the principal lines that define the balcony.

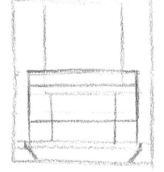

Progressively add new partitions to define the decorative elements of the balcony, its projection, and the doorframe.

Now you only have to erase the initial lines and define the texture of the blind, the ornamental forms on the balcony, and the light and shadow effects.

MEASURING WITH A PENCIL

A simple pencil, stick, or ruler is commonly used to establish proportions. To do so: raise a pencil to the level of your eyes, extend your arm (return to this position every time you take a measurement) and situate the pencil in front of the part of the model you want to measure. Move your thumb up and down until the visible part of the pencil coincides with the measurement of your model. Translate this measurement onto your paper and continue to use the pencil to measure the remaining proportions. Compare distances frequently. Work meticulously, correcting proportions, relating them to one another, and indicating points of reference. Suddenly, without noticing it, you will find that your mind is working in a logical way. Remember to calculate horizontal measurements as well as vertical ones, without ever altering the distance between your arm and the subject.

PROCESSING THE MEASUREMENTS

Starting from these first measurements, the artist creates the forms using a minimal number of lines. All the elements of the model go through a first outline sketch before being drawn in definite forms. This outline sketch, with its proper relation of proportions, will slowly be built.

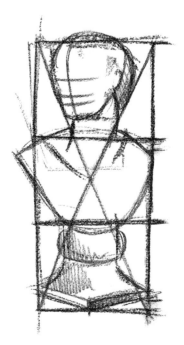

To measure, stretch your arm and visualize the height and width of an object using a pencil. With your thumb, calculate the measurements and proportions of the object that you want to transfer to the paper.

Using an initial outline sketch and geometrical forms provides good reference points by which to measure the height of a torso, checking that the total height of the sculpture is adjusted to the dimensions of the three segments. This measurement system can be applied to any subject.

Drawing
with grids

The third method to ensure that the different parts of the image have correct proportions is the grid, which interprets the direction of the model's lines and its structure. The more divisions the grid has, the more exact it will be, thus avoiding the possibility of errors in the drawing. Besides being a perfect method for copying, the grid also allows you to enlarge a model proportionately. This method may seem boring and mechanical at first, but you must remember that this is just another base from which you can start working.

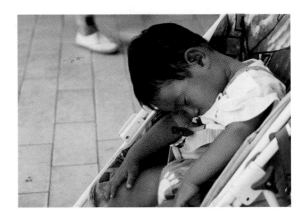

A grid allows you to adjust and draw a model's features to the highest degree.

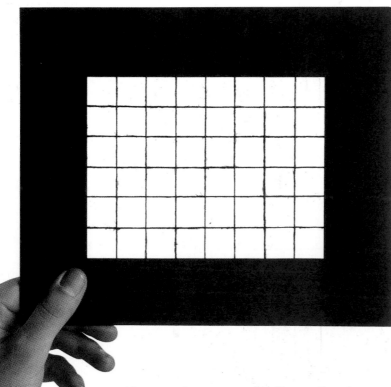

You can make your own grid with a cardboard square and transparency paper that has a grid drawn on it. Place the grid on the photograph that you want to copy or enlarge.

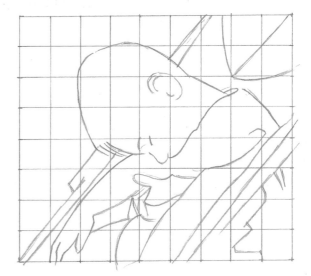

On a different piece of paper, draw a grid with a pencil and try to draw the model's features, paying close attention to each one of the squares and the particular feature that is in each square.

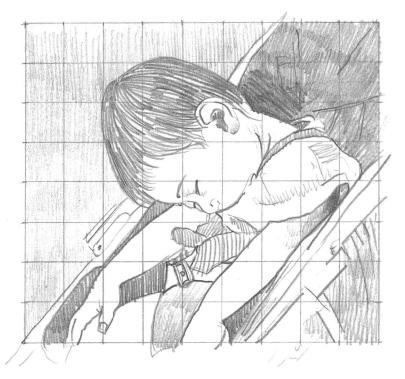

After first blocking in the tones, go over the drawing's outlines carefully with a well-sharpened hard pencil until you achieve clean, defined lines and almost no gray shadings.

The advantage of drawing with a grid on the model is that you can choose the size of the squares. If you want to concentrate on the complex area of the model, draw more sections on that particular area.

A VERY SIMPLE METHOD

The technique of drawing with a grid consists of laying squares on top of the model, usually a photograph or preliminary sketch, to enlarge a drawing. To copy an image with a grid, draw squares on the model and repeat the same squares on a blank piece of paper; each one of the squares is a part of the image.

Even though learning to draw from life is more advisable, there are occasions in which copying a photograph or drawing with this method may be necessary.

A PROPORTIONED DRAWING

The grid is a good method if you still have diffi-culties making a proportionate drawing. The object of this system is to help you see, under-stand, and draw with more fluency and exactitude. As you acquire dexterity and fluidity, this system of drawing will seem excessively mechanical. With time, you will not need the aid of a grid to compose; you will draw with imaginary lines.

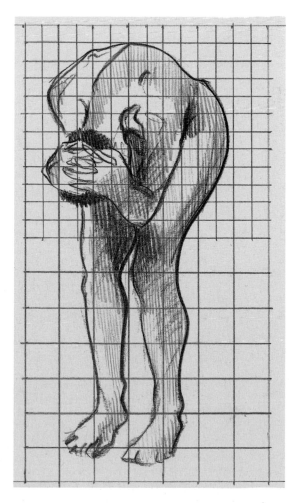

Use a ruler to measure the space into horizontal and vertical thirds. Place the centers of interest on the points where the lines cross each other. This very simple system produces balanced and proportioned compositions.

The "Lorrain method:"
harmony in the composition

We will now study an ingenious grid system that was popular in the seventeenth century by the great landscape painter Claude Lorrain. In his preliminary landscape drawings, this French artist would first draw geometric lines that would cover the paper's surface like a net. It was a simple grid that partitioned the paper rectangle according to its medians and its diagonals. This geometric partition allowed the articulation of the surface of the square according to the composition and the depth effect that the artist wanted to suggest, ignoring the mechanical requirements of perspective.

The system allows you to harmoniously place the different elements of a landscape, moving, if necessary, some tree or shrub so that it coincides with one of the intersections of the diagonals. This method helps to balance the emptiness, distribute the elements throughout the surface, and obey the logic according to how the elements influence one another.

As you can see, the principle of the grid is basic and applicable to any format, whether vertical, horizontal, narrow, or elongated.

To apply Lorrain's composition method, first partition the surface of the paper into four segments by drawing a vertical and a horizontal line that converge in the middle.

Draw two diagonals that converge in the middle of each one of the four resulting rectangles. These four points will be reference points for the composition, just like the diagonals that aid in strengthening the effect of depth in a landscape.

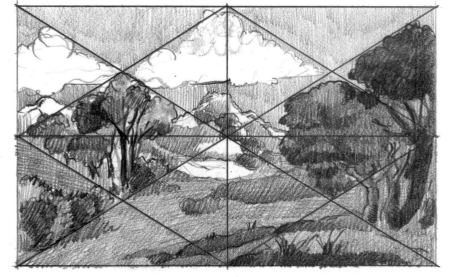

The diagonal system of composition created by Lorrain is very useful for composing landscapes and helps to arrange and distribute the elements in a more harmonious way.

A SENSE OF COMPOSITION

By practicing the principles described in this chapter you will acquire a sense of composition. And although most artists usually theorize about the motives that have led them to organize the theme in a certain way, you will be surprised to realize that most of the drawings conform to the conventions that have been explained in these pages.

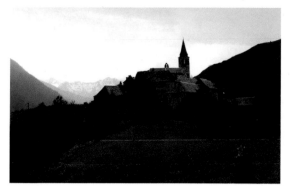

Here is a view of a town on a mountain with a balanced, although monotonous, composition that was applied with the "Lorrain Method."

If you draw the diagonal grid on a paper you can displace the center of attention, the town, towards the upper right-hand side. The profile of the mountains and the nearby meadow is adapted so that it coincides with the main diagonals that cross the picture.

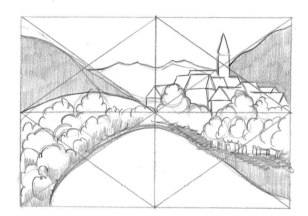

After developing the drawing and applying the tonal values, you will see how the new distribution of the elements turns the initial photograph into a more attractive work. You should never be satisfied with the real model; learn how to interpret it and transform it according to your convenience.

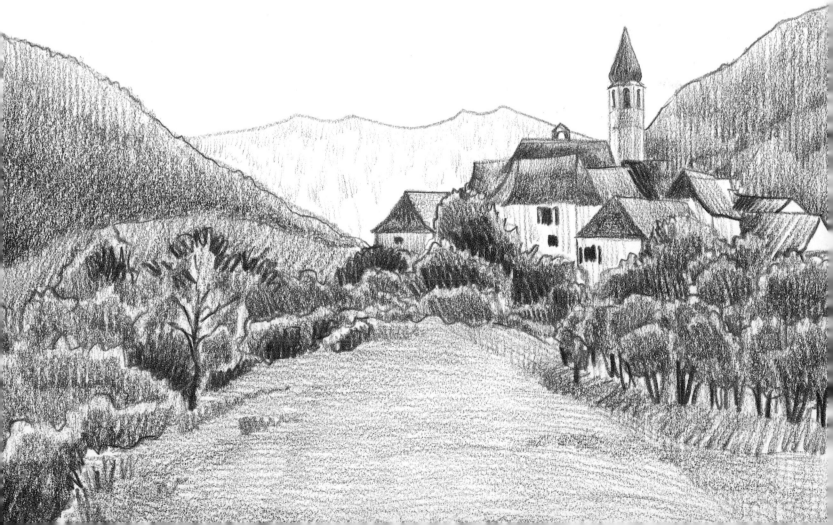

point of View:
transformations in the model

When you are looking at a landscape, trees, animals, figures, etc., you are not completely conscious that your view depends on the position you are in vis-à-vis the real model. Before drawing, it is necessary to move around the model in order to find the point of view that will best express the variation within the unity of the model's forms, sizes, and colors.

VARIATIONS IN THE POINT OF VIEW

A "normal" level of observation, when the theme is situated at the artist's eye level, is most adequate for simple and descriptive images. A model observed from a higher point of view separates even more the different elements of the scene and allows you to play with the different spaces that open up among them. When, to the contrary, you draw a scene from a point of view lower than the usual one, there is a tendency to have the different elements that compose the drawing overlap each other.

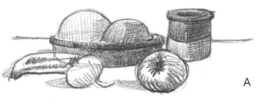

If you look at the model from a frontal point of view, the horizon line is positioned in the middle, dividing the model into two halves. The still-life appears compact and the objects appear together although clearly identifiable.

A

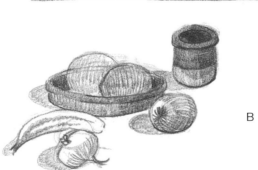

If you stand up and look at the still-life from a higher point of view, the horizon line will appear higher, the objects will reveal more space between each other, and the shadows will appear rounder.

B

If you look at the model from a lower point of view, the horizon line descends drastically, the projected shadows disappear, and the objects are superimposed one on top of the other, somewhat hindering the identification of certain details of the group.

C

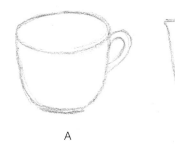

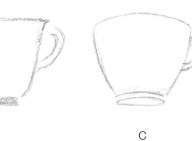

A B C

The variation in the point of view affects the individualized perception of the objects. (A) Drawing a cup from a high point of view makes the circular opening have an oval form. (B) Cup seen from the same height produces a profile view of the object. From a point of view situated below the object (C), the cup's upper border appears convex.

THE POSITION REGARDING THE MODEL

The best way to learn how the view of the model changes if the point of view is changed is to compose a still-life on a table and try to look at it from different points of view, as you can see in the images on the previous page. Notice figure A, in which the objects that form the composition have been drawn below the line that demarcates the table (horizon line); this means that the person is observing the scene from a high position. You can deduce then that the viewer is standing. On the contrary, if the viewer is sitting in a lower position than the previous one, the line of the model will also be lower, and the elements will be observed from a more level position with the table (figure C). Observing both images you will also see that the forms, as well as their respective shadows, have changed noticeably. When looked at from the higher position (B), they present more rounded forms, while when you crouch down the shadows are elongated and are nearer the horizon line. Through this brief observation exercise, you can see that what you want to draw relates to your position vis-à-vis the model.

The principles of point of view explained through the previous figures can also be applied to landscape drawings, such as the view of the cupolas of this church observed from a high position.

Frequently, nature itself suggests the composition to the artist. You should take advantage of these occasions, but do not rely on them too much: if you don't have a previous composition outlines sketch, confusion will soon come into the picture. This impact depends greatly on the combination of the principal forms on the surface and on the divisions of space in the drawing in general.

composing Outline sketches:
balancing the image

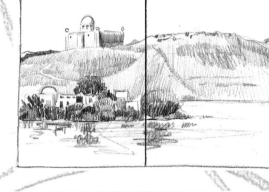

A good artist should introduce a bit of asymmetry in the composition, breaking the formal equilibrium between both sides of the drawing. This adds more interest to the composition.

SYMMETRIC OR
ASYMMETRIC COMPOSITIONS
The first and most basic rule is the one that determines whether you are going to draw a symmetric or an asymmetric composition—the global equilibrium of the theme must be taken into account. A too symmetric composition can appear boring and static. The symmetry will provide equilibrium to an image, but will take emotion away from it. However, this is not always so, since a landscape composed of interesting forms and angles can sometimes offer variation enough to the sight. Asymmetric compositions are the ones that create the most tension in a drawing. They may be apparently unbalanced, but a close analysis of the work will show that even though the landscape is asymmetric, the balance among the different color masses and the elements composing the scene complement each other and give a certain sense of equilibrium.

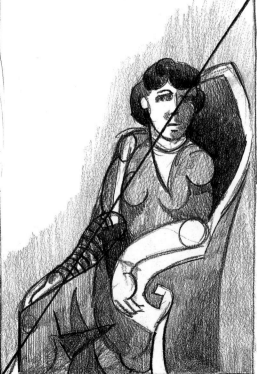

A diagonal composition is one of the more recurrent in the world of art since it provides asymmetry and stability.

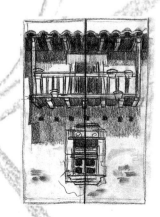

Symmetric compositions appear balanced, static, and monotonous.

SIMPLE FORMS

Composition also implies combining forms within the picture's area. It has been demonstrated that most people prefer compositions based on geometric shapes on account of their simple and concrete configurations. When three simple forms such as a triangle, a rhombus, and a circle are placed separately or superimposed in a composition, the viewer can identify each form and enjoy their interaction.

Therefore, we suggest that at the moment of selecting a theme and determining its composition, you should begin with an outlines sketch, a schema, that responds to a precise geometrical form. Experience has shown them to be pleasing to the majority. This way, you can be sure your drawing will present a visually satisfactory picture.

These outline sketches show different composition schemas for the drawing space. (A) an architectural element presented through an oval form, (B) a human figure based on a triangular schema and on a circular form for the torso, and (C) a marina with the composition schema of an inverted L.

COMMON SCHEMAS

The use of geometrical schemas in a drawing's composition was already being used the Renaissance, with a general predominance of the triangular schema. The arrival of the Baroque caused more use of the diagonal composition, suggested and applied mainly by Rembrandt. Besides these schemas, which may be considered classic, and other traditional ones such as the rectangle, the square, and the oval, some common schemas are those that refer to typographical forms that remind us of the letters L, C, Z, etc.

A

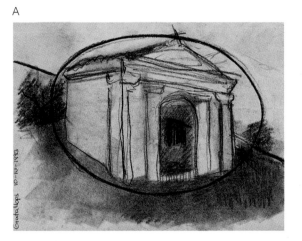

Since making a composition schema of a model is a preliminary step in the drawing process, you should draw it with soft strokes, hardly exerting pressure, so that it can be easily erased once its function has been completed. Experiment with all types of geometrical forms to find the most appropriate one.

B

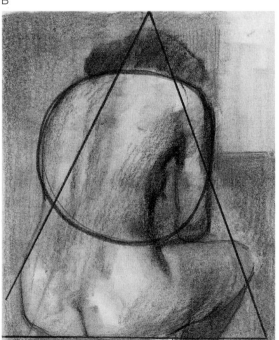

C

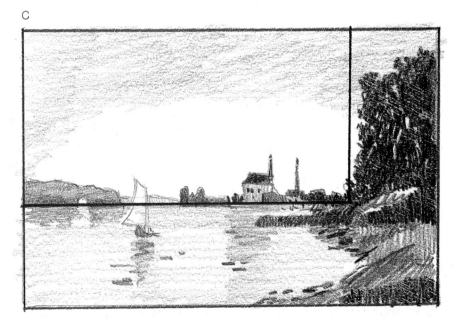

balance
and Rhythm:
a visual order

One of the most important factors when approaching the composition of a drawing is obtaining a visual balance—in other words, the order and disposition of the different elements that comprise the model. Everybody has a certain intuition which can give balance to a work, but this is not enough. You also have to learn to look at a model from a drawing point of view, as an ensemble of strokes and tonal surfaces. The equilibrium in a composition depends a great deal on the harmony it expresses.

BALANCE IN THE FRAMING
When framing, you are placing borders on the view you want to represent. An appropriate framing takes into account the color masses confined within its boundaries. In a landscape it is sufficient to modify the framing, since there are several possible compositions, and many of them can be interesting. In selecting the framing, be aware that centered elements reinforce the balance of the composition, while those placed to the sides may unbalance it.

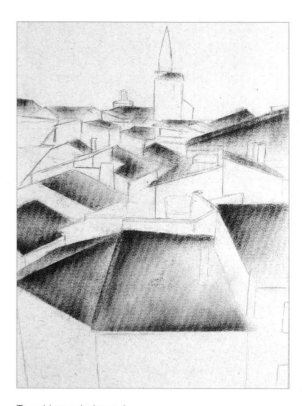

To achieve a balanced drawing, it is necessary to make allowance for the tonal zones. Observe how the artist has balanced the tones and forms of the roofs

A

B

C

D

The most balanced drawing is, without a doubt, the symmetric one, that is, the one that presents equally distributed masses and the one that repeats the same forms on the left and right sides of the paper (A). If you want to create unbalance, you should not equalize the distribution of the tonal masses. You should look at the paper as if it were a scale to indicate that the right side of the image weighs more than the left or vice versa (B). But this unbalance has an easy compositional solution, which consists in placing the small square in a more elevated position in relation to the larger one; the visual effect does the rest (C). Quadrangular forms are heavier than rounded ones, so the circle should be placed higher if you want a visual equilibrium (D).

CHECKING FOR BALANCE

You can verify the balance among the masses through a simple analysis in order to assure that a composition be pleasing and not disproportionate or prone to errors. Turn the drawing upside down, 180 degrees. This will create some distancing from the work. The work has been well fashioned when the object or figure is supported and does not seem like it is going to fall down. A composition gives the impression of falling when you have not taken balance into account. You can also analyze the composition by observing the schema reflected in a mirror. You can better identify the errors in the reflected image than in the real drawing.

DISTANCING

A first impression of something strange in the drawing could indicate that you have made and error. This may not always be evident. You can leave the drawing for some time, since with time you distance yourself from the work and thus will be able to distinguish the errors in proportion or balance.

There are several methods to analyze the drawing to see if you are doing it right. The simplest ones are (1) to turn the sketch upside down to check its balance or (2) to look at it reflected in a mirror, which will reveal its compositional defects.

You should work at a moderate distance from the model as well as from the support. If you work too closely to the paper you will be prone to making errors in proportion, balance, or perspective.

RHYTHM

Rhythm in a drawing has the same function as in music: it joins the different elements and provides a distinct character to the composition. Rhythm can be achieved through the systematic repetition of motifs, through the control of an ordered stroke, or through a succession of lines that direct the gaze of the viewer onto the surface of the work.

When the content of a framing is analyzed, everything is reduced to simple forms in straight, curved, broken, or mixed lines. The repetition of these directions gives the work rhythm. In a drawing, rhythm may be obtained through the repetition of strokes; an example of this can be seen in the law of continuity developed by some British artists during the nineteenth century.

THE LAW OF CONTINUITY

The law of continuity is a method of expressing the unity of the work starting with a succession of ordered strokes or elements from the scene: "For example, the succession of the columns in the wing of a cathedral is more interesting when they are recessed in perspective and become darker the farther away they are. The same thing happens with a succession of hills, when some follow others on the slopes surrounding a valley, or with the succession of clouds, which become hazier towards the horizon. Each hill and each cloud have a different form, but each element evidently follows another in a tranquil and expected order."

The law of continuity guides the gaze of the viewer over the picture through the strokes. In these cases, the succession of strokes creates currents that flow as rivers, or as waves, on the surface of the drawing. You can observe this effect on the beach drawing in the following exercise. The purpose of the artist in this drawing has been to transmit a greater expressive effect, thanks to the control of the strokes, together with the bewitching, swaying, and undulating movement of the clouds and the waves. As you can see, the strokes describe clouds that move in countless rows that follow the sun and converge on a point in the sky. There, the strokes of the clouds find their continuation on the beach and flow to the sea, where in the swell, the same undulating forms of the clouds are repeated. This rhythm of continuity joins the different elements and provides the composition with a distinct character.

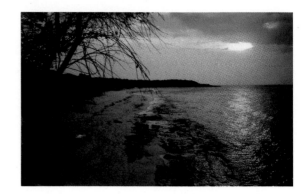

The following exercise will demonstrate how to translate this photograph with the use of rhythmic and repetitive strokes that guide the gaze of the viewer over the picture.

1

1. Before beginning to draw, the artist sketches the model. On this, a series of arrows are drawn which mark the direction of the strokes in each one of the zones of the drawing. Notice that the arrows start on the sea, ascend through the tree in the foreground, and continue through the sky and then back to the sea, to the starting point.

2. With a graphite pencil of medium hardness, start covering the white spaces of the paper, respecting the directions indicated by the initial arrows.

2

3

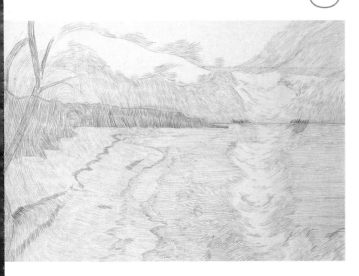

3. With the drawing almost complete, you can see that the application of the "law of continuity" renders a surface covered with undulating strokes that show the direction the gaze should follow over the picture's surface.

To organize a balanced model, imagine the group of objects as if they were on the plates of a scale. Make sure that the objects distributed on the left half of the model have the same visual weight as those on the right half.

4. In adding more lines over the previous ones and contrasting the darker zones, you will obtain a more satisfactory final effect. Observe how the direction of the lines is kept in relation to the initial arrows. The control and direction of the strokes provide the work with an undulating rhythm.

4

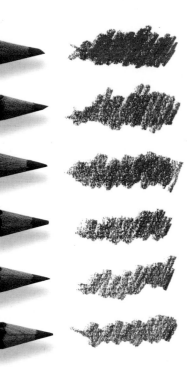

tonal

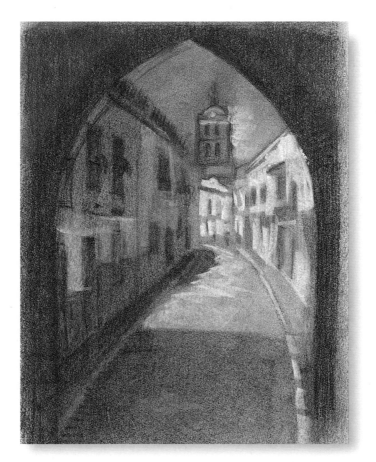

GABRIEL MARTÍN, *A STREET IN ZAFRA*, 2002.
SANGUINE AND CHALK

techniques.

The combination of shading and

line widens the range of drawing possibilities. Studying light and shadow allows a closer approach to the elements that give realism to a drawing. Establishing the value scale of a subject means registering its tonal development, clarifying and comparing tones and hues, and deciding which ones are lighter and which ones are darker. To understand the value of a tone, you should establish on the model a range of shadings that is complete enough for the drawing to acquire corporeity, volume, and atmosphere. When outlining any object, it is necessary to view it as a set of intense stains that vary according to the incidence of light in the various zones. A good drawing value cannot be achieved through sharp contrasts of light and shadow zones. Instead, a progressive value must be rendered, with smooth transitions between shadings.

A B C

D E

F G

SHADING

There are two ways to create tone with pencil. The first method is to use a soft pencil to achieve the desired tonal intensity through the amount of pressure exerted while drawing. The most common shadings are vertical shading, made with lines perpendicular to the lower margin of the paper or to the line of the drawing, and diagonal shading, which is made with diagonal strokes. Diagonal shading is one of the easiest and, therefore, the most commonly used in drawing. The second method is to use a harder pencil and create a series of tones, producing layered shading. For shading it is essential to maintain the pressure all the time and move at the same pace in order to achieve a uniform texture.

DRAGGING

The most common way to produce shadings with charcoal and chalk is by dragging the stick lengthwise, in order to create a wide and thick stroke that allows the paper's texture to be visible immediately. In order to control the stroke it is necessary to cut the stick according to the line width. The amount of pressure you apply will determine the darkness or luminosity of the drawing. A zone can be covered until the paper's tooth is completely covered. Tones can be softened by rubbing, as if using graphite. A soft shading applied by barely pressing the stick against the paper surface will produce a very delicate range of tones.

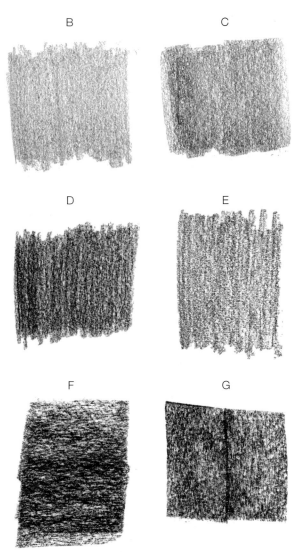

Above are basic examples of shadings made with graphite pencils, charcoal, and chalk, on fine coated paper:
(A) Homogeneous shading made with the side of a sanguine stick, (B) classic shading made with a dull-pointed graphite stick-pencil, (C) homogeneous shading drawn with the side of a rectangular graphite stick , (D) classic shading extended with a sanguine pencil,(E) classic shading with an oily pencil, (F) textured shading made lengthwise with a charcoal stick, and (G) homogeneous shading made with the side of a black chalk stick.

By gradually increasing the pressure of the sanguine stick, you will be able to cover the paper's tooth almost completely. Practice tonal value scales of this kind to master shading quality.

TONAL EXERCISES

Select simple themes and try to create them by applying different approaches to tonal work. First try to apply shading to create shapes. Then, always working with a single color, draw a theme by defining large tone blocks—three to five tones will be enough—and use the tones to create the object's shapes, regardless of whether the tones in the theme are visible or not. Once you have simplified the theme to three to five tones, look at the tonal zones as abstract shapes, and leave some zones of the drawing indefinite so that the eye can complete them. Keep in mind that, often, the most efficient drawings have a minimum of elaboration. As you become more experienced you will be able to assign to the drawings a wider value range which, when applied to the model, allows for a great variety of light intensities. The good use of shadings will make it possible for you to create a more volumetric representation of the model.

Below are four samples of the most common shadings: (A) classic shading based on hatching, (B) homogeneous shading made with a slanted graphite stick, (C) shading by dragging the side of a chalk stick, and (D) staining with a small charcoal stick.

A

B

C

D

Once the shading has been drawn, it can be extended with your finger.

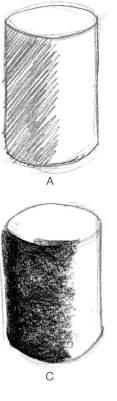

In order to shade quickly and without much variation, the quickest and most effective method is the classic hatching shading.

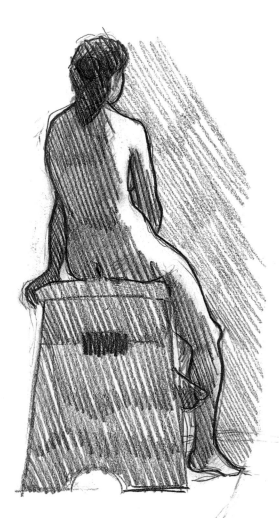

When developing a variety of tones and gradations, it is recommended to use the most homogeneous shadings. You can even combine different types of shadings in one drawing.

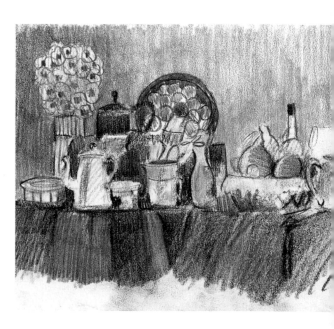

how to Control
the quality of a shading

If you press hard against the paper with the drawing medium you will produce dark lines. However, by controlling the amount of pressure on the medium, the shading will be more tenuous, resulting in a lighter color. A saturated tone is a tone that has the most intensity, the darkest tone. The least saturated tone is a lighter one. Many tonal values can be created. To begin a drawing you should locate the darkest tone and the lightest one, as well as three or four other intermediate values. To create tonal gradations it is important to have several tones, which can be achieved by alternating the amount of pressure you apply on the paper while drawing.

Sketches allow you to explore the possibilities of each drawing medium. In this chase the shading has been made with a 4B graphite pencil

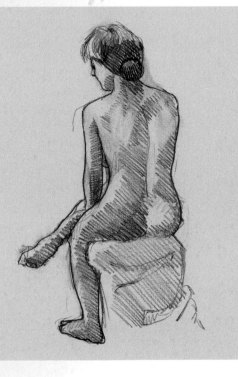

It is convenient to use pieces of the same paper used for the drawing for samplers of tonal ranges. Keep in mind that the color, weight, and texture of the paper will significantly affect the final result of the shading.

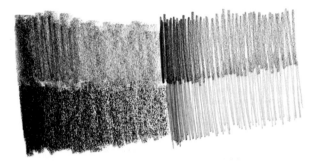

Here you can see a series of arranged tonal values made with graphite and sanguine. These samples show various tonal intensities, which enable you to assess the hardness and quality of the medium. It is advisable to alternate leads of various hardness levels in the same drawing.

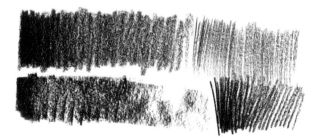

THE QUALITY AND HARDNESS OF THE DRAWING MEDIUM

As we have explained, developing the shading possibilities of the different media is fundamental for value work. Therefore, an artist should know the possibilities of each of the hardness levels of the graphite pencils or sticks used. Once you know the limits of each material, applying it will be a more logical operation, extending the technical scales of grays in the context of the drawing.

It is necessary to have a good knowledge of the properties of every drawing material in order to develop the best shading method to be used in each case.

With your eyes half closed you will have a blurry vision of the model. This enables you to simplify the forms and have a better perception of the general light and color characteristics; then you can establish the distribution of the large tonal zones.

PRELIMINARY PRACTICE OF TONAL RANGES

Before beginning to draw, you may find it useful to practice developing the tonal range on a piece of the same kind of paper you will use to work. When applying charcoal, sanguine, or chalk on the final paper, you should always start by exerting less pressure, increasing it according to the lines outlined in the sketch.

DIRECTION

When applying shading, it is essential to follow the correct direction. This is why it is so important to start out using life models, since it is only through observation that you can analyze and synthesize the gesture needed to produce the desired effect. In general terms, the gesture is perpendicular to the direction of gradation, although sometimes you may need to blend in a curve or impart circular direction to express cylindrical or spherical volumes.

A B C D

Shading should not follow a random direction. You should follow a certain direction, which will depend on the volume of the object being drawn. For instance, on a spherical body the shading will be circular (A), on a curved surface the shading should also describe the curve (B), if the surface is flat the shading should be straight (C). This will also apply when, instead of using the slanted stick, you create strokes. The form of the strokes should be consistent with the undulations of the object's surface (D).

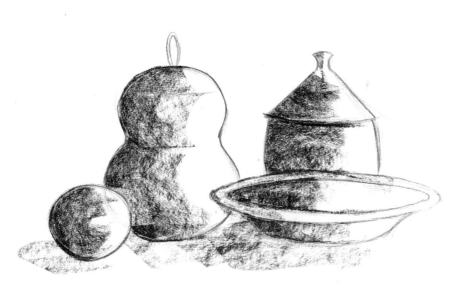

If you want to further develop the shading direction, draw simple still-lifes, such as the one shown in the figure, and try to create the shading following these principles.

dividing areas:
controlling shadows

You should visualize, in each model, the different tonal zones. A tonal zone consists of an area with a similar tone, which distinguishes it from the others. Each tonal zone is related to its corresponding tone; this is the way the value system is established.

REDUCING VALUES

One of the most important things we can do is to establish a system that can analyze and identify the relations of the tone values. It is essential to learn how to break down the system into steps. In general, models have color. The first step is to imagine the theme reduced to black and white with several gray values. This will facilitate the representation of the model with various tone values.

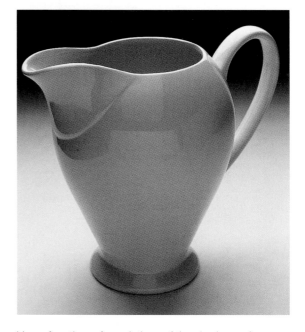

Very often the soft gradations of the shadows of a model may be daunting and confusing. Do not worry. When observing a model, learn to clearly synthesize and distinguish the zones of light, intense shade, and intermediate tones.

In order to distinguish the tones it is helpful to imagine an achromatic version of the model: that is, black and white.

1. Before shading it is necessary to outline the model with linear strokes. The drawing does not need to be very exact, since the forms will be built up later in the process.

1

SHADOW SYNTHESIS

Once the model is reduced to black and white values, an intent to synthesize will enable the location and delimitation of various values of different value. The limits of the tonal zones can be specified on the preliminary outline sketch. Two basic tones will allow you to define the value system. The lighter one is associated with the zones that present the highest light intensity and the darker tone for those areas that are darker.

BLOCKING IN SHADOWS

Through simple sketches where shadows have been blocked in, you may group the zones that have the same tonal value. You may represent with lines the limits that divide the paper in various spaces. Each zone has a tonal value. It is easy to establish the relation among the zones that share the same value. This is the system that allows for relating and classifying all the tones.

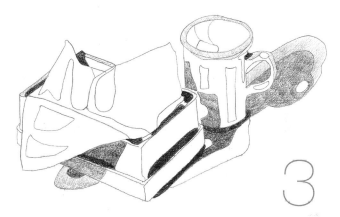

2. With a sharpened graphite pencil, draw a more precise profile of the objects. You should block in the contours of the most clearly distinguishable shadows and their reflections. Once the drawing is finished, shade the most intense shadows of the model with a black oil pencil.

3. Now extend the intermediate tones, evaluating the quality of the grays in the cast shadows—which also contribute to the impression of volume.

4. The block-in work of the shadows is finished now. This system allows the beginner to study the shadows of a model without much risk. After applying this system several times, you should move on and attempt to draw a model without drawing the lines that delimit the different shadow intensities.

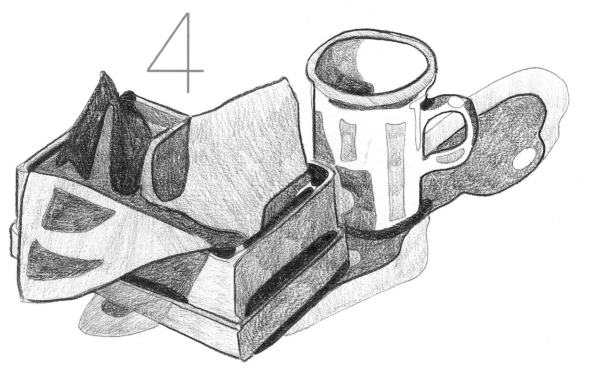

the Importance
of tonal gradation

A

Gradations are smooth transitions from a light tone to a dark one and vice versa. The goal is to achieve, in a shading, the organization of all the tonal values in a progressive range, that is, without tone changes. In order to make a gradation it is necessary to use a tonal range, arranging it gradually in order to minimize the sudden tone changes.

ACHIEVING A GRADATION

A gradation is created by caressing the paper softly with a slanted pencil, beginning with a constant pressure and a zigzag drawing. This pressure is diminished gradually in order to go through the range of grays, from the maximum darkness point to the lightest point, according to the possibilities provided by the hardness of the pencil or charcoal. In order to create gradation through shading, besides controlling the amount of pressure placed on the pencil, it is necessary to juxtapose the strokes. However, to start it will be easier to work on a gradation without using strokes and using the dull point.

GRADATION BY DRAGGING

When drawing with a charcoal, chalk, or sanguine stick you can also create gradations by dragging the stick lengthwise. You just have to exert higher pressure on one of the tips of the stick, so that the resulting shading will be a gradation. This method of shading is very popular. Through practice you will be able to master this type of gradation.

If you add one gradation after another, have them fit appropriately. To do so, make sure that there is correspondence between the tonal values. A thin layer is usually applied to avoid sudden tone changes or visible gradation borders.

B C

Above are some examples of gradations of various lengths created using different drawing media: (A) gradation with black chalk, (B) gradated shading with a graphite stick, and (C) a gradation with a sanguine pencil.

Below are various samples of gradations made with a sanguine and a graphite stick. As you can see, the gradations can also be created by dragging the sanguine stick (D) and (E), and by dragging the graphite stick (F).

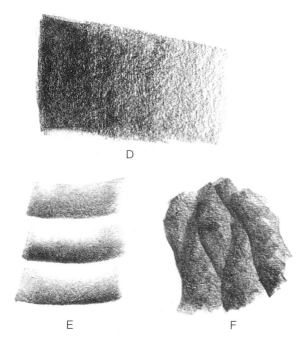

D

E F

Blending tones with your finger, a piece of cloth, a malleable eraser, a blending stump, or a fan brush is a common technique for making gradations.

BLENDED GRADATION WITH HATCHING

Whether you use charcoal, sanguine, or chalk, you will obtain different effects if you blend a gradation. This very soft blending can be made with a fan brush or by blowing on it after it is blended. The strokes disappear more easily when using charcoal, a little less when using chalk, and they stay almost completely fixed when using sanguine.

ATMOSPHERIC GRADATION

One of the most interesting methods of gradation, which is perfect for landscape drawing, is producing a gradation by drawing small circles. This results in a completely atmospheric effect. You should begin by drawing small circles, progressively filling the whole space and regulating the amount of pressure on the pencil, to create a progressive gradation effect.

Atmospheric shading can be achieved by slowly rotating the slanted stick on the paper's surface. This method is ideal when drawing landscapes with interposed atmosphere.

If you create gradations by only varying the pressure on the charcoal stick held lengthwise, you will achieve a synthetic drawing with a strong volume effect.

tonal backgrounds:
drawing on colored paper

Instead of always working on white paper, you can also draw on a tonal surface, a colored background. It makes for an easier and appropriate tone and color value and for drawing light and dark zones easily. The color for the drawing will depend on the theme. Keep in mind the following: (1) drawing on a dark colored background will strengthen the light colors, (2) a mid tone will produce a tonal equilibrium with a background color that will harmonize with most colors, and (3) a light background will display the dark strokes stronger. Tonal backgrounds are ideal to use with charcoal or colored chalks, and are also a perfect base for drawings with white highlights.

CHOOSING THE COLOR OF THE PAPER
There are several options for choosing the color of the paper. The model can indicate the dominant color. For instance, a sunset may suggest an orange paper; a nude will lead you to choose an ochre, pink, beige, or salmon color to match the skin color. For a pier, you may consider using a light blue paper, such as sky blue. But you may also intend to create more dramatic and expressive effects and choose a paper color that has no direct relation to the theme, which will instead allow for a great contrast effect.

There is a huge variety of colored drawing paper available. Your choice will depend on the warmth and expressive effect you want to give to your work.

Neutral-colored and gray or brown papers are those most commonly used by artists because they enable them to incorporate chalk and highlights.

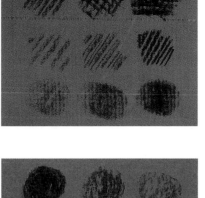
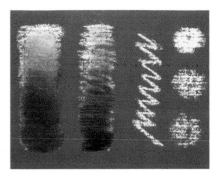

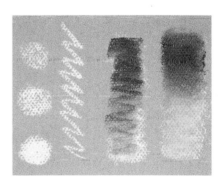

SHADINGS ON COLORED PAPERS

Drawing a charcoal tonal range on colored paper will enable you to see the effect on different paper colors. In the most tenuous layers, this color shows through the shading, while in more intense applications the color of the paper will be completely covered. Blendings with charcoal or chalk on colored paper, though applied identically as on white paper in technical terms, produce different effects that result from the combination of the charcoal applications and the particular color of the paper.

WHITE CHALK: HIGHLIGHTS AND COMBINATIONS

On a tonal background you may use white chalk to highlight the light. If you combine other chalks, in darker tones or charcoal, you will achieve many intermediate tones. In fact, you may play with three ranges: charcoal, chalk ,and the color background, and increase the possibilities of defining the value system.

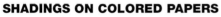

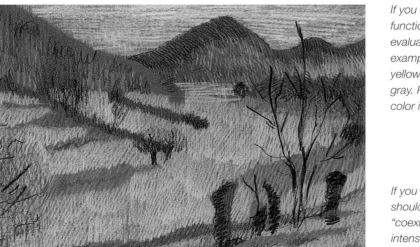

If you want to check the way a drawing medium functions on a colored paper, do one of these tests and evaluate the results. Here you can see three illustrative examples: shadings with charcoal and white chalk on a yellow paper, then on a blue one, and finally on a neutral gray. Practice blending and observe how the paper color integrates into the shading.

If you choose colors with more intense tones you should keep in mind that the paper color will have to "coexist" with the strokes of your drawing, imposing an intense dominant color. If your goal is to transmit the coldness of the snow in winter, a blue color is very appropriate.

Contrasts and

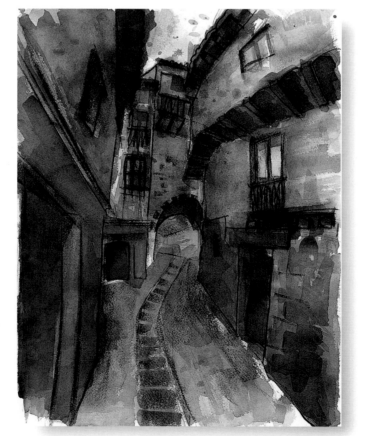

GABRIEL MARTÍN, *A STREET IN ALBARRACÍN*, 2002.
WASH AND CHALK

volume effects.
Knowing the effects
of shading

with the various grays allows you to achieve not only the outline of the position planes of the drawing, but to also render the volume of the forms. When outlining any voluminous object, it is necessary to consider it as a set of intense stains that vary according to the effect of light on the different zones.

First, you arrange the general forms. Then, you outline the different volumes of the shadows. Finally, you establish gray values, increasing the tonal value in the zones with the most contrast and opening white spaces with the tip of an eraser.

blocking in
and modeling

Blocking in starts from the initial outline sketch that has the general shapes of the model. A value system is established from the beginning, according to the planes that will define the limits and forms of the elements. The most important shadows should be schematized with planes in which the direction of the stroke will envelop the forms.

BLOCKING IN FOR MODELING
Blocking in starts from the initial outline sketch that has the general shapes of the model. A value system is established from the beginning, according to the planes that will define the limits and forms of the elements. The most important shadows should be schematized with planes in which the direction of the stroke will envelop the forms.

Blocking in should always be progressive, beginning with the lightest values and moving toward the darkest ones.

A good modeling exercise consists in drawing simple geometric shapes, for example spheres or cubes, with a charcoal stick. Begin with a sphere: first draw the outline, then shade it, and finally model by blending with your fingers. Our goal is to create a sphere with a strong volume effect.

Do the same with a cube. Here you should keep in mind that each side will have light with different intensities. The drawing process is similar to the one of the sphere; however, work more carefully in order to avoid blending the shadings from the different sides.

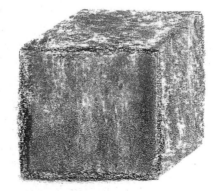

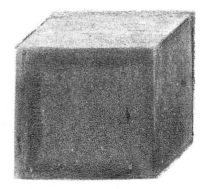

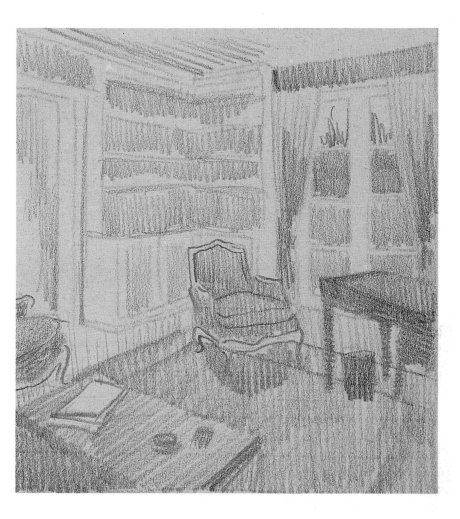

BLOCKING IN

Blocking in is the beginning stage of modeling and drawing; this is why the value system of a drawing should present a detailed study of the zones that will require special shading. The first values should be made without exerting any pressure on the paper, in order to avoid subsequent problems when manipulating forms. If the paper has medium or coarse tooth, the texture will become visible when rubbed.

MODELING

When the first value is blended, the pigment penetrates the paper tooth, creating different tones from those of the initial drawing and losing part of the spontaneity of the drawing. This stage is necessary for studying the lighting and volume of the bodies. The modeling process goes from establishing on the model a range of shadings that will be complete enough to give volume to the form. The various tones start out from the paper's tone, unless colored papers or chalk highlights are used. Once the values of the different grays are understood, it is possible to create not only the outline of the drawing planes, but also the volume of the forms.

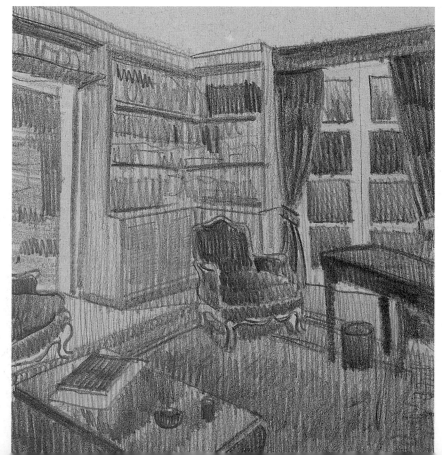

These two images show the difference between the blocking in with uniform tones and the modeling with more complete and contrasted shading. The first stains help situate the masses, while the second ones define the drawing in terms of tone and volume.

WORKING WITH SIMPLE SHAPES

The best way to illustrate the concepts of blocking in and modeling is to begin working with simple shapes: spheres, cylinders, cubes, prisms, and different combinations of these shapes. In some sense, any object is, to a greater or lesser extent, a combination of several simple shapes of various sizes. It is instructional for the beginner to start modeling simple volumetric figures and practice with these shapes the blocking-in and modeling exercises with graphite shadings. In this case blending is crucial in describing the volume of the bodies.

THE NOTION OF MODELING

If the artist has created a correct blocking in of the theme, the forms will be modeled and their volume and relief will be displayed. Modeling in drawing may be compared to the sculptor's work in that it is a two-dimensional imitation of what the sculptor does in three dimensions: giving body to the theme and rendering its presence.

The best way to model, whether you are working with an oil pencil (A) or with a compressed charcoal pencil (B), is to treat the shadows very smoothly, almost caressing the paper with the point of the pencil. This will produce gradual tonal transitions that will better explain the volume of the bodies.

Here you can see the modeling of a cylinder. First, the contours are drawn in the right proportion. The borders of the darkest and lightest shadows are indicated with a soft shading in the middle (A).
The central shadow is intensified, the lightest value being on the left—the one that receives direct light. On the right border line, the value turns lighter again due to the reflected light.

A

B

The correct relationship between values and, thanks to the transition among them, the modeling of a cylindrical volume has been achieved. Now the only thing that needs to be done is to intensify the modeling by darkening all the values in order to maintain the relationship among them (C).

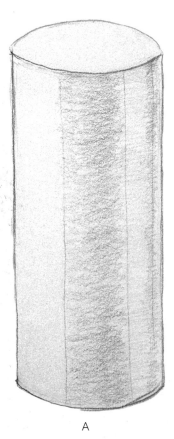

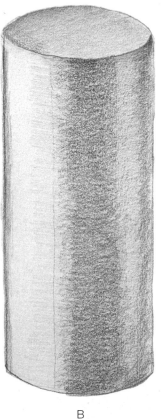

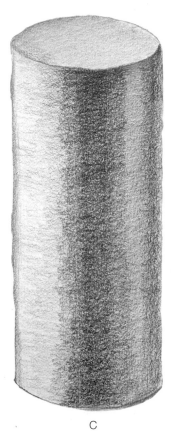

A

B

C

WORKING SOFTLY

Modeling should be done very softly and progressively, avoiding at all times the presence of strokes. Intensify the values by superimposing new tenuous ones. That is, shadings will accumulate gradually over the initial shadings of the drawing, darkening values, highlighting illuminated zones, and rendering more precisely the volume and effects on the forms of the objects. Working the theme as a whole, you can achieve a uniform and atmospheric effect.

You can describe the textures of the materials and volumetric effect in any simple still-life with a minimum amount of modeling. Practice by using simple compositions and change the direction and intensity of their illumination in order to produce new arrangements of form, lights, and shadows.

No matter how dark certain shadows may appear, avoid trying to represent them very intensely in the beginning. Very intense blacks in a drawing will make it difficult to do value work and will result in difficulties when creating volume as well.

Chiaroscuro:
maximum contrasts between light and shadow

In chiaroscuro, the artist attempts to represent objects through developing the light and shadow zones as a tonal contrast. Modeling forms from a study of light is an exercise that requires a detailed study of tonal values and of gradations of grays. The main dark contrasts outline the luminous zones and increase the three-dimensional impression in the model.

VALUE AND CHIAROSCURO

The chiaroscuro is a value system that affects not only the main element but also all the elements within the frame of the drawing. The value of each one of the elements of the drawing will vary depending on the situation of the model in relation to the light focus. The less light the still-life zones have, the darker they will be; this allows for greater contrast where there is less illumination. Chiaroscuro proposes an exhaustive analysis of the model in relation to the illumination it receives; therefore, the treatment of the surfaces in relation to the light is indispensable in rendering the different objects composing the model.

These drawings of a sphere clearly illustrate the difference between a body rendered with modeling effects (A) and a body rendered with chiaroscuro effects (B). The first shows softer tonal transitions, whereas the second has greater contrast between the illuminated and the shaded zones.

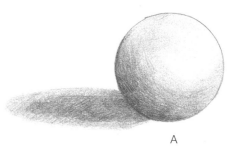

A

The tonal range offered by charcoal is ideal for chiaroscuro works. The only thing you should keep in mind is that the tone is controlled with the pressure of the charcoal on the paper, and also by how much the paper surface is covered.

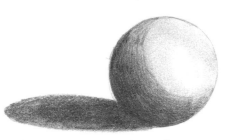

B

ILLUMINATION IN CHIAROSCURO

The model's value for chiaroscuro is determined according to the background and the light focus it receives. It is essential to understand that the light is not the same in the whole surface, given the fact that once it falls on the first plane of the model, it gets distorted and bounces off, changing each zone. When coming laterally from an electric source, the light is direct and creates well-defined and outlined shadows; when the light is diffuse it comes either from a natural focus or as a reflection of the electric light, which produces soft shadows without edges.

THE ZONE OF GREATER ILLUMINATION

The zones that show brilliance, as well as those with great illumination, should be free of charcoal, sanguine, or chalk. However, if there is a mistake these zones can be corrected with an eraser.

THE DARKER ZONES

The zones of maximum darkness, corresponding to the darkest tone in the tonal value system, can also be treated with a special method. Once the desired tone is achieved, it should not be touched. This zone will be definitive. Doing this will help avoid limiting the adherence capacity of the paper, which would impede achieving a darker tone if such tone were necessary.

The edges of a new eraser may be used to work on small surfaces and details.

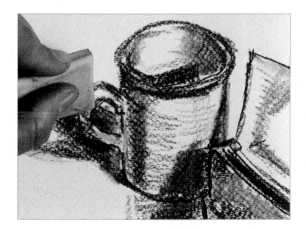

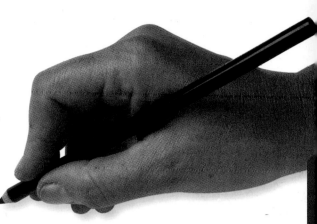

The compressed charcoal pencil is ideal for chiaroscuro; it allows you to outline the forms and create more intense and contrasted blacks than natural charcoal.

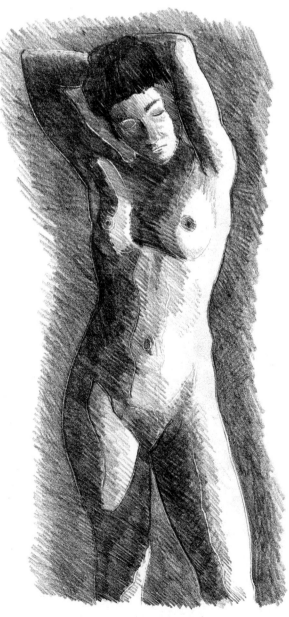

The chiaroscuro effect is characterized by a strong contrast between lights and shadows, which gives a much more volumetric and dramatic appearance to the model.

To learn how to work with lights and shadows, direct intense light directly onto the model. This will clearly create different dark and light intensities.

blending

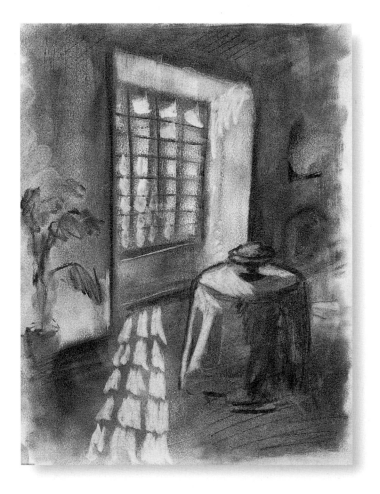

GABRIEL MARTÍN, *THE AFTERNOON LIGHT*, 2002.
CHARCOAL.

techniques.
Blending is one of the
various studies of

tonal value; it facilitates gradations by applying soft tonal gradations on a zone with an established value system. Blending is directly related to tonal value, which is why it should not be used to create effect. Blending is a practical tool used to elaborate the drawing. Soft media, such as charcoal and chalks, are the most appropriate materials for developing layers of blended stains, which will give the drawing a more pictorial appearance. Blending not only produces subtle tone effects, but also gives the surface and attractive texture. Blending softens and combines the different zones in the drawing.

Sfumato:
smooth contours

Sfumato means "a softening of the tones." When applied to drawing, the term refers to producing very subtle tonal gradations, similar to the misty effect of the wash. After an initial composition is made, sfumato is created by blurring the strokes and shadings with your fingertip. The sfumato effect in a sketch is very soft, given that the uniform gray tone integrates light and dark tonalities.

ATMOSPHERE IN LANDSCAPES

The atmospheric landscape requires, more than precise forms, sfumatos, blurred strokes, open lines, and suggested forms. The general atmospheric appearance of the drawing is usually more important than the precision of each detail. For this type of drawing, blending links the different parts and gives unity to the work. The misty effects should be carefully mixed so that the objects are rendered without explicit drawing.

Sfumato can be used as a medium to create atmosphere and to unify the different values of a drawing.

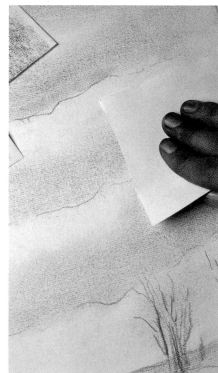

Observe above how a sfumato drawing has a more pictorial appearance than one made with clean and precise strokes.

Because graphite is very soft and allows for a very delicate finish, it blends well.

155

DIRECT BLENDING

On a support treated with graphite, charcoal, or chalk, forms can be dissolved by blending directly with your finger. For sfumatos to be soft and well integrated to the white of the paper, without a trace of strokes, rub the drawing with papers. This method is not as precise as blending but may work for treating large zones of the work, such as the sky or water, which require an especially soft and delicate treatment. You can also rub a graphite shading with a cotton ball to obtain a soft blend, allowing you to create the general tone of a form.

THE IDEAL MEDIUM

Charcoal may be the ideal medium for the sfumato technique, due to the fact that it has rich tonal qualities and can be mixed and dissolved very easily. The sfumato tones can be achieved by rubbing the charcoal on the paper with your fingers, so that the foreground integrates with the background.

A flat charcoal stick can be applied on the zones that require a general shading.

With cotton you can produce softer and more continuous shadings than those obtained with a blending stump.

Charcoal is the best the medium for sfumato effects.

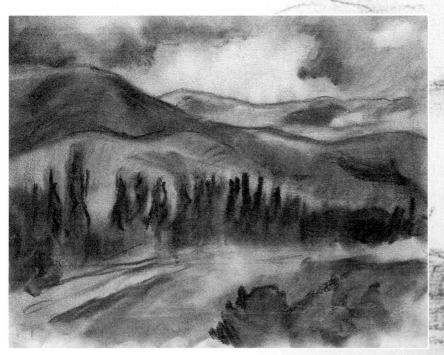

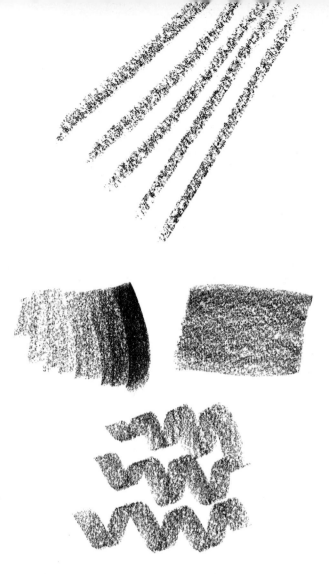

how to Use
a paper's texture

Coarse paper has a pronounced tooth. When a stroke or shading is applied to this type of paper, a medium's pigment is left in the ridges of the paper, leaving the holes free of pigment. Coarse paper breaks lines and strokes, producing a mottled and discontinuous appearance. As the shading is not get completely integrated into the paper's surface, it has a blended, atmospheric effect in the drawing.

TOOTH AND ATMOSPHERE
In order to create an atmospheric effect on textured paper, do not exert too much pressure on the drawing medium. Apply shadings, avoiding any trace of strokes and combining gradated scumbles. You should also avoid defining the outlines of objects, so that the contours of the objects seem blended and blurred.

Working on coarse papers and using the side of a chalk stick is ideal for making tonal sketches with interesting atmospheric effects.

Above are some examples of the various types of textures that the surface of a coarse paper can offer.

CHARCOAL BLENDING

One of the most interesting characteristics of charcoal is its ability to adjust to any paper texture. Charcoal, when applied on its flat side as a shading on toothed paper, creates a uniform tone. According to the amount of pressure exerted on the stick, you can vary the drawing's darkness or luminosity. Coarse papers enable the artist to work repeatedly with charcoal on the zone where two tones meet so that they are imperceptibly blended. Blending is obtained by rubbing a tone on the contour of the one next to it so that they merge smoothly, creating the impression of a soft and misty light.

The best way to work on coarse papers is by scumbling. When a shading is superimposed on the previous one, the result is an increase in the tone and a reduction of the visibility of the paper tooth.

The textured effect of the paper's tooth harmonizes and integrates all the strokes in the drawing, creating an atmospheric effect.

By pressing progressively with the charcoal stick, you will be able to cover the paper's tooth completely.

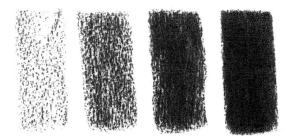

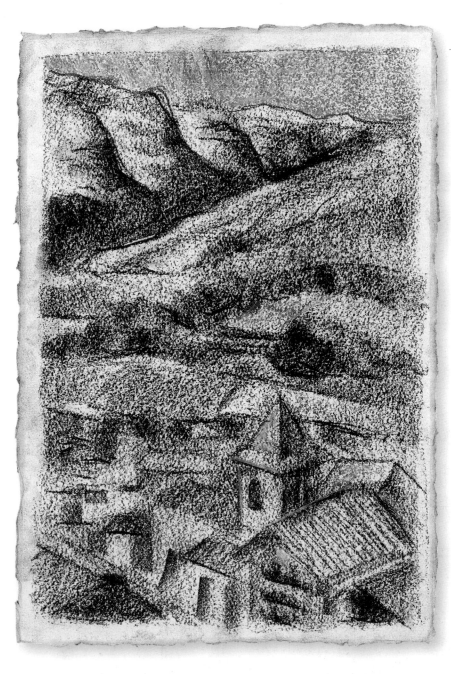

Because of its malleable character, charcoal enables you to hide the *pentimenti* more easily, although they remain as sketch lines.

Correcting without erasing

As it develops, the drawing undergoes a process of continuous change, to the point that the initial block-in is only an initial reference. The artist should transform the work constantly, increasingly marking the stroke that defines the different planes and forms.

As the drawing approaches its final stages, lines gradually cover previous ones. The process is a continuous correction of forms. The final lines are defined with greater decision than the first ones—this correction does not necessarily have to be done with an eraser.

DELIBERATE CORRECTIONS

In many of the drawings by the great artists, the corrections and repetitions are left in the drawing deliberately, as a practical resource, which gives vitality to the work. These corrections are known as *pentimenti*—Italian for "repentance." These corrections add interest to the work; they express a strange fascination for the unfinished, the sketched, and for the drawing process, as opposed to an interest in finished and detailed work, which appeals to the romantic side of every human being. Therefore, we encourage you not to pay much attention to your mistakes, Instead, draw next to them with more precise and vigorous strokes. Every drawing should be an experimental and changing process, correcting is a fundamental action in this creative process.

In the contour of this figure you can see the superimposed strokes, which resulted from the various attempts of the artist. Notice the detail of the correction, for instance, in the position of the arm.

Drawing with a quill pen is good practice. If you make an incorrect stroke, you cannot correct it; therefore, you will have to draw another stroke next to the incorrect one.

SKETCH AND MOVEMENT

The *pentimenti* are very often related to the effect of movement in the drawing. The sketch impression is considered fundamental to transmit the sense of mobility. The sfumato effect, through which a figure's contours are blurred, is a common resource for suggesting action. This is the same principle of the image that is out of focus in photography. The dispersed mass of the figure gives a vibration and movement effect. The silhouette of the model is not outlined; rather, the model is given an imprecise profile or various overlapping profiles, which indicate the effect of movement. Sometimes, a more loose style, with gestural lines, is more appropriate to suggest action. Long, disorderly, and relaxed strokes, as if capturing a subject's high-speed movement, also produce a certain effect of mobility.

A rapid, vigorous, non-defining stroke helps transmit the impression of movement to a figure.

When drawing very quickly, it is common to make mistakes because the work is a result of a process. Here you can observe how the positioning of the church was finally decided upon..

depth effects

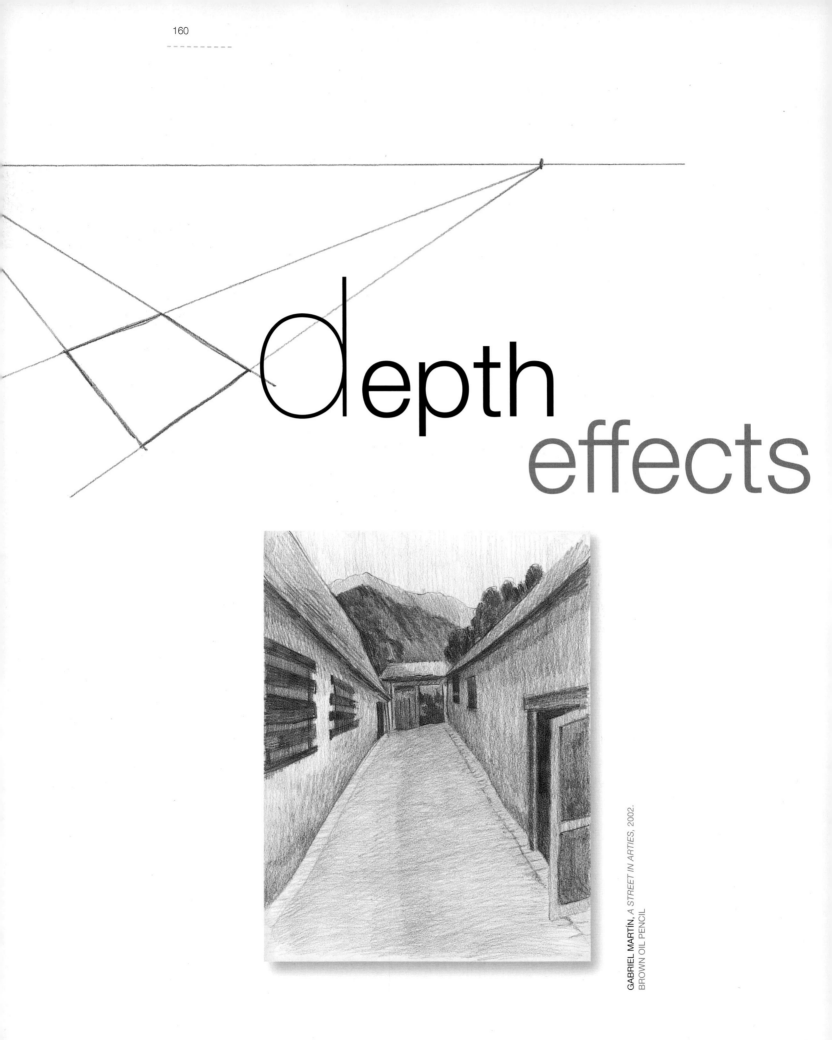

in drawing.
Any object has
three dimensions:

height, width, and depth. However, in drawing the artist only has a flat, two-dimensional surface to work on. In order for the representation to have the appearance of volume, you must follow the principles of perspective. When a model presents difficulties of drawing and if you want to get the most realistic representation possible, you should note in the sketch all the lines that will help better represent its volume: the principles of perspective are very useful to draw these lines correctly. The notions of perspective and learning how to measure will enable you to compose with strokes that will configure the sketch. In this section we will discuss perspective and depth effects, two very important elements.

Perspective:
basic notions

The reality we perceive has three dimensions. To represent this reality on paper or canvas the artist only has a flat, two-dimensional surface. However, appropriately projecting the representation will express depth. Thanks to the basic principles of perspective, parallel, oblique, and aerial, you can create a realistic representation of a model on paper or canvas. Besides being one of the most commonly used formulas, perspective is also one of the most effective in representing depth. You just have to choose the point of view and the composition that will best reproduce the distance effect.

LOCATING THE HORIZON LINE

The first thing to do when drawing a landscape in perspective is to locate the horizon line. This line is very easy to locate: it depends on the position of your eyes when you are looking forward. It is an imaginary line on the horizontal plane that crosses exactly at the height of your eyes. The position of the horizon will depend on the composition and will be a point of reference throughout the drawing process.

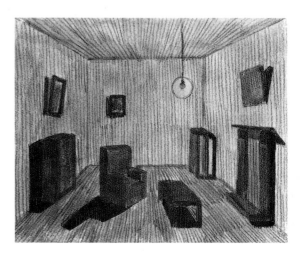

Our surroundings are represented in three dimensions. Some of the simplest objects are polyhedrons formed by four-planed surfaces or more.

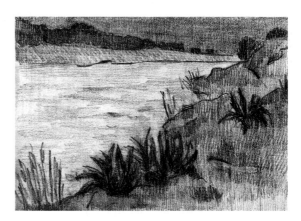

The horizon line is the principal line to be located in the model. After locating it, all the objects are placed in relation to this imaginary line. By raising the horizon line and placing it closer to the top of the composition, you will enlarge the area of the ground included in your field of vision.

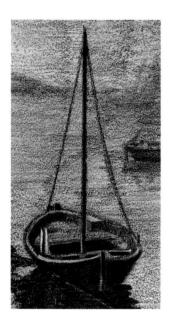

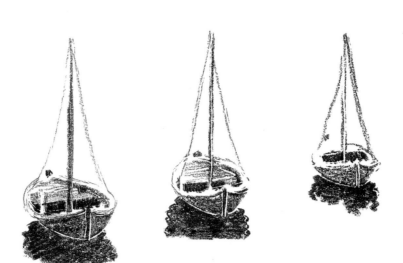

The point of view indicates the perspective of the bodies that appear in it. Some themes are more easily depicted, whereas others require a detailed study of the vanishing points and receding lines.

The more distant an object, the smaller it becomes. The distance effect causes the forms to dissolve progressively, the contours to become increasingly imprecise, and the detail to fade, as the synthesis and abstraction degrees of the object increase.

BODIES IN THE DISTANCE

Depth works by reducing the size of the body's image. As the distance increases, the object becomes smaller until it becomes a shadow abstraction; this is often due to the fact that in a distance effect, the shade is more important than the body. This means that the content of a model should be classified by determining the particular plane to which each object corresponds (foreground, middle distance, background).

The example that best illustrates the reduction of the object size with distance is an avenue bordered with trees. You may observe that there is a reduction not only of the size of the trees but also of the distance among them.

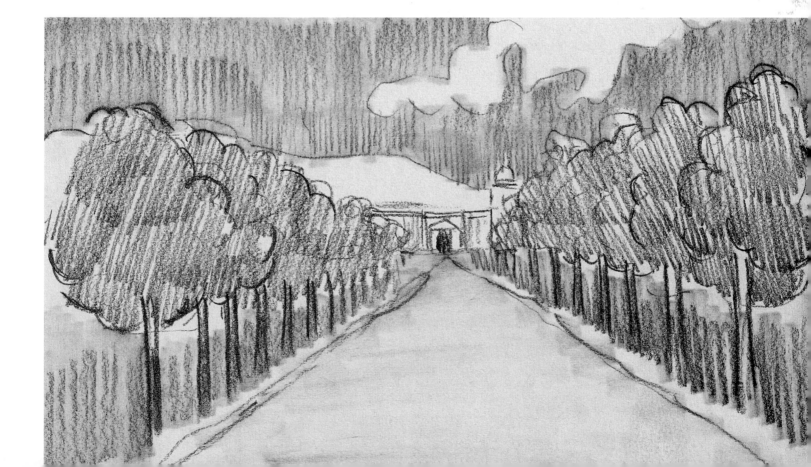

PARALLEL PERSPECTIVE

The parallel perspective of a vanishing point is the most simple one and is used when the objects have a vertical side that almost completely face the viewer. The lines of the sides converge into a single vanishing point. In the frontal view, the vertical lines are parallel, as well as the horizontal lines. In order to find the vanishing point you only have to draw freehand the lengthening of the lines of the lateral sides.

BEGIN WITH A CUBE

The cube is the most useful regular figure to understand the way perspective works. Afterwards, you may project any other regular geometric figure by analogy. From the cube you will be able to develop new forms of perspective. The simplified spherical or cylindrical objects are drawn the same way in parallel perspective. The foreshortening of the circle, if there is one, does not change. A horizontal cylinder in oblique position looks very different from the way it looks when it is vertical. The two parallel lines seem to be approaching each other as the distance increases, receding into a single point (vanishing point) located exactly on the horizon line; this is the case for a road or a path that disappears into the distance.

In urban and rural landscapes it is common to apply principles of parallel perspective to render streets or façades.

We will draw a cube in parallel perspective below:
A. *To develop any simple geometric figure you should first draw the front line that is closest to you.*
B. *Then, link the vertices on the vanishing point located on the horizon line.*
C. *Move the measure that marks the cube's depth.*
D. *Draw some straight vertical lines to finish defining the back profile of the figure.*
E. *You will finish forming the figure by drawing the parallel lines that coincide in their vertices.*

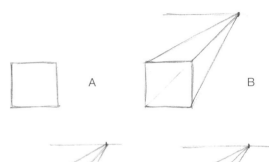
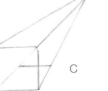
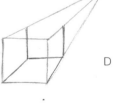
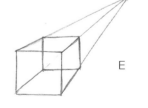

To draw a cylinder you should adapt to the measures of the box or cube. Draw the circles in perspective on the upper and lower sides and draw the border of the flanks.

Now you can see the vertical cylinder. You will just need to lengthen the distance between the two sides of the cube and include the figure inside it.

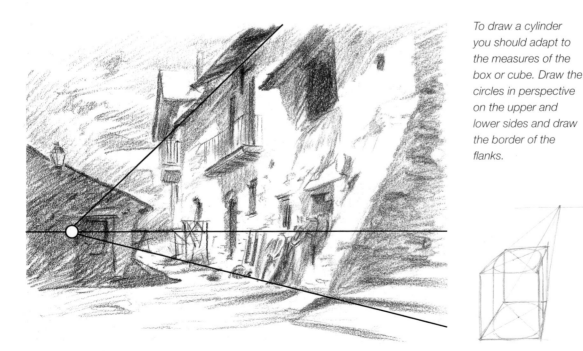

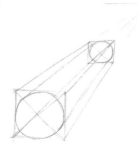

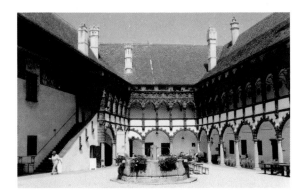

The following steps show how to carry out the parallel perspective from a life model, in this case an old Austrian castle.

PERSPECTIVE IN LANDSCAPES

In general terms, when you draw a natural landscape you don't need to work with perspective, unless there are urban elements that require it. Applying perspective to a landscape correctly is important in order to give veracity to what is observed. Although it is not necessary to make complicated mathematical calculations to be able to draw in perspective, you should keep in mind the vanishing points and the need to reduce the size of the objects at a distance.

1. To draw this model you need to apply the principles of parallel perspective. In order to do this you should begin with a low horizon line, a central cube, and a pair of receding lines that will converge into two points located in the flanks of the geometric figure.

2. From these perspective diagonals you can situate the staircase and the inclination of the roofs. Divide the length of the cube in five equal parts and draw the arches of the upper gallery.

3. The secret to achieve this level of development is to always work with accurate and secure lines and to constantly measure the distances. This will allow you to verify the way the size of the arches and the gallery diminish as their distance from the viewer increases. As you can see, perspective enables the creation of very visually interesting works.

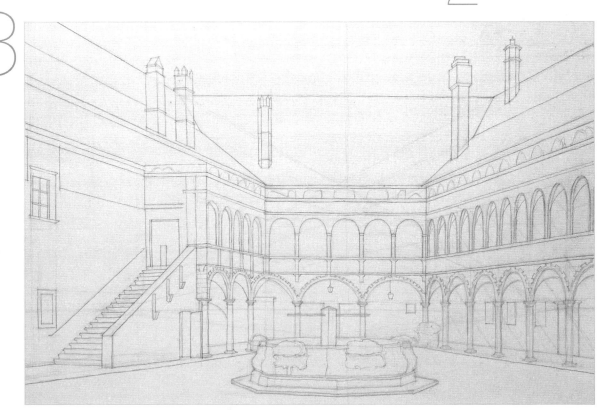

GREATER DEPTH

Oblique perspective produces a greater impression of depth than parallel perspective. It is characterized by having two vanishing points, because the vertical lines are the only parallel ones. The other lines, the non-vertical ones, recede to one vanishing point or the other. The name of this kind of perspective is due to the profusion of oblique lines.

OBLIQUE PERSPECTIVE

There is a sequence to follow in order to develop any simple geometric figure using oblique perspective. First, you locate the horizon line. Taking into account the measures, you should draw the most visible side of the geometric figure. The lines that cross each other in this figure establish a vanishing point on the horizon line. Then, draw the side next to the first one. This side has more foreshortening, although it remains visible. You can also link the lines that cross one another, the ones that locate the second vanishing point on the horizon line.

When you see the façade of a house from a front point of view, the lines of the construction will generally be horizontal and vertical; however, if you observe the same building from a more lateral position, distinguishing several sides at the same time, these same lines will show inclination because of the perspective effect.

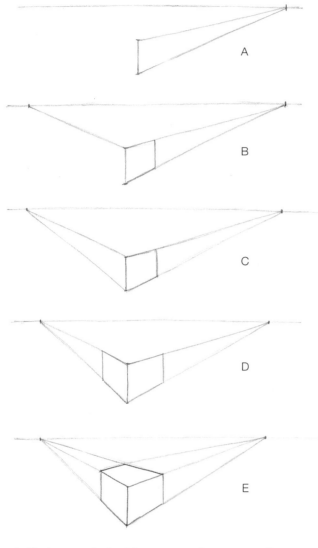

A. To draw a cube in oblique perspective measure the nearest and most visible edge. Then draw the horizon line and link one of the vertices of the edge to the vanishing point.

B. Project a parallel line to the original edge to define one of the cube's sides.

C. Locate another vanishing point in the opposite side and draw the corresponding perspective diagonals.

D. Using the same procedure, raise a third edge to define the second side of the cube.

E. When you draw the final receding lines you will be able to verify if the representation of the cube is correct.

Oblique perspective is very useful when drawing the corners of a building. It gives a solemn appearance to architectural constructions.

You may want to develop a guide, such as the one shown in the figure, for cases in which you need to locate the vanishing point outside the paper.

When locating the vanishing points beyond the edges of the paper, there are various ways to achieve the recession of oblique lines. For example, you can place a piece of packing paper underneath the paper on which you are drawing and use a thread or a ruler to draw and lengthen the receding lines until reaching the vanishing points.

DRAWING WITH A GUIDE

When two vanishing points are very far from each other a guide must be established. You should first draw a bigger box in which the model will be framed, keeping the original inclination of the receding lines. Secondly, you should segment the most visible edge, the vertical straight line in the middle, into equal parts. Then, draw the vertical lines of the ends to create a guide in both sides of the paper. In turn, divide these segments into the same number of equal parts than the main edge. The two series of oblique lines are a guide to draw balconies, windows, etc.

AERIAL VIEW

This type of perspective consists of three vanishing points. Two are located above the horizon line. The third one is located on the vertical line and, therefore, perpendicular to the horizon line. There are three series of lines. Each one converges toward its corresponding vanishing point. The particular characteristic of this type of perspective is that there are no parallel lines. Some aerial views may turn out distorted. The best position is one in which the forms do not become extremely distorted. A low object, for instance, does not look very distorted from an aerial view.

The aerial view consists of three vanishing points. In order to develop it, draw the upper side of a cube in oblique perspective.

Then, drawing a cross from the vertices, find a mid point. After that, raise the vertical line from the center of vision, at the intersection of the medians.

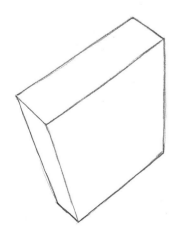

There are no parallel lines in the aerial view. Each set of lines recedes to its corresponding vanishing point.

In the lower part of this vertical, locate the third vanishing point. From this vanishing point you will project new receding lines. The resulting figure resembles a building seen from an aerial position.

drawing with atmospheric
perspective

There is a type of perspective which is not made with lines, vanishing points, or division between spaces, and which also creates a three dimensional effect. This is atmospheric perspective, which is achieved through contrasting and defining the foreground and spreading and fading the background planes. The depth effect and the atmosphere are an optical illusion caused by the water vapor and the dust particles in the air, which partially fade and blend the colors and the forms at a distance. The three dimensional representation through light and shadow effects and the sensation of distance are achieved by using this atmospheric perspective.

In drawings where the three dimensional effect is recreated through atmospheric perspective, the most intense tones are located in the foreground and fade toward the background

When creating the atmospheric effect, the artist's goal will be to work the particles and the water vapor in the air.

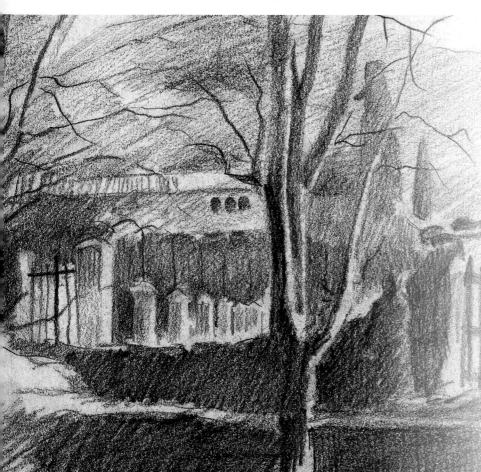

ATMOSPHERE AND LANDSCAPE

This atmospheric effect is stronger in the landscape drawing when you are trying to give a depth effect to the planes that are further from the viewer. The foreground will always be clearer and contrasted than the background planes. As the planes approach the background, they lose clearness and color, and show more blended forms and lighter colors. Having the correct value assigned to every plane of the drawing, you will be able to recreate an atmosphere with greater or lesser density for each, determining, by looking at the intensity of the drawing tones, which range of grays corresponds to each plane. Keep this in mind and try to find this way of establishing the value to emphasize perspective, atmosphere, and, as a result, the three dimensional effect. The best time to find this effect in a landscape is at first light, when the landscape is still covered by a gentle mist and a bluish light.

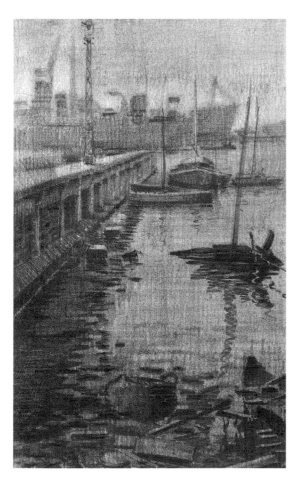

This drawing shows you how to apply the depth effect with grays. Look how the darker blacks appear in the lower part of the drawing, while the lighter ones are in the upper part of the drawing.

THE ATMOSPHERE OF A STILL-LIFE

Consider that, when looking at an object at a short distance, your eye immediately focuses on the object and takes out of focus all the bodies that surround it that are not at the same distance. When drawing a still-life, try to follow this logic: draw relatively clear, sharp objects in the foreground, with less precision in those behind it. You may also create gray tonalities of the still-life with an eraser or simply with a blending stump; the goal is to create the atmosphere through the subtle difference among the planes.

The depth effect by atmosphere is summarized in this figure: A shading that fades gradually toward the top of the drawing.

In this atmospheric still-life, less importance is given to the planes in the back of the apple; this effect produces a separation in the atmosphere of the two established planes.

a contrasted foreground

Emphasizing depth by means of a contrasted foreground is one of the classical formulas to represent the three dimensional effect. Placing in the foreground any object of known proportions and dimensions—such as trees, cars, or boats—the viewer will be able to compare the dimensions of the object in the foreground to the objects in more distant planes, unconsciously establishing the distance between what is near and what is far, that is, the depth of the drawing. Instinctively you can compare the size of the distant forms, especially if their size is recognizable, as in the case of an animal or a human figure. You can introduce variations with objects of various sizes or play with the distances among them. In order to emphasize the theme, you can heighten an element in the foreground, which will produce a strong visual impact and give additional interest, as the depth sensation is enhanced.

With a contrasted foreground you can increase the depth effect, since the viewer will instinctively compare the size of the foreground element with that of the background elements.

A detailed foreground near the viewer will provide interesting compositions, resembling those of a photograph.

DIFFERENCE IN LUMINOSITY

In a still-life, a portrait, or a figure, you can identify foreground objects by just selecting a single background on which the objects will stand out. The effect of the so-called *repoussoirs*, which are elements of considerable size placed in the foreground to make the background look more distant, will be reinforced in landscape drawing if, in addition, there is a strong difference of luminosity between the foreground and the background.

LOOKING FOR A FOREGROUND

When drawing a landscape outdoors, try to find a point of view in which you can situate a distinctive foreground: a tree, a hut, a hayloft, etc. In case there is no tree in the foreground, you may can apply the formula of the English landscapists from the end of the 18th century; these artists represented the third dimension by drawing some bushes, rocks, or blurry edges in the foreground without definition, as if the objects were out of focus.

You can see the difference between these two photographs. The one on the right is, without doubt, more interesting, since it includes a distinctive foreground, which gives greater depth effect and variety to the composition.

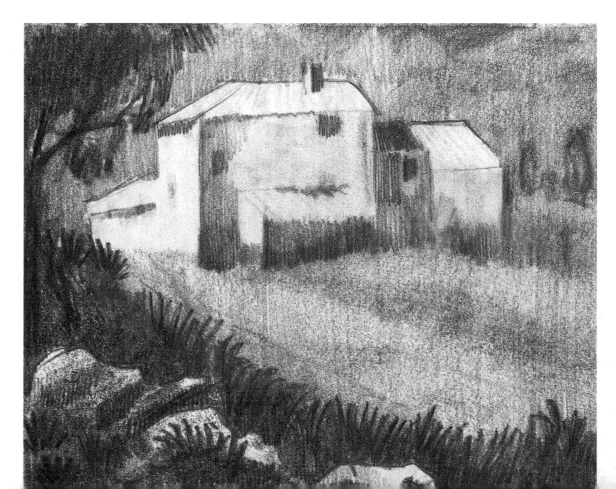

A distinctive foreground is more effective if the drawing also has a difference in luminosity; the result is a strong contrast between the object in the foreground and the background.

To draw wide strokes, just hold the pastel with your thumb or index fingers, using the latter for support.

Pastel enables the artist to outline a drawing from the beginning, just like any other medium. However, according to the way it is applied, this material, which is both luminous and opaque, may be used only as part of the process or as part of the media involved in rendering the final result. The point, line, and shading are the most commonly used methods with pastel.

conventional techniques
with pastels

STROKES AND LINES

The linear and dry stroke of pastel enables you to outline a profile, although it can also be used repeatedly to apply color to a space. The strokes can be juxtaposed or superimposed to represent hatching. If the blended colors give more depth to the composition, the line and stroke control makes it comprehensible to the viewer, by unifying and harmonizing the composition. They give texture and "touch" to the materials. The direction of the stroke helps explain the theme as much as possible. For instance, if you draw portraits or figures, given the cylindrical or spherical tendency of the model's volume, the stroke should be enveloping; for example, it should be vertical in a wheat field; irregular, like doodling, in a dense forest ; and undulating and sinuous in flowers. If you are able to achieve a well-rendered stroke for the model, the work will have an enhanced sensation of volume.

Tonal ranges can be achieved through overlapped strokes. The more strokes you draw, the darker the tone. Tone ranges can also be achieved by superimposing hatchings. The denser hatching will correspond to the most intense tones.

The stroke will be as wide as the contact surface of the pastel and the paper. The degree of contact will depend on the way you hold and drag the stick.

The detail of the paper surface will remain visible in a soft shading; the more intense the shading, the more it will cover the surface.

THE OPAQUE STROKE TECHNIQUE

Given the ability of pastel to cover the paper, the technique of opaque strokes involves superimposing various strokes without mixing, blending, gradation, or sfumato. In this technique, tonal blendings are produced by adding opaque and dense strokes, covering an initial color with the same thickness. Therefore, one of the main characteristics of this technique is its ability to draw a dense stroke. The stroke becomes visible, the color fusion is achieved through superimposition, and the color density produces more brilliance and contrast among the various areas. In order to apply this technique it is necessary to make the strokes directly onto the paper, using the appropriate color for each case if possible. Keep mixing and blending to a minimum. The resulting opacity makes it easy to work on tinted or colored papers, enabling you to alternate the use of tonal values and to add opaque strokes that will blend them.

THE TONAL STAIN

The tonal stain is made by varying the amount of pressure exerted on the pastel. The most intense tone is produced with greater pressure or superimposing shadings. For lighter colors you just have to reduce the pressure. The shadings are usually made with the longitudinal part of the stick, and they express the shadow zones or values, which will give the volume effect to the object.

It is important to know how to differentiate stroke from coloring. The stroke always follows one direction, while coloring covers a zone with color.

The technique of opaque strokes utilizes a pastel's ability to cover the surface. This technique is characterized by a juxtaposition of directional strokes, which will give vivid colors to the composition.

For wide shadings, hold the pastel with three fingers and apply the color lengthwise.

The technique of opaque strokes preserves a color's impact and purity. Blending tends to smudge the colors.

COMBINING LINES AND TONES

When combining lines and stains avoid using both to express a single form. For instance, if a stroke or series of strokes expresses the form of an arm with energy and visual grace, it would not be advisable to add shaded stains or anything else, because that would make it difficult to explain what has already been expressed through strokes. The same applies to a drawing made only with shading; finishing with a continuous line will be redundant and the result will be a solid, heavy mass and a lack of lightness.

HATCHING GRADATION AND BLENDED GRADATION

Practicing these techniques will allow you to create gradations with complete tonal ranges. The hatching gradation is made on coarse paper or with linear strokes, letting the white of the paper remain visible through the strokes. The general appearance will be soft, to prevent the shading from covering the paper's tooth completely. If you want to create a blended gradation, juxtapose the two colors to be gradated, pressing strongly against the paper to make either a shading or a stroke. When a gradation between two colors is blended, the movements of the fingertip will produce very different effects. When blending a gradation, a lot of attention should be paid to maintaining the direction of your fingertip while gradually passing from one side to the other. In addition, different effects will result from blending a light color to a dark one and vice versa.

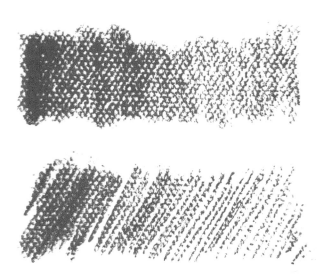

Gradation through coloring is obtained by gradually modifying the pressure you apply. In stroke gradation the drawing pressure is alternated progressively.

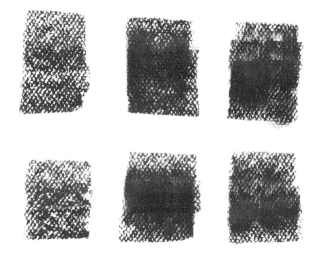

By combining stains and strokes in the same drawing you will obtain graphic variety and a rich modeling in the work.

With dry gradation you can let the white of the paper be visible; it produces shadings with a granular appearance, which allows two or three different colors to be superimposed.

A dense blending allows you to cover any area of the paper, even when it is colored paper.

BLENDED DRAWING

Blending modifies the appearance and texture of a color through smudging and dissolving the surface. This will turn the paper into a layer of fine and semiopaque color. Besides giving depth to a composition, blending also fulfills the artist's need to smooth contrasts and unify colors from various zones of the work.

To make a gradation, first apply a color. Then with a superimposed zone, apply the second color. The two colors are blended until the dense transitions between them are achieved.

To blend strokes or a shading, rub a cotton ball against the pastel. Pastel's volatility enables you to extend and blend it until it has almost disappeared, which is a very popular method for this medium.

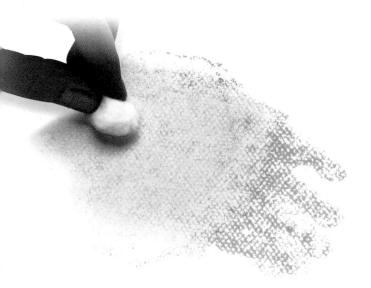

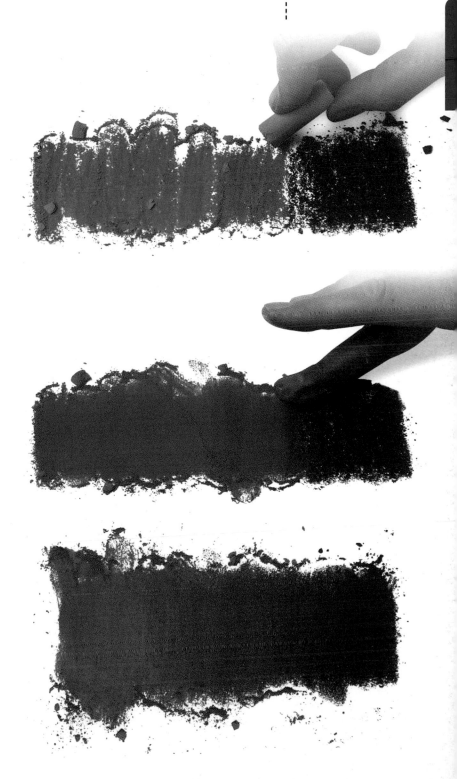

how to Mix
colors

One of the most attractive characteristics of pastels is their ability to mix with different colors to produce soft and velvety tonalities, as well as subtle gradations from light to dark. The artist's personality is reflected in his work, the material used, and the way he or she mixes colors.

MIXING WITH STROKES
Superimposed mixtures of pastel hatchings produce the so-called "optical mixtures." The eye, from a certain distance, establishes the mixture between the strokes of both colors. If you want to crate a zone of tonal mixture, draw soft random strokes with the tip of the pastel or use it on its flat flat to draw wide strokes; do not apply too much pressure because if the pigment adheres too much to the support's surface, the mixture will be more difficult to make.

When working with three or four different colors at the same time, place a piece of cotton cloth on the table. This will protect and isolate the surface, and can also be used to clean the colors that have come in contact with other colors.

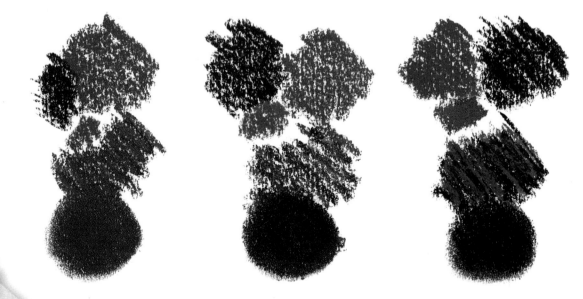

The blended mixtures where more than two colors have been mixed look dirty and imprecise compared to the corresponding manufactured colors.

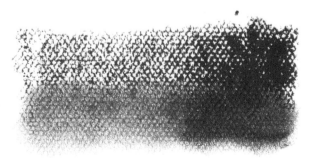

Through blending you can reduce the width of the pigment layer and smooth the color contrasts on the paper.

In order to measure the amount of each pigment involved in the mixture, control the amount of pressure exerted on the pastel and the size of the area being colored. After that, proceed to blend the tones.

Even though you may have the habit to store pastels in a safe place, they break as you work with them. You can take advantage of their fragility: keep the little pieces so that you can make powdered pigment and have pieces of various sizes available.

TONAL MIXTURE

To create a tonal mixture, draw a series of strokes with the tip of the pastel, exerting little pressure, with the two colors you intend to mix. Then, rub gently with your fingertip the painted surface to obtain a uniform color; this way the mixed colors will be equivalent to a pictorial background, which gives a greater depth effect and subtlety to the drawing. To measure the amount of each pigment involved in the mixture, you should control the pressure and the area of the surface being colored.

BLENDING

Blending is the action of rubbing two juxtaposed or superimposed colors with your finger or a blending stump. The goal in blending is not to extend the color or blur the contour of the coloring, but to merge the powder of the colors. Blending can be applied to gradations. Blending keeps the intensity, while softening the color or tonal changes in the mixture.

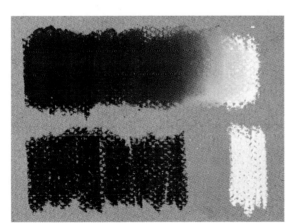

When blended, gradation displays a more gradual tonal transitions.

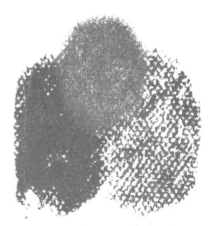

In order to blend two tones, rub the colors with the tip of your index finger until they mix.

colored Pencil
techniques

The characteristics of colored pencils allow for the combination of some of the basic resources of drawing and the polychrome effect in a single work. With a good knowledge of the material and an appropriate technique, the expression possibilities of this medium are ideal for practicing, exploring, and discovering the nature of color, its combinations, harmony, and variations.

A MORE LINEAR DRAWING

The characteristics of colored pencils enable you to develop some of the most basic techniques of the linear stroke. The weight and width of the line, its fluidity, its experimental character, and its possibilities of being continuous or discontinuous produce effective optical illusions in a drawing. Besides the fact that it is the most elementary form of drawing, linear drawing is the basis of all the other techniques.

Before beginning to draw, the first step any beginner should take is to explore the variety of possible strokes and familiarize him or herself with them. This can be done using the sharpened point of the pencil (for fine strokes) or the side (for wide strokes). Purely linear drawing is the most difficult approach: the artist must render the colors, tones, and textures of the subject without creating shadings or tonal gradations. A skillful artist is able to describe, with a single line, all the possible visual strokes for a drawing.

A purely linear approach is the most difficult approach to use in a drawing. At the same time, it is the beginning of any work.

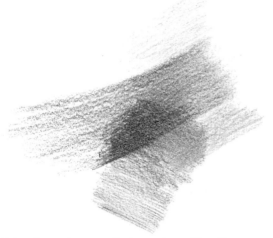

Colored pencils use optical superimposition. The different tonal variations are achieved by superimposing new scumbles to an initial color.

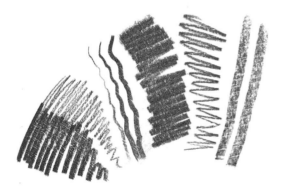

In order to master the techniques of colored pencil drawing, first experiment with the stroke, the degree of pigmentation of the pencil, and the hardness and shape of the point—whether it is sharpened or wedge-shaped.

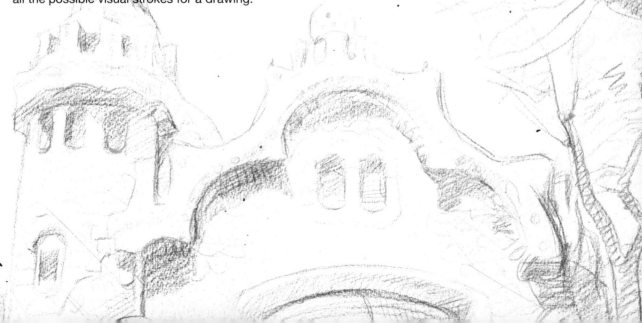

COLORING FROM LIGHT TO DARK

The colored pencil technique is based on progressively intensifying tones, hues, and contrasts and on superimposing color layers, that is painting from light to dark. This will result in a more efficient control of values and tendencies. Otherwise, the paper surface will rapidly become saturated, making it difficult to overlay colors. Besides scumbling, you may also use hatching or cross-hatching.

THE AMOUNT OF EACH COLOR

Each color may have one or more tones. These values depend on the amount of pigment that is applied onto the surface, which will constitute the amount added to the mixture. A small amount of color should be added for scumbling or for applying tenuous layers, whereas the first shadings should be more intense and opaque.

SHADING WITHOUT STROKES

In order to obtain homogeneous shadings, try to choose a direction and maintain it while drawing. Each stroke is drawn next to the preceding one, exerting the same amount of pressure at all times. This will produce a homogeneous shading. When the area to be covered is large, the color should first be applied to a small zone. Another adjacent coloring should be added afterwards and so on, trying to hide the borders of the zones.

A modulated line shows shifts of width, which are achieved by turning the pencil in a controlled manner.

The most common technique in colored pencil drawing is to always draw from light to dark, beginning with very soft shadings and finishing with the most intense and contrasted colors.

Shading with spirals provides a very homogeneous result without color changes. This allows you to return to the drawing at any point without creating scales or sudden changes.

The continuous superimposition of colors gives colored pencil drawings tonal gradations without sharp color changes, as well as an attenuated atmosphere.

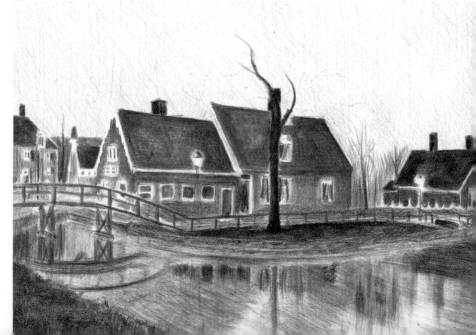

mixing with hatching:
the optical effects of color

Pencils are the ideal tool to create hatchings. There are many ways to establish the right type of stroke or hatching, depending on the goal to be achieved in a given drawing. It is possible, in a single composition, to use various hatchings and to alternate them with shadings and colorings. It is advisable to practice hatchings since each type gives a different appearance to the drawing. The mixtures with hatching are different from uniform shadings in that in these mixtures the strokes of the pencil point are visible. Superimposing a hatching mixture with two different colors creates an optical mixture between them. Drawing different-colored lines next to each other or superimposing lines at right angles will create the illusion of a third color. As mentioned before, a mixture produced by stroke hatchings is mostly optical, which means that if the viewer is standing at the right distance, the retina will create the mixture.

WHICH COLOR SHOULD BE ON TOP?

When using colored pencils, applying a first color and then a second one on top produces a different effect than applying them in the reverse order. The order greatly influences the result. This is due to the waxy consistency of the colored leads, which turns the first layer into a resist for the following layers. If you superimpose a light color on top of a dark one and vice versa, you will see that the resulting mixture will be different.

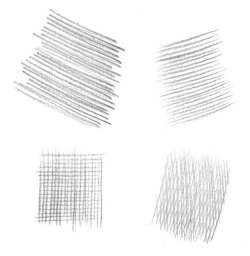

Above are a couple of examples of hatching and cross-hatching. The succession of strokes turns into homogeneous shadings when viewed at the right distance.

Colored pencils allow for many possible mixtures; the two most common ones are superimposing very soft color layers, avoiding to cover the tooth of the paper completely, and crossing strokes of various colors.

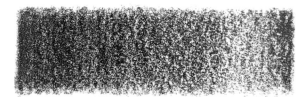

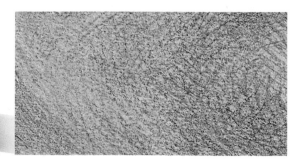

Above is an example of cross-hatching. Cross-hatching is one of the most common forms of hatching in linear drawing. The inclination of the lines and distance between them determines the intensity of the shading.

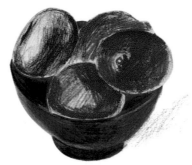

The color should be added progressively, trying to let it breathe by leaving some white zones of the paper free of color. The scumbles allow for a very subtle, low-contrast work, which produce very high color quality.

The pressure exerted with the pencil will determine the tone.

COMPOSING WITH SCUMBLES

Working with scumbles may be a long process, given that this technique involves the gradual depositing of the color on the paper. It is important to exert little pressure on the pencil in order to avoid saturating the paper. Similar to using watercolor, the secret of scumbling is to take advantage of the white of the paper. Instead of applying dense layers, you should darken the colors gradually, allowing the white zones of the paper to be visible through the hatching.

WHITE ON DARK

The positive effects of working on a dark background can be seen in this example. Colored pencil drawing acquires interesting plastic connotations when it is appropriately combined with a dark background; the highlights look more intense and the chiaroscuro effect is enhanced, showing an interesting range of luminous and expressive connotations.

POINTILLISM

Pointillism is a technique in which the colors are applied onto the support in the form of small dots of pure color so that, when viewed from a certain distance, the reflected light in each of the individual dots blends in the eye. When using colored pencils to apply this technique, you can obtain a great deal of brilliance and luminosity, in addition to an interesting atmospheric effect.

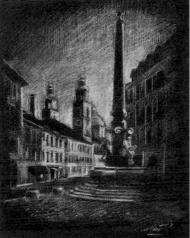

Drawing on this type of background with light colors is traditionally related to the chiaroscuro effect, in which the contrast between the totally or partially illuminated objects and the dark-colored background is heightened. The final result is a blended and vaporous drawing, in which the light effects illuminate the atmosphere.

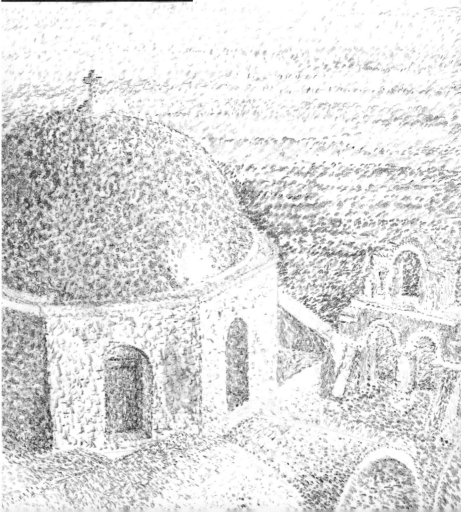

Applying the pointillism technique using colored pencils is an interesting exercise and offers excellent and very surprising results to the beginning artist.

Feathering and whitening are perhaps two of the most interesting, complementary colored pencil. While in feathering the goal is to achieve harmonization and obtain atmosphere through the stroke, whitening gives luminosity to the color by lightening the colors with superimposed layers of white.

feathering and Whitening
techniques

FEATHERING

Feathering is a method in which a soft drawing is made on an area covered with a different color with gentle, juxtaposed strokes, always in the same direction, to achieve an atmospheric effect and harmonic rhythm and direction. In this technique, delicate directional strokes are drawn over the subjacent color, with a loose wrist and exerting little pressure. This technique is ideal for intervening with colored pencils on a monochrome drawing, smoothing pronounced margins, and creating smooth light and shadow transitions.

The feathering technique is based on the juxtaposition of short and directional strokes, which give a characteristic texture to the drawing.

A CHARACTERISTIC APPEARANCE

With this technique the drawing surface presents a very characteristic appearance, reminiscent of a feather—hence its name. The accumulation of vertical strokes modifies the basic colors, producing subtle and dull mixtures. These mixtures are sometimes similar to those of impressionist artists like Degas, who often used this method in his pastels. As the whole surface of the drawing shows a tonal range of the same intensity and the same vertical stroke, the work acquires greater harmony. The feathering stroke also suggests dynamism, movement, and a vaporous effect. In the figure you can see a vertical feathering which contrasts interestingly with the horizontal emphasis of the sleeping figure.

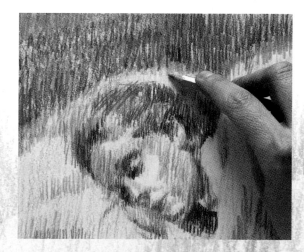

After the first tonal values have been applied, more colors are added, covering the whites of the drawing completely except for the zones with maximum luminosity.

In the feathering technique the accumulation of strokes modifies the basic colors, producing a clear dividing effect of color.

First render the drawing with tonal techniques; then you may apply the white strokes, saturating the paper tooth.

With whitening you can obtain creamy, pastel-like tones, whose texture will be very different from that of the direct colors. It will cause the tone to become lighter and the color will acquire a different quality.

WHITENING

Colored pencils, due to their physical consistency, have a particular characteristic: they allow for the blending or softening of strokes by adding light gray or white on top of other colors. This gives the drawing a more harmonious appearance and a softer, less contrasted chromatic effect.

The whitening technique consists in polishing, balancing, and mixing the colors on a surface covered with shadings by only rubbing them with a blending stump, a white pencil, or an eraser. Besides the combination of colors, this process makes the pigment particles finer and gives the drawing a glossy, brilliant finish.

WHITENING THE TONES

The best way of whitening is to apply the white color intensely on the shadings, which causes the initial colors to look duller, more pastel-like that is with softer and less saturated tones. The strokes are blended with the white pencil and the effects of the paper texture disappear. It is not necessary to completely cover the paper's surface with white tones; you may also obtain gradations from more vivid, intense colors to more whiter, lighter ones. When using this technique, be aware that the paper can break easily because of the amount of pressure exerted on it.

If you apply successive color layers and whiten each layer, you can create a very soft, marble-like surface

scratching and Sgraffito

Drawing with colored pencils on a previously engraved paper is an ancient procedure used by illustrators and one which many art professionals are beginning to use again. When applied on a previously engraved paper, the colored pencils produce a very unique result.

COLORED PENCILS AND SGRAFFITO

The sgraffito technique with colored pencils is depends on the impression that is left by paper's texture. First you will use a metal lancet to scratch the paper and draw an invisible drawing on the paper surface. Then you will create a soft shading, without applying too much pressure. The shading will remain intact and a scratched white line will appear through the color. When applying sgraffito on the surface of the paper be careful to not tear it, so if a lancet is not available, do not use a very sharp tool. If you intend to use this technique regularly you can have lancets of various widths or custom-made lancets in order to have a better control of the results. In order to mark straight lines you can use a metal ruler, since the lancet would damage the edge of a regular plastic ruler.

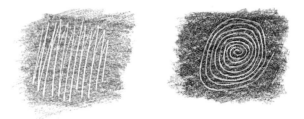

Above are two examples of sgraffito with colored pencils. In the first example the sgraffito has been applied directly on the paper, hence the white color of the line. In the second example the sgraffito has been applied to a tonal background, which resulted in a yellow line.

These graffito examples were created by eliminating part of the color layer with a metal lancet—you could also use a nail—to produce a lines with different graphic effects.

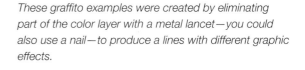

In these examples of colored sgraffito, oil pastels and various colors were rubbed so that the stroke of the line would change color with the successive strokes.

The sgraffito technique offers several practical applications when applied with waxes. In this case any instrument can be used to produce the white marks, even nails.

SGRAFFITO

The sgraffito technique consists in producing a layer of impasted color and then scratching the surface with a stylus. Oil pastels, because of their waxy consistency, are very good to use for this technique. Each scratched stroke will remove the upper color layer, which easily comes off, uncovering the first layer color and allowing it to be visible. In the sgraffito technique any sharp tool may be used to create a great variety of lines, from dense scratches to fluid and thin lines.

COLORED SGRAFFITO TECHNIQUE

This is a common technique when drawing with waxes, which offers spectacular chromatic results. This technique consists in drawing various superimposed layers of dense and thick color and using a sharp tool to scratch lines through the color areas to reveal the colors and paper underneath. Dark colors are usually applied over light colors.

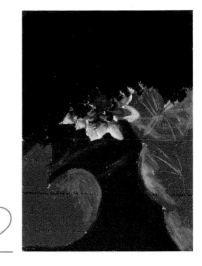

1. In order to use the colored sgraffito technique with waxes you should first create a very basic outline of the drawing. You should avoid adding details, because they would end up being covered with the dense wax layer.

2. Then with bright-colored oil pastel, cover all the model's zones with thick stains—do not worry about defining them. After that, cover the initial color outline with a thick layer of black wax. Only use enough pressure to cover the surface fully.

3. Now you can scratch the black layer with a lancet or sharp tool to uncover again the underlying colors. Remember to control the direction of the stroke to achieve the desired effect. The darkest zones will remain intact.

drawing a ∩ude
in charcoal

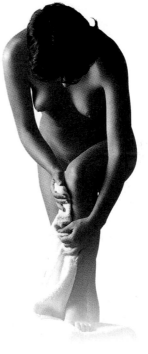

Even though charcoal may seem like an extremely messy drawing medium and one difficult to control due to its powdery characteristics, its ability to reflect tonal gradations is so great that this technique is worth learning. Charcoal is difficult to manipulate in small format drawings, so it is better to work on a large sheet that is mounted on a rigid support. Here the model is a female nude with interesting light and shadow contrasts, partially illuminated from the front with chiaroscuro effects. In this exercise, presented by Carlant, use the charcoal's point to perform the fine strokes, the charcoal's flat side to introduce the large tonal areas, and your fingers to create the various tonal intensities.

1. The two initial outline sketches are created with the model's forms correctly proportioned and the model's contours defined. To start, do a couple of quick sketches while observing the mode. In these sketches try not only to register the form of the figure but also to capture the pose correctly: an oval for the head, arched lines for the height of the shoulders, the position of the arms, and the support of the legs. In the second sketch, pay attention to the blended shadings and the light on the model.

A good aid in drawing a proportioned figure is to establish a relation between the different parts of the body through geometric forms.

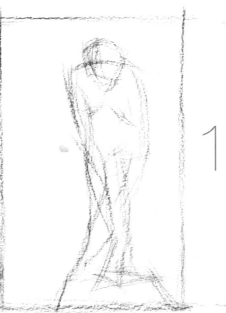

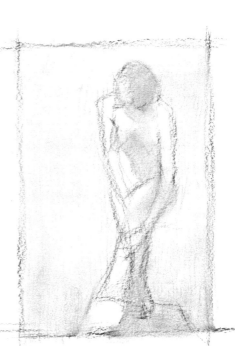

1

2. Place the forms in their correct proportions and reaffirm the contours, working linearly and schematically. Then create the principal volumes. The drawing should be very linear, concentrating basically on the contours of the figure with firm strokes. You should be able to see the figure in terms of simple forms that relate to each other.

Erasing is common when working with charcoal. In most occasions, you erase to specify the form.

3. Emphasize the profiles of the model's anatomy with the end of the charcoal stick, describing precisely the forms of the members. To analyze the pose better, draw a series of lines: the diagonal on the breasts is an indication that there is a slight inclination of the body towards the right, which means that one of the shoulders should be in a higher position than the other. The proportions should be carefully established since they are fundamental to the correct equilibrium of the figure, especially with figures that are standing up.

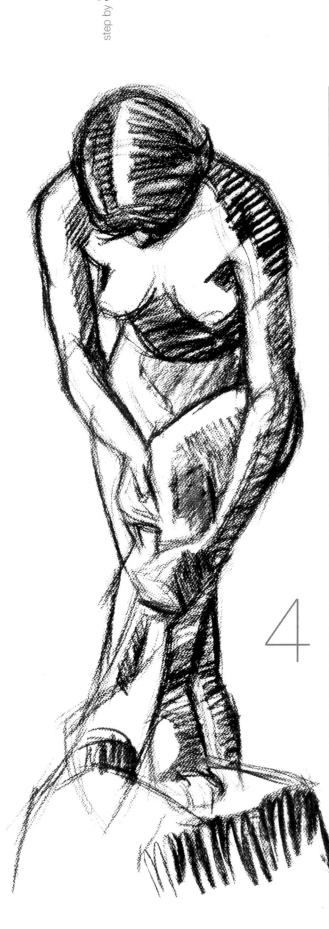

4. With the end of the charcoal stick, block in the shading, all with the same intensity, filling in and clearly delimiting the main shadows. Make sure that the relief of the forms takes on the appropriate aspect. The lighter parts of the model's skin should be completely void of any strokes. The profiles, drawn with thick strokes and reinforced with the shadowed areas, give the figure a solid construction. If at the beginning you have defined two basic light zones, you should now reaffirm these zones until they are exactly right. The most effective technique for achieving mid tones is blending and mixing the intense strokes from the previous step with your fingers or a blending stump. The light and shadow zones are well indicated, which facilitates the modeling. You achieve the modeling for the most part through the gradation of tones.

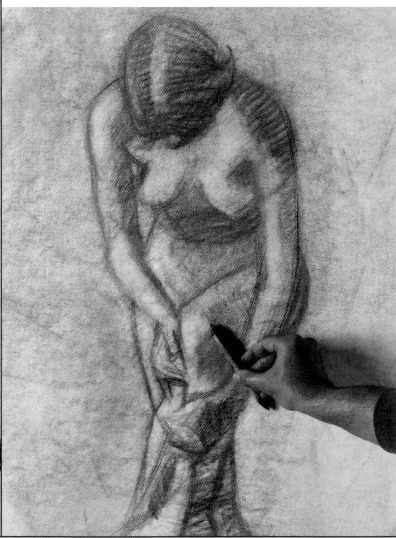

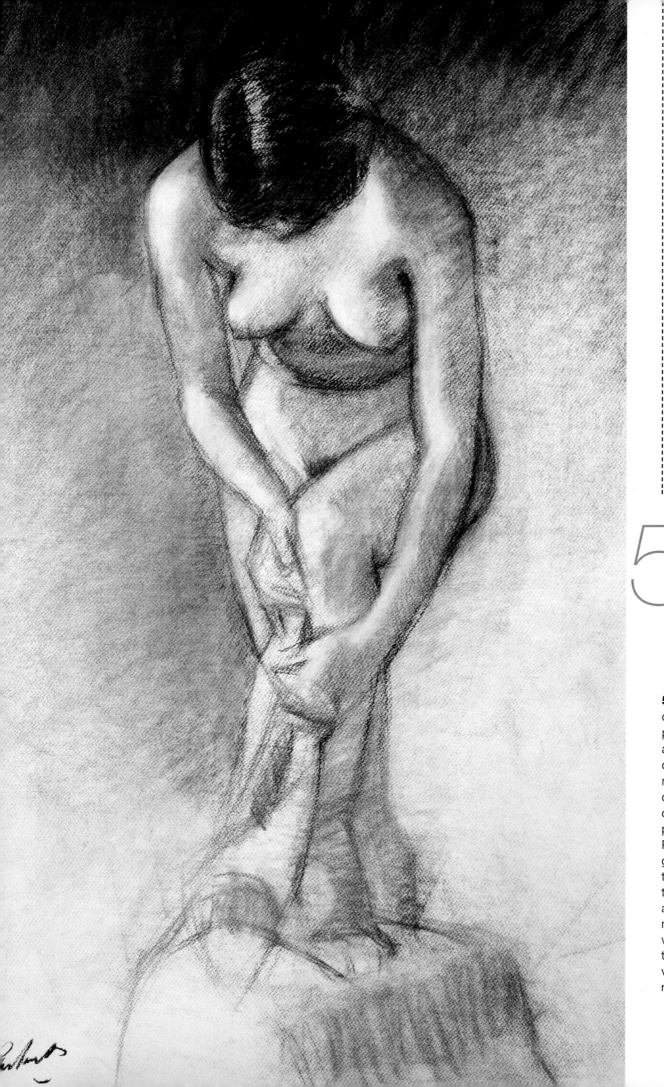

Many people tend to make the upper part of the figure too large, failing to notice that in the classic canon the head represents approximately a seventh part of the model's height and that the height of the legs equals half of the body.

5

5. In this phase we complete the processes of adding and eliminating charcoal, and of modifying the model's contours so that you can create more precise forms. Proceed making gradations of various tones and intensifying the shadows until you achieve a good modeling effect, which will contribute to defining the body's volume and roundness.

a Still-life
with sanguine

Sanguine is a very interesting monochromic drawing medium. It has a wide range of tones, but because of its color, it is much softer and warmer than charcoal, providing more luminosity to the drawing. In this exercise, carried out by Mercedes Gaspar, giving relief to a still-life by using the modeling technique with sanguine is illustrated based on gradating and blending. Pay attention to the changes of direction in the lights, shadows, and reflections, since, as you know, these factors describe the object's form and curvature.

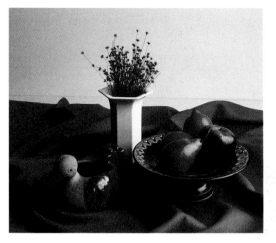

1

1. First sketch the basic forms of the model with a blending stump that is saturated with sanguine. This is the perfect medium to describe form without worrying about details, staining the paper, drawing profiles, and looking at the object's size and angle. Drawing with a blending stump also has the advantage of being easily erasable.

The beginning of the drawing requires careful hand movements and strokes. Even a form as simple as an apple or a dish should be drawn with a great deal of attention and with the least number of lines, since any small irregularity will be immediately visible. You have to concentrate on the contours, erasing and redrawing them if necessary until they are suitable.

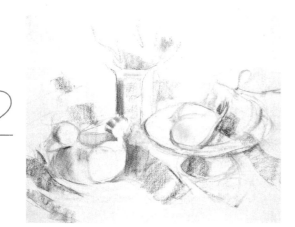

3

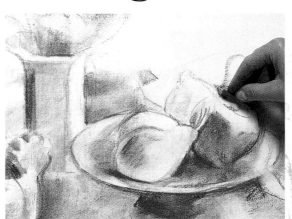

When modeling with sanguine, it usually extends past the object's outlines. If this happens, simply erase the lines or strokes and profile the drawing again.

2. With the sanguine stick on its side, block in the shadowed areas. The first shadings should only be blended lightly; they should simply separate the different planes within the drawing. Do not place any stains on the more illuminated zones. Afterwards, rub your finger on the contours to fade the stroke's profile on the paper.

3. After the blocking-in is completely developed, you can start to add the mid tones and model the forms with tonal gradations and blending. With the sanguine, draw softly and insistently on the more intense zones.

4. Blend the shadings and the initial strokes to clearly define the contrast between light and shadow and also to make each one of the drawing's component's form and texture stand out. As you can see, the modeling does not appear heavy, but rather light and atmospheric, thanks to the sanguine color.

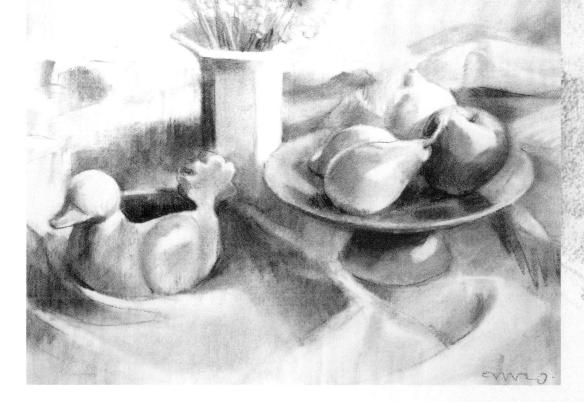

You now will draw, with the erasure technique, a rural scene outlined by Ester Llaudet. The only difference between this drawing procedure and others is that you erase the strokes instead of adding them. Look for the illuminated zones and erase the background shading to obtain lighter tones, or even pure white. The model is an interesting rural view. Drawing with an eraser is especially needed when the theme presents chiaroscuro contrasts.

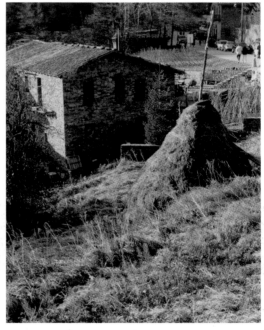

erasure technique:
drawing highlights

1

1. Prepare the tonal background by covering the paper evenly with charcoal shading, using the stick on its side. It is important to work the whole plane at the same time if you want to obtain a homogeneous background. Then, rub the surface with a blending stump to eliminate any traces of strokes.

2

2. Draw a very synthesized contour of the model's forms, being careful not to apply too much pressure. Pay special attention in this phase of the drawing, since the next steps will be based on these results. Avoid excessive erasures.

3

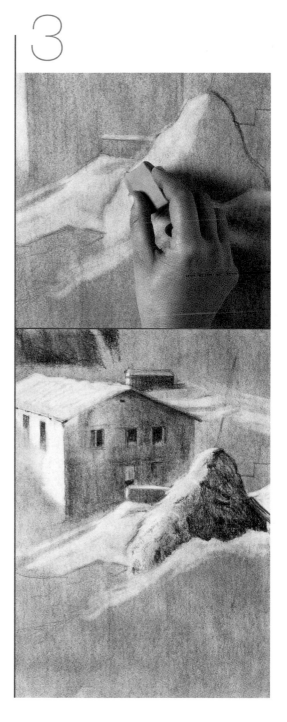

3. The advantage of working with an eraser is that the light is integrated into the image from the very beginning .You can add and erase tones until they are adjusted in the image. The erasures will be the light zones; the background color will be the mid tones; and the charcoal will be the dark zones. Shading will stand out more if you apply it by using the side of the eraser.

Using a piece of paper as a mask lets you obtain straight borders.

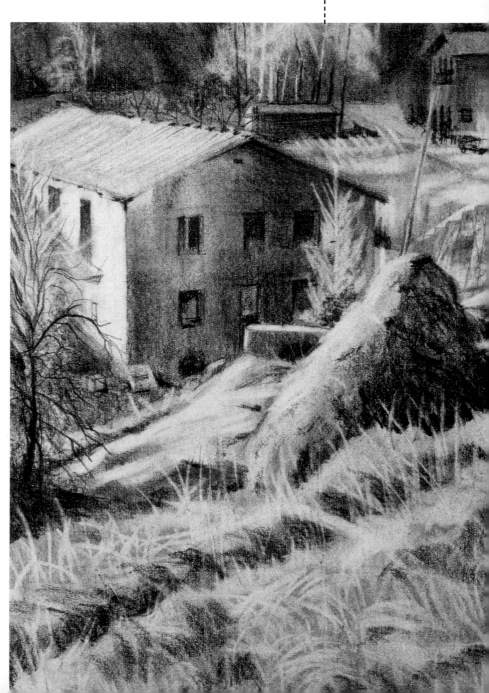

4

4.The final result is a vivid and interesting composition. To obtain the texture of the vegetation, vary the angles of the eraser strokes or even cross them over one another.

a landscape
on gray paper

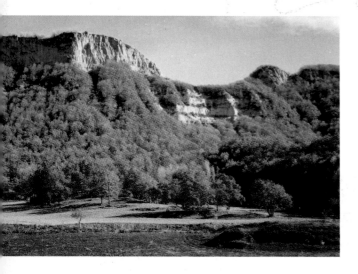

In this next exercise by Gabriel Martín, shading and white highlights are combined to give volume to the trees and mountains. The texture of the landscape's elements will vary according to their distance from the viewer: the farther away the trees are, the more uniform their texture will be; the closer they are to the viewer, the more detailed they have to be. This is not a drawing with a realistic character; its interest lies in the composition and the study of the light.

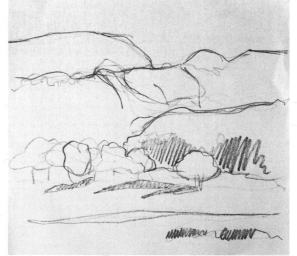

1. The main elements of the landscape are defined with simple strokes, made with a black oil pencil. The sizes and proportions are then determined and the composition is laid out. This first phase of the drawing is extremely important, since it deals with arranging the elements correctly in order to balance the picture. When you decide that the location of each plane is correct, reaffirm the forms with more definite strokes.

1

2

2. Block in the shadows with short strokes, varying their intensities according to their zone. In this phase it is not important to create extremely intense dark zones; it is much more important simply to establish each dark zone. The darker areas are achieved by superimposing the same stroke as many times as needed until you obtain the desired tone.

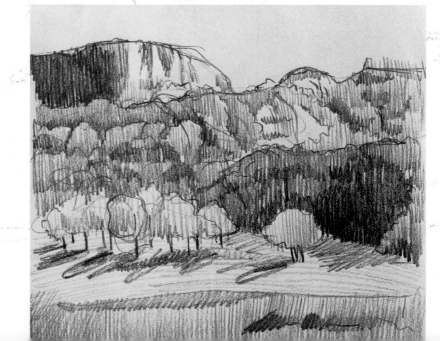

3. Finish the drawing by using a white pencil to highlight the illuminated zones in the landscape. Instead of studying the details and nuances, break down the landscape into light and dark zones that are combined and juxtaposed. The white highlights play a fundamental role in defining the foreground's texture. The result is a landscape with its most significant elements clearly emphasized.

When you superimpose white strokes on top of black strokes, they may get messy. You should take into account this factor when drawing on a saturated shading.

3

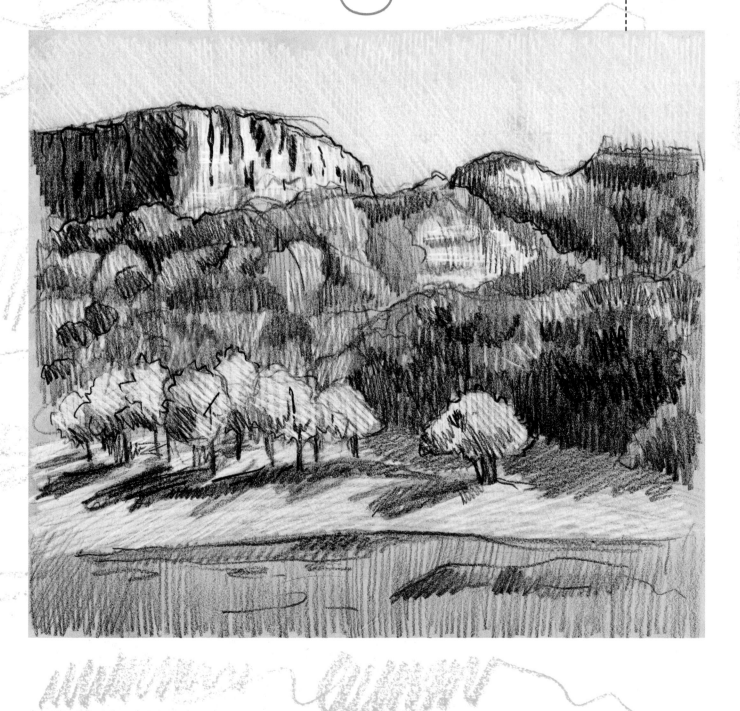

an Interior
with the white-on-white technique

The white-on-white technique uses artists' chalks and oil pencils on a tonal background. The monochrome work method which we see applied in this exercise by Gabriel Martín, allows one to construct the model without distraction from local colors or shadings, directing all our attention to representing its vivid luminous effects.It could be said that to work with the white-on-white technique is to draw light.

The selected model is an interior corner with mixed lighting, meaning daylight and artificial light are combined. The framing, the scarce furniture, and the absence of ornamental motifs will help us to understand space, texture, and volume.

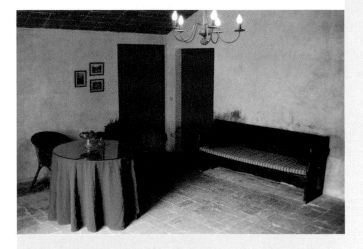

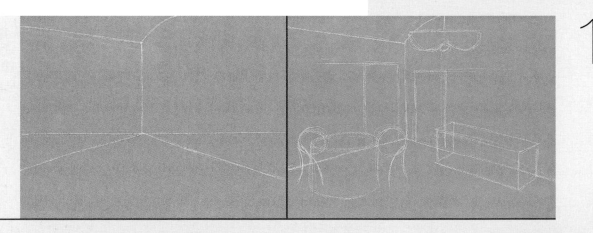

1

2

1. First we have to express the perspective of the corner. To do so, draw the horizon line, which is located somewhere below the middle of the paper. After adding a vanishing point, project two diagonals, which will be the lower limits of the two walls. To finish the schema, draw another diagonal and a curve to delimit the vaulted ceiling. In order to place the furniture correctly, imagine that they are simple geometrical forms. Remember, draw the objects as if they were transparent.

2. Reaffirm the basic forms, taking into account how the oblique perspective affects them. Use a white chalk pencil with a very sharpened point.

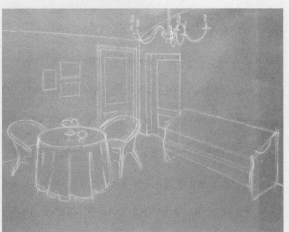

3

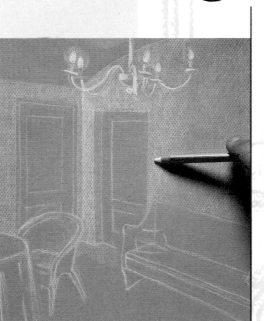

3. Cover the walls with soft shading in order to block in the first tones. Apply a small amount of pressure on the white chalk pencil and avoid hatching. Tones should be regular and homogeneous. Work softly to ease the impact of the stroke on the background walls. Then, exerting more pressure on the white chalk pencil, draw the curvilinear arms of the ceiling lamp. Draw the light bulbs in absolute white, very saturated strokes. Surround the bulbs with a soft aura to indicate that the lights are on. As you progress in the drawing and increase the tone, you should also intenslfy the light that is radiating from the light bulbs.

Work with the point of the white chalk pencil somewhat slanted; otherwise, you will obtain extremely intense strokes.

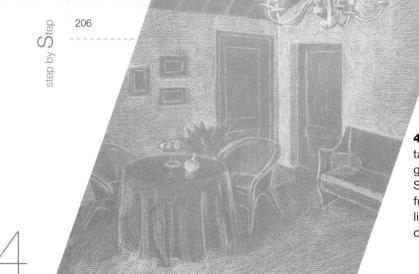

4

4. Start to lightly shade the folds of the tablecloth. Increase the density and the tonal gradation on the background walls. Streamline the form of the doors and the furniture in the room. Draw the perspective lines of the floor tiles and of the vaulted ceiling.

5. Forms will not appear suddenly, but gradually, as you build the illuminated zones and as you continue to shade. Thus, you obtain a very atmospheric drawing, where the furniture's profiles are perfectly integrated into the environment. The brightness of the lights should not stand out too much in the drawing, but it should have general tones without any sudden changes. Enhancements are not effective when they are scattered and unwarranted over an entire drawing. They should be placed on those zones that increase the contrast and enhance the volume effect.

5

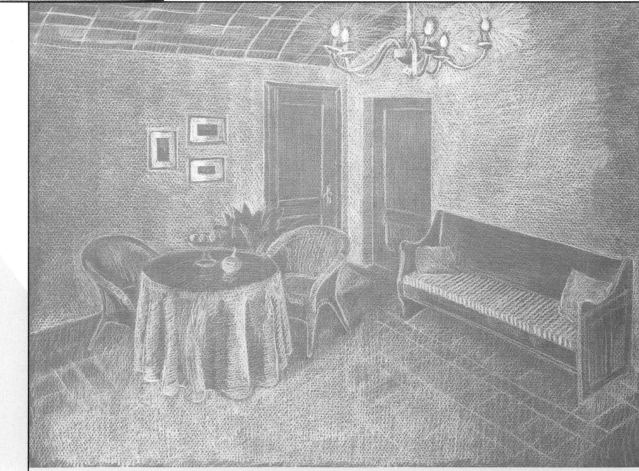

6. The lines of the chairs are linear and follow the design of the wicker. The contrasts in the tablecloth are meticulous and have visible hatching so that they differ from the textures of the other furniture. The shading on the doors should be minimal and should follow the direction of the wood.

6

Radial strokes create the effect of light radiating from a light bulb.

the "three Color" technique:
drawing with pictorial qualities

The "three color technique" uses three different chalk colors to create intense, light, and mid tones on a drawing with a colored background. The following exercise, performed by Óscar Sanchís, combines colored chalks and a colored background to achieve a drawing with pictorial qualities. The theme is a picturesque dock in Venice, which was selected because of the simple forms in its composition and because of the different light variations within it.

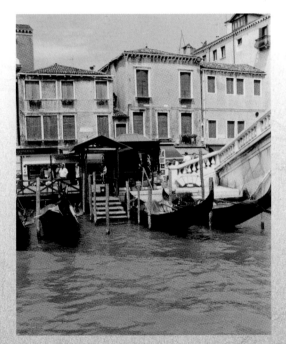

1. A medium-grained brown paper was selected for this exercise. Begin by drawing the outline sketch with a graphite pencil. Then, with schematic strokes, draw the houses on the background. Begin with geometric forms that have an unfinished and imprecise appearance.

1

2

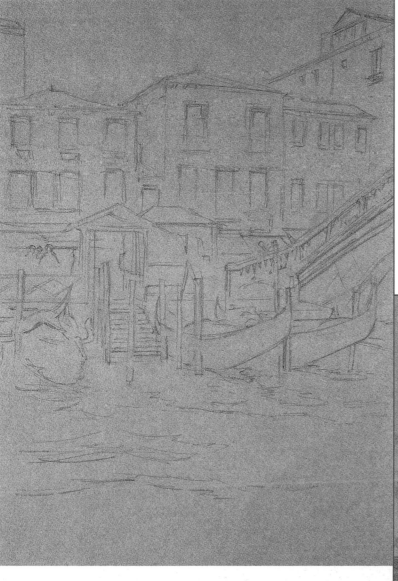

2. The foreground will require a bit more effort on your part since it contains complex architectural elements, such as boat slips, stairs, and balustrades—aside from the foreshortened forms of the gondolas and their reflections on the water. You will most likely have to frequently adjust the structural lines with an eraser.

Avoid clear, open spaces on the paper, since the brown-colored background will be a component in the drawing.

3. The contours should remain open, not closing the lines completely, in order to leave the option of shading, rounding, and defining the forms.

Block in the shading with sanguine, which will give the drawing a second gradation with mid tones. With very soft strokes, work on the shadows on the houses' façades and on the water, trying not to make them too intense. The beauty of sanguine lies in the warmth and softness it imparts to the drawing.

3

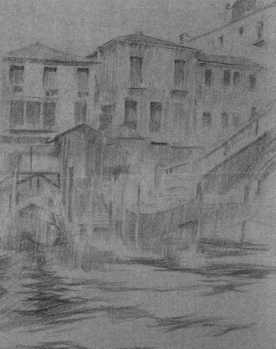

the blending stump technique:
just a blurred stain

Now we will use the blending stump as a drawing tool. You will need compressed charcoal powder and blending stumps of different sizes. Works performed with blending stumps, like this one by Carlant, produce soft, atmospheric drawings without any hard and pronounced profiles or lines.

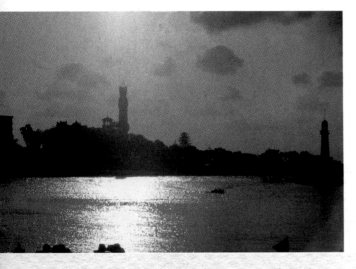

1

1. Draw the horizon line at approximately one third of the way up the sheet. Since you will be starting with light tones, take the largest blending stump and add a small amount of the compressed charcoal powder to its end. Block in the sky's shading completely. The sea's shading should be lighter and more transparent.

2. The blending stump spreads the charcoal and creates graduated tones. Make the profile of the buildings on the coast with blurred, vague stains. Use even strokes to create the clouds' forms. The more saturated the stump is with charcoal and the more pressure you apply on it, the darker the tone will be. If you make a mistake, correct it with a kneadable eraser.

2

Using two or three blending stumps of different thickness is common in this type of exercise.

A brush can also be a good blending tool. Since it is softer than a blending stump, it lightens a tone much more.

3. Continue the drawing, modifying the intensity of the shadows by adding more charcoal powder. Emphasize the building's outlines and bring out the contrast between the coastal line and the sea, which appears much brighter.

Apply horizontal strokes on the water with the blending stump to describe its calm and crystalline surface. Use the white of the paper to represent the sunlight's reflection on the water.

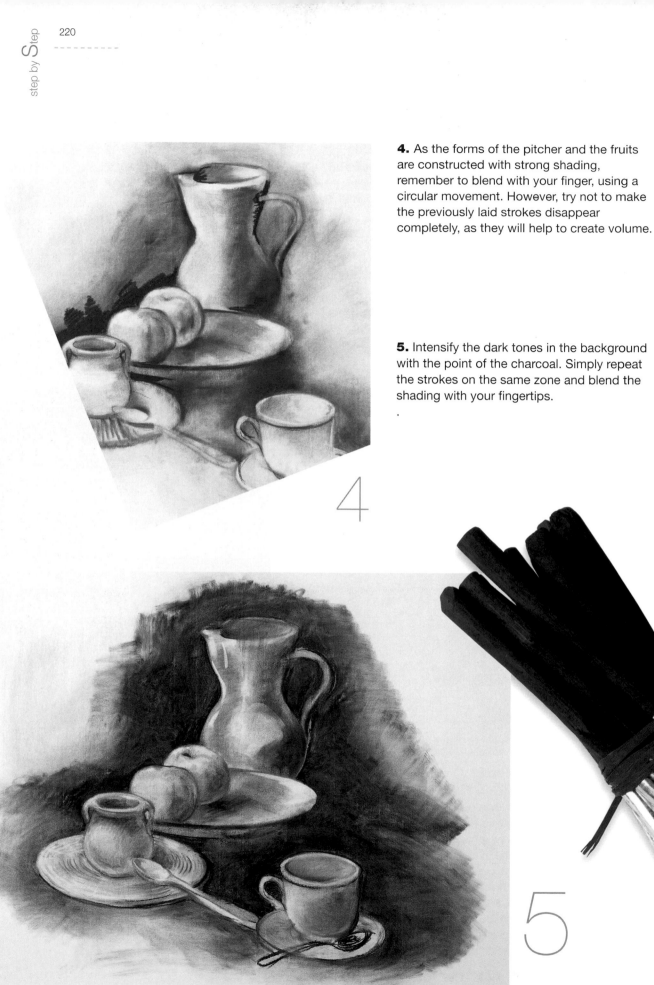

4. As the forms of the pitcher and the fruits are constructed with strong shading, remember to blend with your finger, using a circular movement. However, try not to make the previously laid strokes disappear completely, as they will help to create volume.

5. Intensify the dark tones in the background with the point of the charcoal. Simply repeat the strokes on the same zone and blend the shading with your fingertips.
.

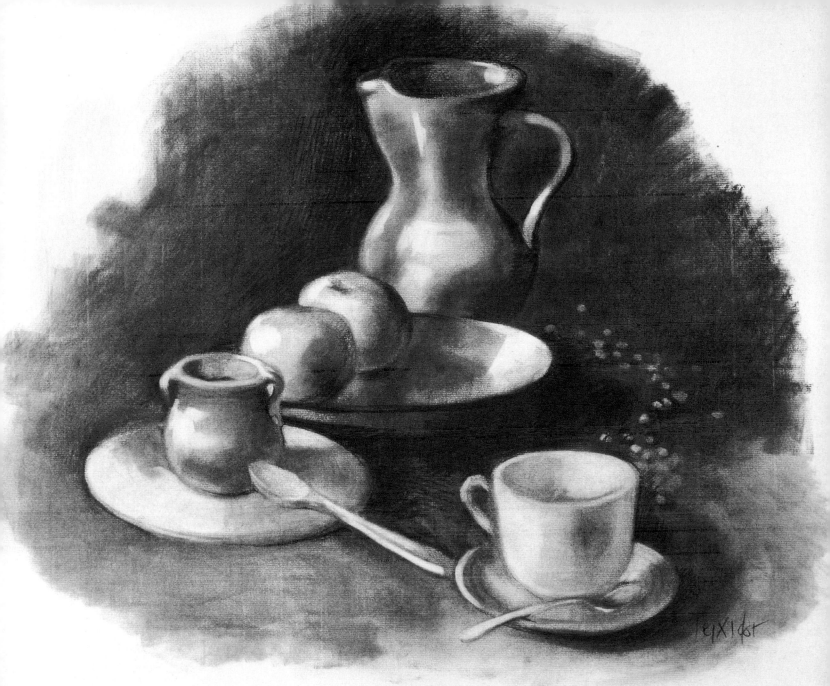

6. Once the background shadows are completed, retouch the profiles and the more pronounced contrasts with a compressed charcoal stick. With compressed charcoal, the blacks are more intense than natural charcoal. You can still correct lines, as well as any badly located shadows, as long as you have not drawn extremely intense black strokes that are difficult to erase.

You can make your own blending stumps by rolling a piece of paper into a tube and then shaping it like a spatula. If you work with the wider end of your handmade blending stump, you will achieve pictorial blends with effects similar to those produced by a brush.

white Chalk highlights:
an explosion of light

This next exercise, by Esther Llaudet, will use white chalk to represent illuminated zones. A beginning art student may think that illuminated zones do not have many tonal variations and contrasts; however, after a closer look, you will see that it is just as varied and nuanced as the previous exercise—where dark shadows dominated. Instead of concentrating on dark areas and shadows, we have to pay attention to the white and illuminated areas found in the next drawing.

1. When drawing a strongly lit scene, we must first present the structure. With a natural charcoal stick, outline the forms of the sofa, plant, and pillows. Working with the chalk stick on its side, apply the first white stains to the pillows, concentrating on their characteristics and fundamental form.

2. At the same time you are developing the sofa's form, build up the texture and the folds in the fabrics using tonal gradations. The intermediate tones are achieved by letting the color of the paper show through the white chalk shading.

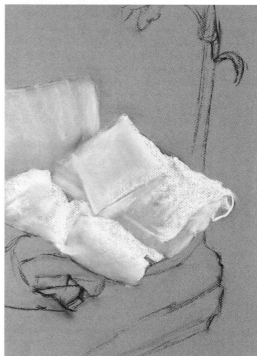

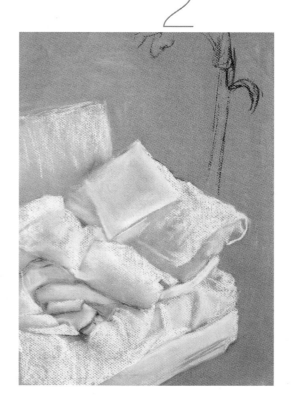

3. Shade the whole background with white chalk. Blending it with your hand will give an unfocused look to the second plane. Later, you can add some finishing touches with a darker color to enhance some of the profiles and contrasts. Emphasize the interior profile of the sofa and give some folds more weight with the natural charcoal stick.

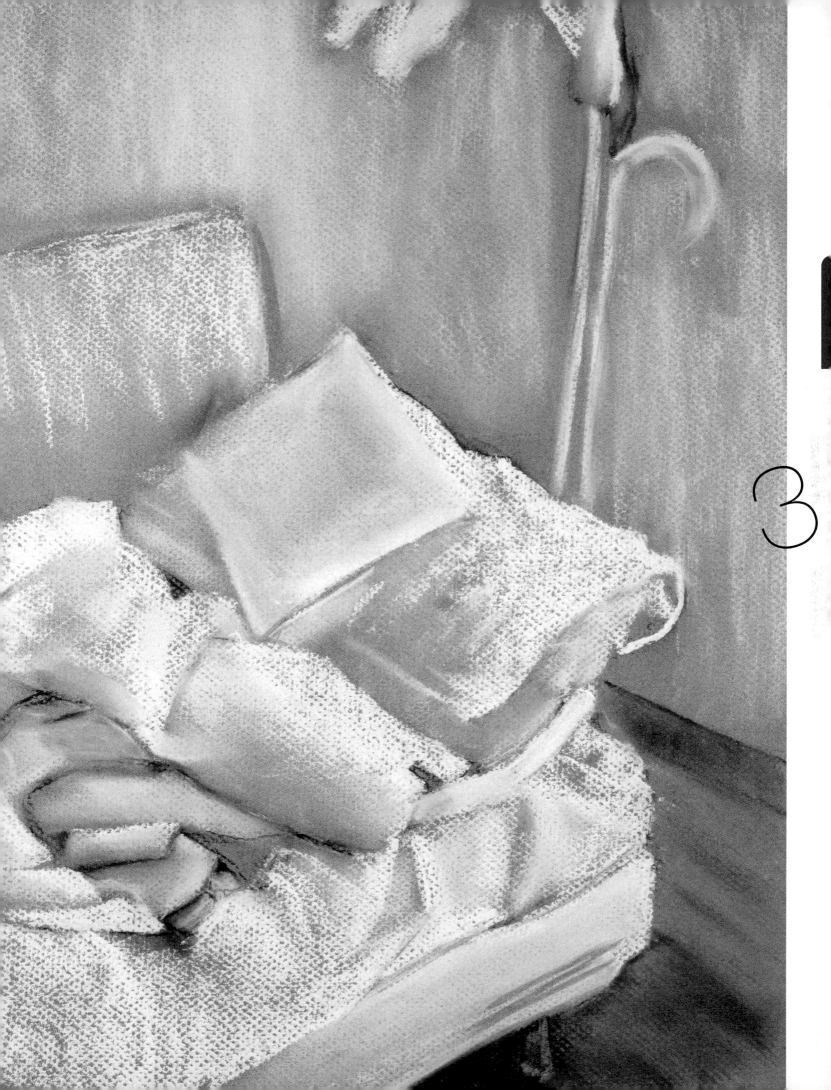

3

a landscape
with graphite

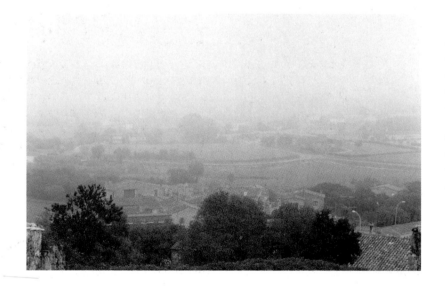

If you want to be an expert in drawing landscapes, you will have to become familiar with obtaining three-dimensional effects and depth, just as Gabriel Martín has done in this exercise. This effect looks best when you are drawing a landscape in the early morning, a misty haze, or in snow. In order to give this theme a convincing sense of depth, the tones should gradually go from dark and strong in the foreground to pale and hazy in the background. This allows for a clear, sharp foreground that contrasts with the distant landscape.

Erase the light zones in the upper part of the drawing to make them clearer, allowing the tonal transitions to be smoother.

1. Draw the foreground with an HB pencil. Through linear drawing, detail the form of the houses and the main vegetation in the foreground. Then, add the first tones on the lower part of the drawing and apply texture to the vegetation.

1

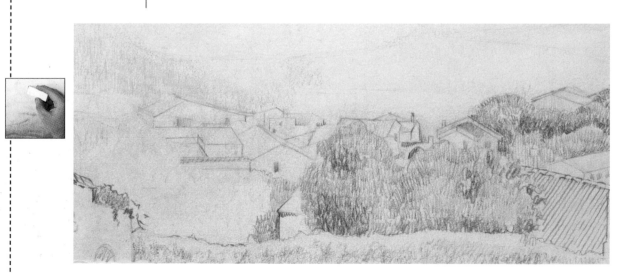

2

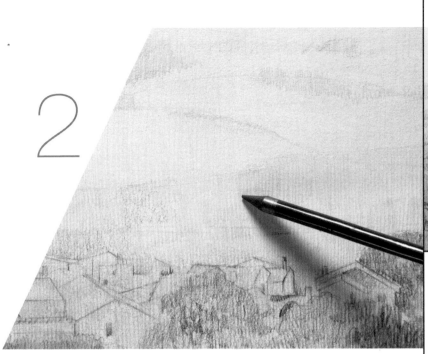

2. As you progress to the top of the drawing, the shading should be more subtle. It is better to have less intense shading at first rather than too much. The whole drawing should present a gradation; that is, the viewer's gaze should start at the bottom of the drawing and move up and through the subtle tonal and textural variations.

3. To accent the sensation of depth in the group of trees in the background, blend their contours. This way, the vegetation will merge with the ground and the horizon will disappear.

3

4. Finish the drawing with a 4B lead. By intensifying the tones of the group of houses and by adding texture to the trees in the foreground, you will make these appear closer to the viewer and, as a consequence, increase the depth effect. Do not apply texture to the rest of the vegetation in the landscape; these effects should appear only in the foreground.

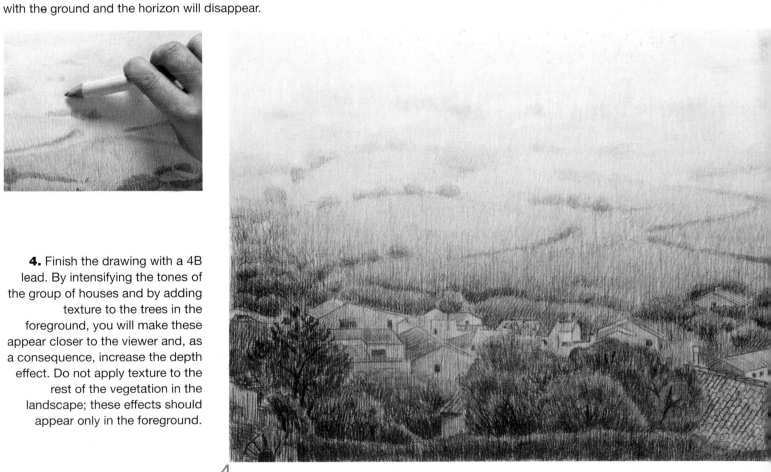

4

an interior Patio
in wash

Washes allow for some scumbles and some delicate light and dark contrasts. This next exercise, by Oscar Sanchís, is an interior patio that has strong contrasts between bright light and shadows. Due to this theme's lighting effects and the richness of mid tones, we are going to focus on gray tones.

1

1. As always, begin by outlining the structure, in this case an ellipsis in the lower part of the paper and two perspective diagonals in the upper part. Make the doorframes line up with perpendicular lines. The initial outlines are combined with circular forms that define the arches of the doors and windows. Another circle in the middle indicates the position of the well. Erase the geometrical outlines and reaffirm the contours of the patio's structure.

2

You should keep the zones that will have lighter tones reserved.

2. After the forms of the drawing have been made, you can proceed to detailing the drawing. In this stage you have to be very scrupulous in observing the model and presenting the forms in detail.

3

3. Since the white of the paper lightens the grays, the wash should be applied using a small range of mid tones, starting from a lighter tone and moving towards a darker one. Use this technique to block in the mid tones. All of the tones should be applied before the washes dry so that when you add more tones, they will gradate with the zones that are still wet.

The first washes modify the background and prepare the drawing for the addition of more grays.

4. With a more intense black and a round, fine brush, contrast the mid-toned shadow zones with the illuminated zones. In a wash, handling the brush correctly is very important, since the brushstroke—even though it is a drawing technique—creates the stains, tones, and strokes.

5

4

5. Using different brushes, continue to contrast the forms and make them concrete. The contrasts should be accented with dense washes having less water.

the reed Pen
and its effects

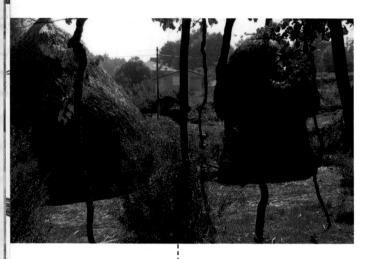

In spite of its rustic appearance, the reed pen is a very versatile drawing tool. Its stroke is softer than that of the metallic nib, with more variations in the thickness of the line. You have a certain amount of control in the intensity of the strokes if you blot the reed pen on a piece of paper before drawing. The theme of this exercise, performed by Mercedes Gaspar, is some bales of hay seen against the light.

The difficulty here is to keep the whites intact, since you will not be able to make any corrections.

1

1. Before starting any ink drawing it is important to sketch the theme in pencil to make sure you will be working with correct dimensions and proportions. In this case, you will start with a quick sketch that will serve as your outline.

When there is little ink in the reed pen, the stroke is softer and covers less.

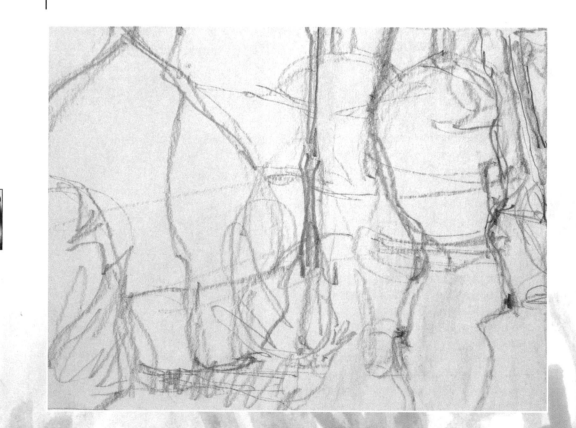

2

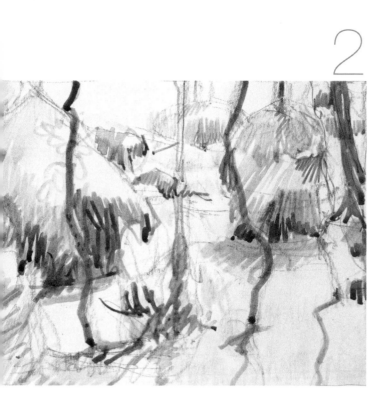

2. First, accent the drawing with the edge of the reed pen by drawing thick ink lines diluted in water. When the ink is diluted, in case of an error, you can correct with more intense strokes. Once the main elements of the theme have been silhouetted, you can start shading with dense strokes, according to the degree of darkness of the shadows.

3. The larger width of the reed pen's strokes allows you to create solid black stains easily. Draw several superimposed strokes of different intensities on the bales to give them texture. On the foreground, several blank spaces have been left so that the the trees' shadows can be projected against the light.

3

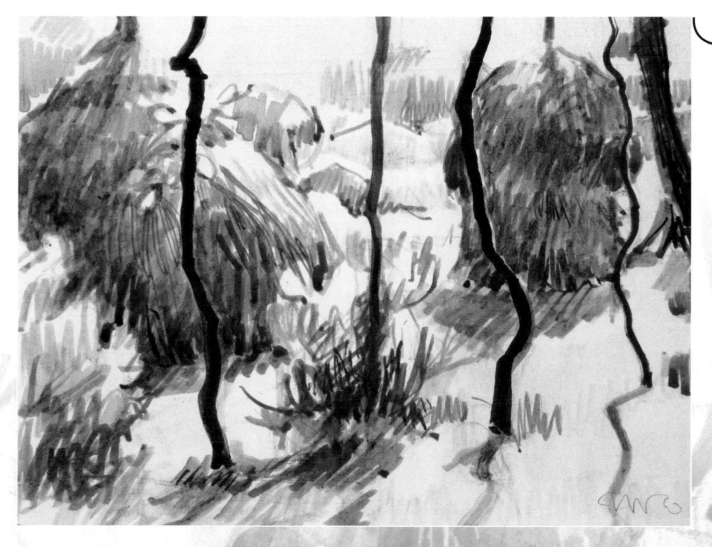

drawing on Colored paper
with white and black inks

Alternating between white and black inks on dark paper is a traditional drawing technique. The white ink is used for the illuminated zones, the mid tones are provided by the paper, and the black ink is reserved for zones with intense shadows, as Carlant describes in this next exercise. The model, in spite of being very simple, is rich in contrasts and reflections. Aside from the above, it presents a challenge in representing the lighting effect and perpetual movement on the water's surface.

1. The initial outline sketch is very simple. First draw the horizon line with a white pencil. Then project the diagonal that composes the picture where the boat is located. A couple of creative strokes will be sufficient to situate the boat. Once the outline sketch is resolved, you can begin to draw with white ink and metallic nib.

Draw the profile of the boat and its crew with an intense and firm stroke; try to capture only the contours. Exert more pressure on the metallic nib to produce thicker and more intense lines.

1

2. The profiles and the proportions has to be absolutely correct in these first stages. As you draw new forms you can shade with very fine hatching, which will give the first tones to the drawing.

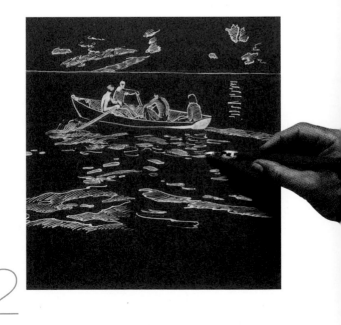

2

3. Concentrate on the reflections on the lake's surface. Initially, these appear silhouetted as if they were perfectly defined oil stains. To distinguish these lighter zones from the rest of the surface, cover their interior space with diagonal stroke hatching. These lighter and broken lines will serve as tonal zones. With another metallic nib, apply shading with black India ink. Concentrate on the darker shadows of the vegetation on the upper part using intense and uneven doodling. The change from thin to thick in the same stroke can give certain sensation of fluidity. A freer and random hatching will give the vegetation an incomplete and less concrete aspect while providing a richer tone depth.

During the drawing process it may be necessary to clean the tip of the reed pen with a rag in order to get rid of any particles of ink that could make the stroke of the pen or charging it difficult.

4. Through a careful observation of the model you can capture all the details and tonal and textural variety, especially those of the water's reflections. The contrasts achieved through the black ink in the upper part of the drawing help to enrich the tones that give the drawing a three-dimensional quality, accented by the greater contrasts between lights and shadows.

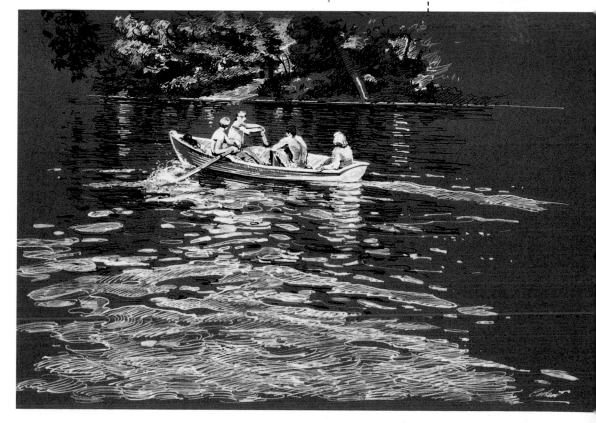

a Still-life
with colored inks

A drawing with colored inks presents the same characteristics as a drawing done with India ink, except that it requires us to use a specific work method. Although inks can be mixed with one another, we recommend that you do not mix them often because the colors tend to get dirty and the tones become cloudy. The only really viable mixes are the ones that result from combining different color strokes on the paper, just as Esther Rodríguez explains in this next exercise.

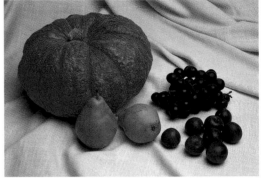

1. It is extremely important to first construct a very simple outline sketch on which to base the lines of the the still-life. We chose oval and circular shapes to begin describing the pumpkin and fruit's forms.

When the ink strokes are still wet, you can blend them with a wet paper towel to achieve rich tonal effects.

2. The silhouettes of each one of the elements of the still-life are detailed. The stroke should now be more accurate and describe the profile and characteristics of each fruit and the pumpkin. Before starting to apply the strokes with ink, the sketch of the model must be complete, since shading has to be applied on a perfectly constructed outline sketch.

3

3. Create the general tone through shading, giving each object volume. Describe each object's folds, shadows, and mid tones by intensifying the shading with short strokes in two colors. Instead of using only one tone to create the shadows, use two tones with different values. As you can see, the contrast between light and shadow is evident and adapts itself perfectly to the object's form.

Gouache can also be used as a colored ink. Dilute it with water until it acquires a watery consistency.

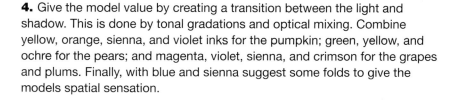

4. Give the model value by creating a transition between the light and shadow. This is done by tonal gradations and optical mixing. Combine yellow, orange, sienna, and violet inks for the pumpkin; green, yellow, and ochre for the pears; and magenta, violet, sienna, and crimson for the grapes and plums. Finally, with blue and sienna suggest some folds to give the models spatial sensation.

4

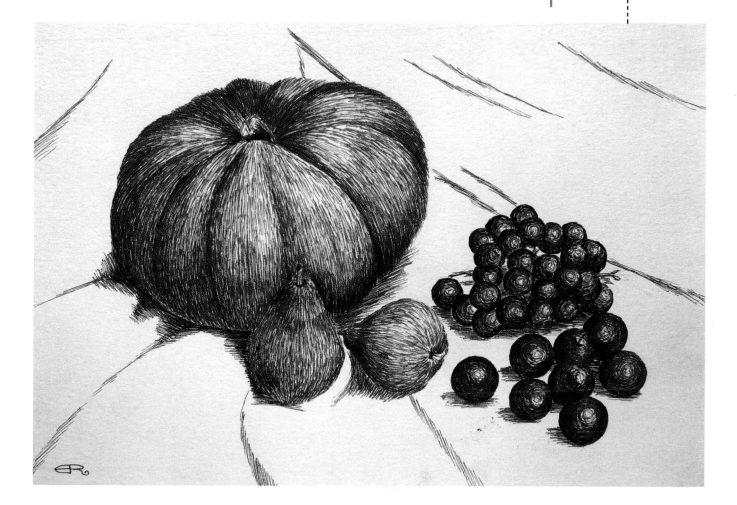

controlling the line:
hatching

1

The hatching technique is a method by which you draw on an area with soft strokes, always in the same direction, of different juxtaposed colors to achieve an atmospheric effect, rhythm, and harmony. Your objective in this exercise, aided by Mercedes Gaspar, will be to draw a still-life with colored inks, using different varieties of reed pens and metallic nibs.

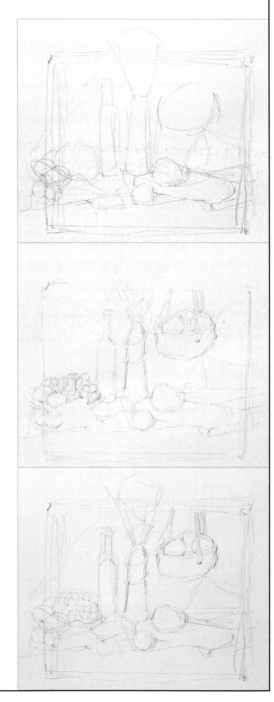

1. The initial outline sketch is an arrangement of synthetic lines and contours of the elements in the composition. In this stage, the objects can barely be identified; they are summed up by a few geometric shapes. Once you have created the forms, build up the picture but leave out the outlines of some objects. Thanks to the initial pencil sketch, you attain the profiles of each form and the linear harmony of the ensemble. The strokes are not equal, in some areas lines are defined with thicker strokes that indicate the presence of shadows or pronounced contrasts in the model. The initial pencil sketch has to be complete in order to begin the next phase.

If you have made an error in ink and cannot fix it by rubbing it with a blade, glue a piece of paper the size of the fragment you have to correct and draw on it.

It is a good idea to use several reeds and metallic nibs so that the residues of a color do not mix with the next color.

2

2. You will start working on the background light by making short, delicate yellow and red strokes. Mix them until you have an interesting range of pink and orange tones. It is extremely important that you reserve the white of the paper when applying the first colors; therefore, apply them with the ink jar's cap.

3

3. Finish covering the background by applying some new yellows to the table. Start to define some of the objects with diluted tones or with tones mixed with other colors. The strokes turn into an elongated stain that gives variety to the drawing and reinforces its intensity. Work with strokes that go from less to more dense and intense.

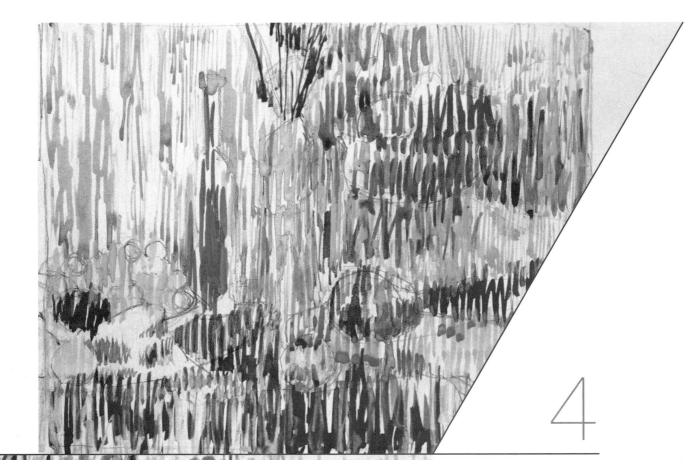

4

4. In this stage you can see the chromatic effect of the ensemble after several bluish and purplish strokes were added to the objects, contrasting with the warm and luminous tones on the background. Alternate the strokes' thickness by combining different reeds and metallic nibs. Colored inks are very transparent and can be mixed with each other; it is possible also to lower their intensity with a little bit of water.

The enlarged detail shows how the accumulation of strokes modify the basic colors, producing a clearly divided color effect. A stroke's density in a concrete zone determines the form's shading and volume. If you want an object to stand out, you have to give it contrast; that is, you must surround the object with complementary colors that define its profile and form.

5. Intense violet and brown inks are the last ones used to darken the shadowed zones in the composition to contrast with the illuminated parts. These last finishing touches are performed with a metallic nib. The hatched stroke suggests energy, movement, and a transparent effect.

5

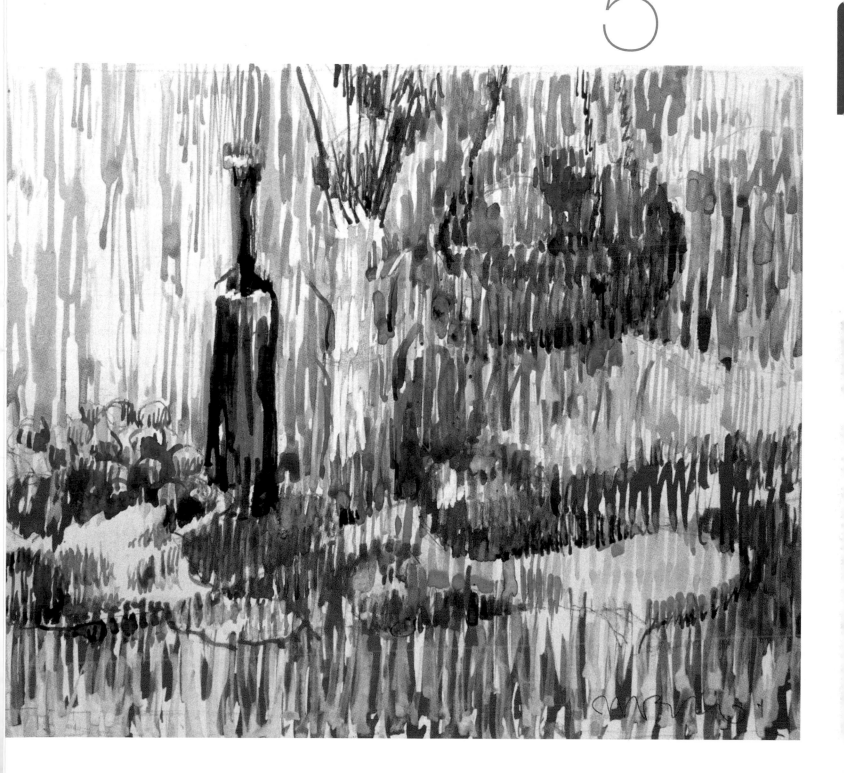

an Urban view
with oil pastels on a tonal background

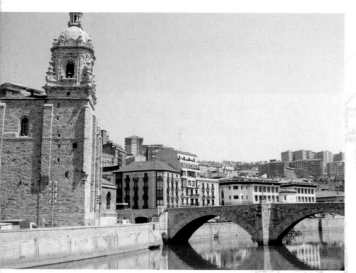

For this exercise, Gabriel Martín has chosen an urban view that allows the development of a chromatic drawing with oil pastels or wax crayons. What is sought here is to capture the effect of light on the landscape, avoiding details and constructing the forms through a set of short and vertical strokes in the form of color marks. The expressive capacity of the stroke, working on a tonal background, and the trace that the sticks leave are drawing resources that together give a more expressive treatment to the work, show their versatility, and give special results that can become the artist's personal style.

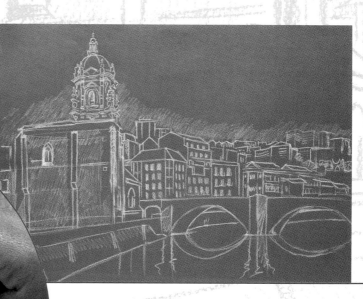

1. Through an outline sketch performed with a white pastel, create the architecture with simple and linear lines. Give a more detailed treatment to the church in the foreground and a more schematic treatment to the rest of the buildings. The first thing you do in a landscape is to cover the sky. You will do this by combining Prussian blue, ultramarine, crimson, cyan, and white through direct, superimposed, and directional strokes that create a small gradation without blending, still retaining the contours of the buildings.

2. First add the shadows on the bridge and on the church's façade with bluish and violet tones. Looking for the contrast effect of complementary colors, cover the rest of the façade with yellowish and orange contours. As the buildings recede from the foreground, the intensity of the color is also attenuated.

Apply strokes with progressively more energy, distinguishing more clearly the illuminated façades from the shadowed ones. Also, increase the sensation of atmosphere by fading and making the profiles of the buildings undefined.

The positioning of the pastel on the paper produces different strokes with different thickness.

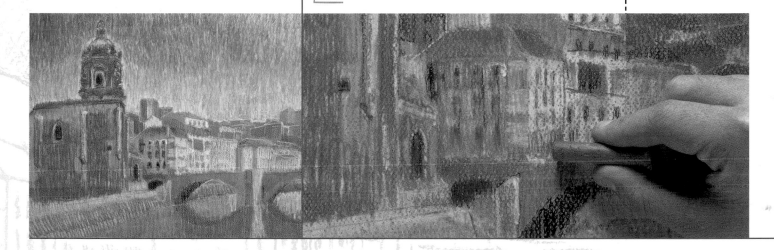

3. The juxtaposition of the strokes gives the drawing a vibrant and dynamic aspect. To simulate the reflections of the façades on the water, apply saturated white and olive-green strokes. Emphasize the accented contrasts of the church windows and the shadowed zone of the arcs of the bridge with more intense earth tones and black.

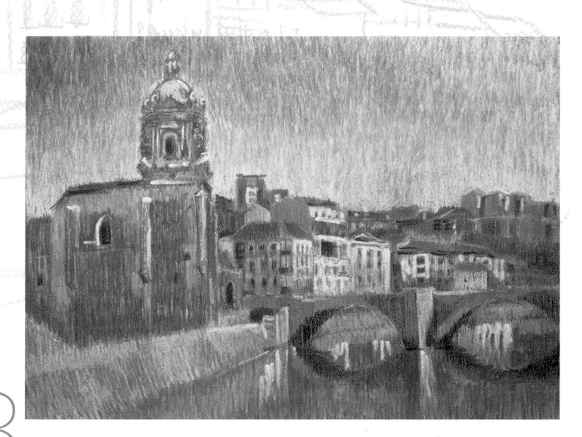